Democratic Principles

Portraits and Essays

FOREWORD BY
SENATOR JOHN KERRY

COMMENTARIES BY
ELEANOR HEARTNEY, PETER FRANK
AND ELIZABETH McCLANCY

HARD PRESS EDITIONS, LENOX, MASSACHUSETTS

A Hard Press Editions Publication
© 2008 Elizabeth McClancy
Design & Package © 2008 Hard Press Editions
Foreword © 2008 Senator John Kerry
The View from Within © 2008 Eleanor Heartney
To Be Self-Evident: Purpose, Principle, Portraiture © 2008 Peter Frank
Essays accompanying portraits are public domain with the exception of President Jimmy Carter's
Nobel Laureate Address © 2002 and Eulogy for Coretta Scott King © 2006 Jimmy Carter

Published in the United States by
Hard Press Editions
45 Walker Street, Lenox, MA 01240
Edited by Elizabeth McClancy
Designed and typeset by Jonathan Gams
Managing Editor, Anne Bei

ISBN: 978-1-889097-74-9

Printed in China by Everbest Printing Company
through Four Colour Imports, Ltd., Louisville, KY

Front Cover Image: Detail, *Secretary of State Madeleine K. Albright,* 2007, oil on canvas, 18″ x 24″
Democratic Principles Series, No. 1

Contents

The liberties of our country, the freedom of our civil Constitution, are worth defending at all hazards; and it is our duty to defend them against all attacks. We have received them as a fair inheritance from our worthy ancestors: they purchased them for us with toil and danger and expense of treasure and blood, and transmitted them to us with care and diligence. It will bring an everlasting mark of infamy on the present generation, enlightened as it is, if we should suffer them to be wrested from us by violence without a struggle, or to be cheated out of them by the artifices of false and designing men.

—Samuel Adams
Essay written under the pseudonym "Candidus," in *The Boston Gazette* (14 October 1771)
American revolutionary and organizer of the Boston Tea Party.
Governor of Massachusetts from 1793 to 1797

In the councils of government, we must guard against the acquisition of unwarranted influence, whether sought or unsought, by the military-industrial complex. The potential for the disastrous rise of misplaced power exists and will persist. We must never let the weight of this combination endanger our liberties or democratic processes. We should take nothing for granted. Only an alert and knowledgeable citizenry can compel the proper meshing of the huge industrial and military machinery of defense with our peaceful methods and goals, so that security and liberty may prosper together.

—Dwight D. Eisenhower
Farewell Address to the Nation, 1961

Foreword
Senator John Kerry

Like one of Elizabeth McClancy's arresting portraits, the face of the Democratic Party is many things: bold brush strokes, fine shading, and powerful contrasts among the distinctive Democratic personalities who share the political stage.

But as you step back, you find a full and irreducible vision of the world as it is—and the world as it should be.

Step back and what emerges is a vision of family, faith, hard work, opportunity, and responsibility for all. The Democratic vision is a vision where every child, every adult, every parent, and every worker in America has an equal shot at living up to their God-given potential. That is the American dream—and it is the heart of Democratic values.

We Democrats aspire to create an American society that respects and embraces our differences. We celebrate an America that believes in ingenuity and isn't afraid to be bold. We demand an America that empowers hardworking families to help themselves and fights for those who cannot fight for themselves. We are the party that understands that America leads best when it leads by example. In the end, we are strongest when our leaders engage with the world, follow the law, and tell the truth to the American people.

These are Democratic principles, but they are also the republican virtues that define and sustain our system of government. In fact, many of the greatest leaders of both parties have followed them to meet the demands of their time and place. Great men like Abraham Lincoln and Franklin Delano Roosevelt were defined less by allegiance to their party than faithful adherence to their core principles.

These Democratic principles are at once timely and timeless: as suited to meet the demands of terrorism or an oil crisis today as they were to the Great Depression or the Civil War.

In every generation, these principles must be defended, advanced, reinvigorated, and reinvented. From the heartbreak of 9/11, to the immensity of looming threats from climate change to resource scarcity to nuclear terrorism—all have conspired to create as great a challenge as I have seen in public life.

Democrats understand that these threats are real. We do not flinch from what must be done to protect the American people and our way of life. But we believe that America is strongest when strength is guided by wisdom. We believe that America's greatest weapon is not a bomb or a missile but the force of our founding ideals and the promise they offer to all humanity.

We will defeat these enemies not by compromising our moral authority but by strengthening it and sharing with the world a vision of American leadership. We will meet these challenges—whether it's global climate change or global jihad—by offering a brand of American leadership that inspires others to follow.

Today, Democratic principles are being eroded by those who believe the ends justify the means. Our dialogue is being hijacked by those who confuse dissent for treason and see no contradiction in fighting terror with fear. Our politics is cheapened by those who mistrust the American people too much to speak honestly with us, our reputation sullied by those who mistrust the people of the world too much to make an honest effort to win hearts and minds.

We Democrats believe that what matters most are not narrow appeals masquerading as values, but the shared values that show the true face of America: not narrow values that divide us, but the shared values that unite us. Values are not words—they are what we live by. They are the causes we champion and the people we fight for.

My Democratic Party is a party that embraces diverse people and viewpoints. We understand that the rights Americans enjoy today—workers, minorities, women, the poor, the elderly—are the result of hard work from people who chose to stand up and protect the rights of regular people over powerful interests.

We understand that true patriots must defend the right of dissent and open dialogue. Dissenters are not always right, but it is always a warning sign when they are accused of unpatriotic sentiments by politicians seeking a safe harbor from debate, from accountability, or from the simple truth. Truth is the American bottom line. Truth above all is fundamental to who we are. It is no accident that among the first words of the first declaration of our national existence it is proclaimed: "We hold these truths to be self-evident." The Democratic Party is a party that believes in telling the truth to the American people.

The Democratic Party is a party of compassion. Hubert Humphrey once said, "The moral test of government is how that government treats those who are in the dawn of life, the children; those who are in the twilight of life, the elderly; and those who are in the shadows of life, the sick, the needy, and the handicapped." From children's health to cancer research funding to voting rights, those words ring as true today as they did when a Democratic politician first uttered them four decades ago.

We believe that those who talk about family values must also value families.

You value families by funding after-school programs, and putting cops on the street. You value families by giving children health care and by giving them clean air to breathe, clean rivers and lakes to swim in, and clean water to drink. You value families by making sure the elderly have financial security and access to life-saving medication. You value families by ending the deficits that pass on the cost of today's misplaced priorities to future generations. You value families by making sure soldiers have body armor, so that sons and daughters and fathers and mothers can come home safely from the wars they fight.

These are family values, and they are Democratic values.

At their best, Democratic values are about optimism—not opposition to a single man or another party. Even after the slings, arrows, and low blows of a cynical political era, we Democrats still believe in unity and mutual respect. We stand ready to lead. The high road may be harder, but it leads to a better place—and we

Democrats still aspire to be a party of big ideas and not small-minded attacks. No one—Democrat or Republican—who has something to contribute to our Nation should be left on the sidelines.

Those are our values. But in the end, all these ideas only become powerful if you stand up and fight for them.

Let me tell you about one of the people who reminded me what values really are: Austin Griffin. Austin died this year at 91. You've probably never heard of him, which was just fine by Austy.

I met Austin Griffin over twenty years ago. I was a prosecutor, going after the Mob. A group of thugs from one of the most ruthless gangs—real killers—had walked into the Disabled Vets Hall that Austin helped run. They told him, "We're putting in slot machines, here. We want protection money. Do this by Friday, or else."

They picked the wrong guy. Austy was a World War II hero. He came to me and told me what was happening. We got him protection around the clock. But when you take on killers, you're scared no matter how much protection you have. Scared every time you walk out the door. Every time you turn the key in your ignition.

Austin Griffin never wavered. He testified. He looked them right in the eye. We broke up that gang and they're still in prison. When Austin died this July, his daughter said she knew her dad "wasn't going to cave." "My father had his values," she said.

Well, we have our values too. And we're not going to waver. We're not going to cave.

These paintings capture essential truths about some of the greatest champions these values have seen. I am very proud to call these men and women my colleagues, and they make me very proud to call myself a Democrat.

The purpose of the *Democratic Principles* project is to rekindle in the American people, and to reveal to those who have never understood, the serious principles that are central to the founding of our democracy and to its future. To understand the necessity of those principles for the survival of our democracy is to recognize the paramount importance of defending those principles against all who would subvert them in the interest of power or personal gain.

This is a noble project—and a terrific set of paintings. It is said that art holds the mirror to life. Elizabeth McClancy's portraits have eloquently captured some essential kernel of each of the politicians she painted. And in much the same way, her clever juxtaposition of the words and images of such a complex and varied group has vividly rendered a picture of the Democratic Party heading into 2008—ready to help America be America again, and ready to lead.

November 2007
Washington, D.C.

The View from Within
Eleanor Heartney

Despite the disavowals of the art for art sake crowd, art and politics have had a long and distinguished relationship. Historically, political art has taken many forms—for instance, there is Guernica, Picasso's anguished cry against the pointless suffering inflicted on helpless victims of war; Goya's Capricios, a set of searingly satirical caricatures of the follies and vices of Spanish society; Georg Grosz's bitter revelations of the corruption of Weimar society; and Leon Golub's dissection of the psychology of power in his monumental Mercenary paintings.

Such works belong to the tradition of political critique-—works created to reveal the depths to which society has fallen from its stated ideals. But there is also another kind of political art—art that is meant to inspire and to awaken, in Abraham Lincoln's felicitous phrase, "the better angels of our natures." In this category are the works of artists like the Mexican muralists Diego Rivera, David Alfaro Siqueiros, and José Clemente Orozco who used their art to promote a revolutionary version of history that led from the century-old oppression of peasants and workers toward the hoped-for socialist utopia of the future. A similar impulse motivated American artists such as Thomas Hart Benton, Jacob Lawrence, and Ben Shahn during the 1930s and '40s, leading them to explore the shining promise of American democracy in paintings that highlighted both the struggles of workers and the efforts of social reformers to hold America to its standards. A more recent example is Maya Lin's Civil Rights Memorial in Montgomery, Alabama, which offers a visual and verbal evocation of Dr. Martin Luther King's stirring exhortation: "We are not satisfied and we will not be satisfied until justice rolls down like waters and righteousness like a mighty stream."

Both these approaches assume an outsider's perspective—they stake out a position beyond the fray of the actual political process and conceive of the artist's role as that of commentator or agitator. Much rarer is art that deals with the mundane and unglamorous work of legislators negotiating the pull of myriad interest groups as they attempt to translate some semblance of their ideals into practical policy.

Elizabeth McClancy's *Democratic Principles* brings art and politics together in the most practical way. She combines portraits of the leaders of the Democratic party with texts of their speeches on a variety of important issues. But despite the often inspirational nature of the words documented here and the serious and decidedly non-ironic quality of the assembled portraits, these works are not designed to operate as party propaganda. McClancy is an independent artist and this is not a partisan project. Rather, by focusing on the words and portraits of leaders of the Democratic Party, McClancy affirms her belief that change is best affected by working through the system. This is an important message today, because as fewer and fewer Americans participate in elections, we have seen a deepening erosion of our core values of equality, inclusion, and collective effort. Particularly among young people, there is abroad today a cynical belief that all politicians are on the take, and that there is no difference between the two parties (an argument tragically refuted by the consequences of the 2000 election).

Such cynicism is belied by the positions charted out in speeches here, which reveal a deep desire to reawaken America's latent generosity, internationalism and dedication to civil rights, social justice, and democratic

(small *d*) ideals. McClancy's portraits of figures like Al Gore, Howard Dean, Bill and Hillary Clinton, Nancy Pelosi, Robert Byrd, and Madeline Albright offer a counter to the media game of "gotcha" in which politicians are ridiculed for their clay feet or viewed as chess players to be judged solely on the efficacy of their political "moves." Instead, she depicts them as real and complex individuals, who are by no means perfect and whose ideals often come into conflict with the rough-and-tumble of day-to-day politics. Rather than dismiss these figures as hypocrites and opportunists, she pays them the respect of taking their stated beliefs seriously. By pairing these thoughtful portraits with their subject's words, McClancy holds members of the Democratic leadership to the standards they have set for themselves. In the process, she demands that they—and we—attempt to make these stirring ideals a living reality.

While acknowledging the truism that politics is the art of the possible, *Democratic Principles* nonetheless exudes a deeply American belief in the democratic process. McClancy reminds us of the beliefs that should be the bedrock of American policy. Dramatizing these through the interplay of images and words, she demonstrates that art has a role in the healing process of the dead center of our political system.

November 2007
Queens, NY

To Be Self-Evident: Purpose, Principle, Portraiture
Peter Frank

From the beginnings of civilization, deities, monarchs, and outstanding citizens have figured prominently among the subjects of artistic depiction. Even in societies biased against visual representation, the creative arts have served to glorify the supreme creator(s) and to honor and memorialize those felt to be most responsible for bringing humanity closest to the divine—or at least closest to peace and prosperity, which could be interpreted as the same thing. Certainly in the West, art has chiefly glorified God and gods, and secondarily glorified kings and conquerors, powerful nobles and triumphant generals, men of political power and women of social standing. Only in the last couple of centuries has the rest of the world—landscapes, still lifes, places, things—captured the imagination of artists anywhere near as completely. But, then, lords and industrialists are more likely to pay to have their pictures painted than flowers are.

Still, even in our time, it doesn't take a commission to inspire an artist to turn her or his attention to "traditional" portrait subjects. Indeed, what currently challenges a painter of people to paint well-known people is the fact that these people are well known to us visually as well as verbally. For every thousand words written about a president nowadays, there is at least one picture—or film clip, or video, or even caricature. In our age of universal, and instant, communication, visages of our leaders are all too familiar to us. And in this era of consumer celebrity, too many of us know our leaders only as visages. What happens when those visages are captured by a non-camera medium, a medium that promises a view of such visages that is not instantaneous but profound, not immediately discardable but enduring and iconic?

Elizabeth McClancy gave herself a task unusual for a contemporary painter: paint the faces of a political party's leadership. It's an eccentric task; it would have been odd enough had someone associated with the party commissioned the series, but for the artist to undertake the task unbidden reflects the peculiarities of that artist's own impulse. McClancy is clearly motivated by her preference for the policies currently advanced by the Democratic Party, a preference she shares with a growing number of Americans who feel betrayed by the decisions, and the behavior, of so many in the other major party. But as an artist—and especially as a painter of faces, steeped in one of Western art's oldest, deepest, and most affecting traditions—she is also fascinated with the way the character of her party of choice comes out in the faces of the characters she paints.

There are those who would aver that certain facial characteristics are inherently "progressive" or "reactionary." (Robbie Conal, the noted painter of political satire and protest, once painted a series of "Men With No Lips," thus identifying the perpetrators of the Iran-Contra scandal as prim, self-righteous, ideologically driven conspirators.) McClancy does no such thing. If anything, she stresses how distinctive each visage is, one from another, positioning and highlighting each of the diverse faces in its own way, capturing each at a different kind of dynamic moment. What connects the troubled frown of one senator to the pensive reflection of another is simply the thoroughness of attention both senators clearly direct to the matter(s) at hand. McClancy regards these women and men as intensely serious and devoted to their ideals, their constituents, and their nation. She does not portray them as perfect but as worthy—not as politicians, but as statesmen and stateswomen motivated by something greater than themselves.

In stressing the gravity reflected in these faces, McClancy calls for a return to a seriousness of design as well as purpose in the exercise of our national polity. Like so many of us, she has watched the federal government corrode under the weight of fatuous ideology and opportunistic partisanship, compromising the health, wealth, and reputation of the Nation as they've rarely been undermined before. By accident or design, the United States is the leader of the free world and its only superpower, more than ever the example to the globe of the right and might of democratic principles. But policies and practices instituted over the last decade have made a mockery of that example, robbing it of the noble purpose to which it once had claim. Our exercise of democracy, at home and abroad, has never been flawless, but it has never been so foolish, not to mention venal, as it is today. By emphasizing the seriousness of purpose etched on these faces, McClancy reminds her subjects and her audience alike that, however this unfortunate recent history may now work to the advantage of the Democratic Party, the important matter at hand is the responsibility the Democrats are being handed to remedy the situation. The times call for diplomats and engineers, bridge-builders and dam-builders; hacks, amateurs, and self-appointed warriors need not apply.

In essaying a series of political portraits, especially a series so clearly impelled by rhetorical urgency, McClancy also calls out to contemporary American artists, suggesting that they reconsider the vitality of their purpose and the substance of its results. A number of critics and commentators have come to decry the vitiation of current American art in comparison with the power, drama, and intelligence of its immediate predecessors. It is debatable whether contemporary art lacks the punch and profundity of American art from the 1950s, '60s, and '70s, of course, but one does get a sense that, as opposed to the artistic practice of the postwar era, today's artists have little sense of their relation to art—or for that matter, American and human, history. By employing traditional media to ends that are technically traditional but in many ways visually innovative, McClancy reminds her fellow artists that they, too, cannot escape history—but that they can escape the blandishments of current cultural exploitation. Don't model your art on reality shows, McClancy admon-ishes, model it on reality. Don't get your art history from Wikipedia hits, but from museums. Look at the entire world around you. Acknowledge but do not succumb to its mediation. Be proactive.

We may not be mired in a depression, but the economic and social lot befalling too many of us indicates just by itself the need for some sort of *Renewed Deal*. Similarly, the rut art has driven itself into calls for a new clarity of reason and motivation. McClancy has forged one way of responding to both these calls, proposing a practice that transcends mere painting and mere propaganda and yet serves the ideals of both art and politics. Indeed, she conceives of her series as itself an integral project, one derived from and addressing artistic and political issues equally. Like politics, McClancy believes, art does not simply result from but incorporates its generative process, so that, ultimately, one does not (or ought not) simply see a picture when looking at one, but sees—or knows, or senses—everything that has gone into the making of that picture. And in this, she views art making, like policy making (and king making) as a result-driven chain of events.

Democratic Principles, then, is more than a sequence of paintings, or a series of pictures of affiliated people. Just as it is a mirror held to a particular group of like-minded individuals, it reflects on its own becoming. Included in that becoming is the public exposure of the paintings—that is, how an audience is attracted to and informed about the spirit and purpose of the art and its subjects alike. It is not enough for McClancy to produce portraits of Democratic Party leaders, sensitive as those portraits and substantive as those leaders may be. Getting those portraits "out there" is as important to McClancy's conception of her work as getting

out the vote is to the Democratic Party's conception of its work. All art, no matter how hermetic, is in some way a dialogue with its viewers; but McClancy subscribes passionately to Marcel Duchamp's dictate that "the viewer completes the work of art," and, further, that the work of art's own history completes it as well. That is to say, the work of art incorporates its own history and future. *Democratic Principles* thus comprises paintings; exhibitions of those paintings; publications about those paintings; films about the exhibitions; discussions about the paintings and the exhibitions and publications and films; and American politics and society of the last and next several years.

That does sound like a lot for a single artist to tackle, even when what is meant here by "American politics and society" actually constitutes one woman's comprehension of such broad tendencies and sweeping events. But art is nothing if not the meeting place for individual vision and universal comprehension. Few artists, after all, fail to recognize that they live in the world, among humans, and must negotiate, just as those other humans do, the daily conditions of life. Not every artist votes, but every artist enjoys or suffers the result of each election. Taking the bull by the horns, McClancy has decided to devote her art, and the process of its being made and seen, to affecting the outcome of the next election.

Can art affect elections? We learn over and over again that it can despite itself—as for instance in the early 1990s, when self-appointed arbiters of morality campaigned against certain artworks deemed offensive (and against the federal agency that supposedly helped bring them into existence). But can it attract support for causes, especially in America? Elizabeth McClancy wants to find out. In this sense, *Democratic Principles*—like so much art—is a social experiment. But McClancy also wants to effect change. She wants to support her cause and its best hope, the Democratic Party—and she wants to do so by looking into the eyes of the party's leaders and thinkers and finding women and men of action and compassion. McClancy finds uniqueness in these faces, but also finds common cause and common sense among these *Democratic Principles*.

September 2007
Los Angeles

Preface to the Plates
Elizabeth McClancy

I was born in 1951, female, WASP, and Republican—born Republican, the way you're born Jewish.

From the day I could pull my highchair up to the table, the talk was politics, and Sam Rayburn was the devil. By the time I was married and carrying playpens to Reagan Headquarters to stuff envelopes, that hostility had fixed on Tip O'Neill. The enemy. Seriously. I had worked myself into a 30-year-long lather with my demonizing.

And then Tip O'Neill died, and the 6:30 news played a two-minute clip of him—huge and full of himself in a stuffed chair, talking about America and his love for it and the miraculous processes of democracy. And I said, "If I had known he loved this country like that, I would not have hated him." So I stopped hating him.Graduate work in communications would soon teach me why the irrational hatred had taken hold in the first place, why the same thing happens with "born Democrats." For one thing, the bias of the media is not political or philosophical; it is a bias toward entertainment. To keep you watching, they dramatize: news as soap opera; elections as horse races. Fights bring 'em in; reasoned debate sends 'em clicking; keep it moving; sound bites; images.

For another thing, we live in a time of "overwhelmingness." The population is exploding; worth is measured in quantities, not qualities; and we are so deluged with stimuli that most Americans believe simply that "that day is good which is survived—grab some coffee, get through work, have dinner, watch TV, get up and do it again." We see a story about Darfur and say, "Isn't that AW-ful…. Pass the ketchup." You can't absorb it all, and really important parts of life and bigger truths slide by.

I didn't know the truth about Tip O'Neill because someone has to die for TV to yield the floor and let them say what they have to say for two whole minutes. So, how do we find a way through to the truth we need in order to make the decisions required of us by these extraordinary and highly complex times? We must find a way to stop the din, figure out what's really important, and think it through.

In November of 2005, I painted my first-ever painting. By the third canvas, I knew what I wanted to paint. By the fifth one, I knew I had a way to stop the din.

What is so fundamental to the promise of America that it must not be compromised for any person, profit, or plan? Our principles. The degree to which government leaders, candidates, and policies adhere to the principles upon which this country was founded is an essential and reliable indicator of what America is in 2008, where she must go and who should lead her.

The purpose of the *Democratic Principles* project is to carve out a series of spaces in which to consider many of those fundamental principles. In these spaces we can look into paint for human qualities, qualities of tenacity, intellect, and courage that the times demand from our leaders. In these spaces we can study, in context, thoughtful renderings of principles that should define America—principles worth fighting for,

worth dying for, worth losing an election to defend. And in these spaces we can talk together, in the moments provided by the book and the exhibitions, about the centrality of those principles to American democracy. In so doing, we can plan for local, regional, and national political activism and social evolution.

The essays, most of them speeches in the public domain (with the exception of President Carter's, who graciously permitted us the use of two recent addresses) appear here as compelling renderings of democratic principles. Some statements, like Senator Biden's, are conveyed in bold strokes of conviction. Some, like Senator Feinstein's, are described with the painstaking detail demanded by thorough examination of complex social issues. And some, like Senator Kennedy's, resonate with the vibrancy that comes from placing brilliant contrasting colors side by side.

You won't find a "definitive source" here. But what you can discover—or re-discover—in the paintings and declarations and conversations and footage will be real, because it will result from a thoughtful interaction between you and the first-hand source you behold. Start anywhere, but if you were born Republican, as I was, start with the rendering from Senator Edward Kennedy (on page 32.)

<div align="right">
November 2007
North Carolina
</div>

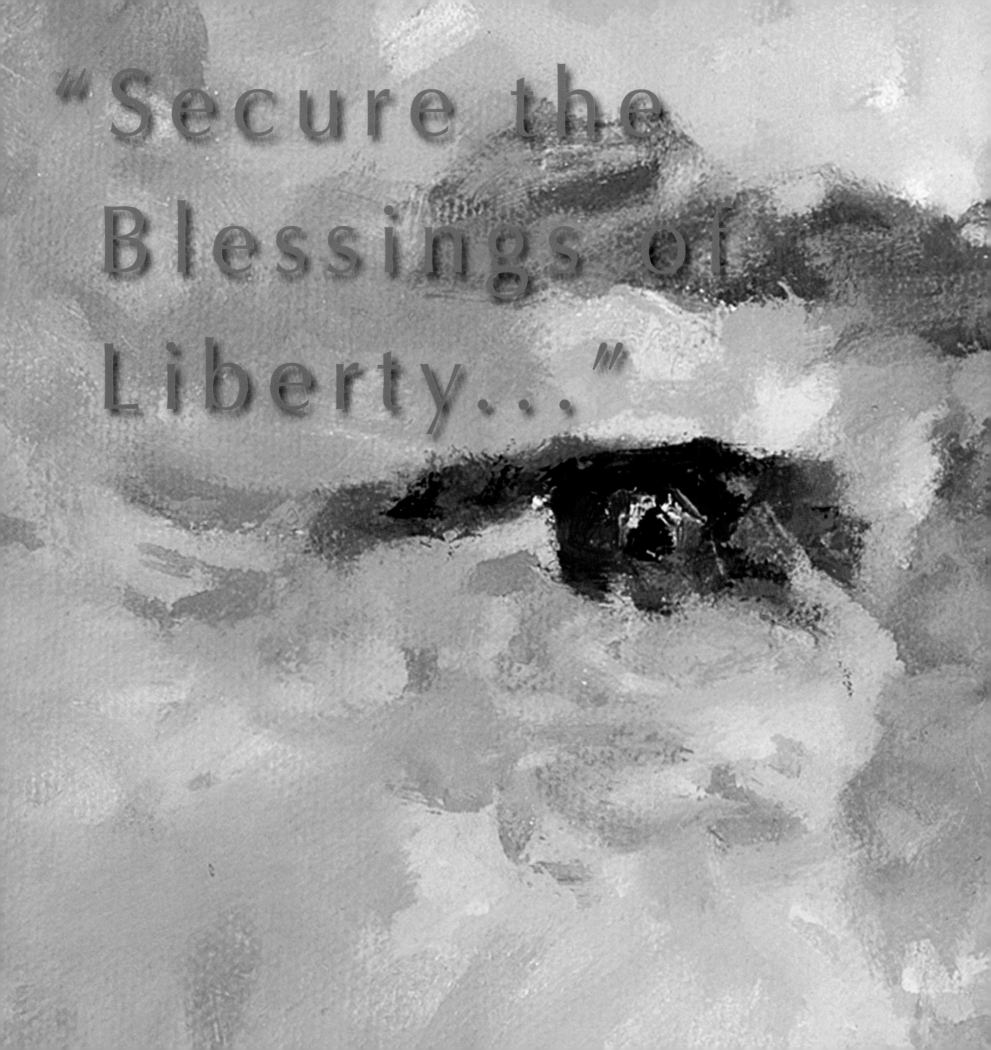

"Secure the
Blessings of
Liberty..."

I have been called the most powerful woman in the world, but I have on occasion lacked even the power of speech, because although we have crossed the threshold into a new century, there are still too many questions for which we have no answers.

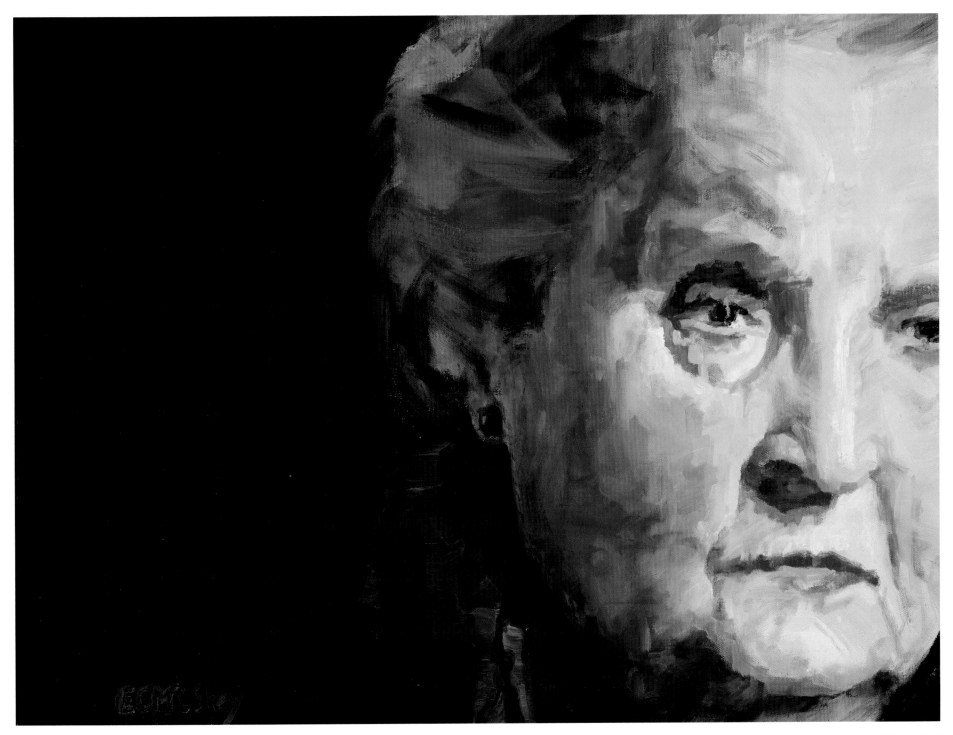

Secretary of State Madeleine K. Albright, 2007, oil on canvas, 18" x 24"
Democratic Principles Series, No. 1

Good morning. I always knew this day would come, and I thought I would dread it because I love this job and working with all of you so very, very much. But I find instead that the sadness is overwhelmed by pride, not in what I've been able to do, but in what we have all been able to do together.

Tomorrow, for me, a new life begins. I will have to relearn how to drive, place phone calls, and plan my own day. And for most of you, foreign policy will remain a full-time job. In that I envy you, but my purpose today is to thank you. The past four years have gone by more rapidly than I could have ever imagined, but there are some images and events that even a frenetic schedule cannot erase.

are those encountered in refugee camps, hospitals, schools and clinics; amputees from Sierra Leone, too young even to know what they had lost; widows of those massacred in Srebrenica, seeking justice; girls from Afghanistan whom the Taliban had driven from their homes; mothers with AIDS pleading for assurance that their children would be cared for after they are gone.

I have been called the most powerful woman in the world, but I have on occasion lacked even the power of speech, because although we have crossed the threshold into a new century, there are still too many questions for which we have no answers.

I am grateful that we live in a country where the parties and the personalities may change, but the principles that guide our republic do not.

For example, on the Orioles' opening day I threw out the first 'ball, which flew like the Pentagon's description of an air crash —uncontrolled descent into terrain. At ASEAN, I sang for my supper, including a duet with Foreign Minister Primakov that made many nostalgic for the Cold War. A magazine honored me as one of the world's 25 most intriguing people—alongside a cloned sheep. And I will forever cherish the memory of being picketed in Seattle by people dressed up as butterflies and turtles.

Of course there were truly uplifting moments as well, brought about by your hard work: Standing on a podium in front of the Truman Library in Independence, Missouri, and welcoming Poland, Hungary and the Czech Republic into NATO. Listening to Israeli, Palestinian and Arab youngsters talk of their shared desire to grow up in dignity, free from terror and fear. Hearing refugees from Kosovo chant, "USA, USA," knowing that because we had acted they would soon be able to return to their villages. Visiting Pyongyang to explore the possibilities of reconciliation along the Cold War's final border. And watching the Yugoslav people toss Milosevic out on his ear.

I will of course remember the leaders with whom I deliberated in fancy rooms, but the faces etched most clearly in my mind

I have recently been rereading Dean Acheson's book, *Present at the Creation*. Together, you and I have been present at the transition from one era to the next. Like our predecessors, we have had a responsibility to build or adapt institutions that would enhance security, prosperity and freedom for generations to come. In this, we have made a really good beginning, from NATO enlargement and paying our UN bills, to strengthening regional institutions in Africa, Asia and our own hemisphere.

We have spent much of our time on the critical and traditional issues of security and prosperity, war and peace. But we have spent some of our time on virtually every issue under the sun. As globalization broadens, so does the scope of America's interests overseas, and therefore our foreign policy as well. I had never expected when I took this job to find myself talking so much about bananas, biotechnology and the impacts of global climate change. But I have, and I know that Secretary-Designate Powell can expect more of the same.

And incidentally, I think it says something very good about America that the first female Secretary of State is about to be succeeded by our first African American Secretary of State. I am confident that General Powell will be a superb Secretary, and I am pleased that the transition has gone so well. And I am

grateful that we live in a country where the parties and the personalities may change, but the principles that guide our republic do not.

I have told General Powell that he can count on my support, especially when it comes to backing the State Department as an institution. I am pleased that these past four years we have increased resources for the Department by 17 percent in real terms. This, too, is only a beginning.

In this hall are the people who make this building function, who keep the logs, write the checks, train the talent, procure the equipment and enable us to communicate with each other and the world. Here and at our overseas posts are the men and women who constitute America's first line of defense. Each of you deserves—because you have earned—the full backing of the American people.

I will leave this Department believing that its greatest strength is its capacity to function brilliantly when the stakes are highest and the pressure is on. That is when our regional and functional Bureaus pull together most effectively. It is when the various components of policy, from the military to the economic to the environmental to the humanitarian, are best coordinated. It is when distinctions between foreign and civil service melt away and public diplomacy is a full partner.

But the truth is that this Department does a magnificent job every day. I know because I have seen you at work in embassy compounds that look like they were designed by Joseph Stalin, although perhaps built before his time. I have seen one US Ambassador reduced to washing her dishes in a bathtub. I have seen many of you pass every test of performance and conditions that would fail any test of what is acceptable.

And my admiration stems not simply from what I and others have asked you to do, but rather from what you and your families have chosen to do, far beyond the dictates of duty. Time and again, I have seen you and your husbands, wives and children give freely of yourselves to comfort the ill, teach the illiterate, aid the impoverished and give a desperate cause hope. I have seen you share your knowledge and enthusiasm for democracy with those striving to build a better life in larger freedom. I have seen you win friends for America simply by virtue of your presence and warmth. And I have stood, with

head bowed, at memorial services for colleagues struck down while representing our Nation or helping others to achieve peace.

During the past four years, the good days far outnumbered the bad, but the worst was August 7th, 1998. [On Aug. 7, 1998 two bombs exploded almost simultaneously at the U.S. embassies in the East African nations of Kenya and Tanzania.] It was more than two years ago, yet still we mourn. Still we are conscious of the risks involved in defending our interests around the world. And still we understand that there could be no greater responsibility or honor.

I have said that one of the things that I will miss most, starting tomorrow, is the view. From my office I have been able to look out over the Mall, to the Lincoln Memorial, the Washington Monument, and the dome beneath which the likeness of Thomas Jefferson, our first Secretary of State, silently stands. Each day I witness a steady tide of visitors to these shrines of freedom from all corners of our country and all parts of the globe.

Many of you have heard me say it before, but this morning I want to reiterate to you the depth of my gratitude to President Clinton and the sense of honor I have had to represent America, first at the United Nations and now before the world.

Our country, like any, is composed of humans and therefore is flawed. We are not always right in our actions and judgments, but I know from the experience of my own life the importance and rightness of America's ideals. I have seen firsthand the difference that American foreign policy has made and continues to make in the lives of men, women and children on every continent. I believe profoundly in the goodness of the American people, and I will bear witness all my days to the value and the values of those who labor in and for this Department.

I said at the outset that I have dreaded this day, but because of all you have done, all you believe and all you will accomplish after I have gone, I will cherish this moment forever. Thank you, and God bless you all, and farewell.

Governor Howard Dean
Address to the Yearly Kos Convention
August 2, 2007

What I say to young folks is this: you need to remember that Martin Luther King was not just an ideal that we all worked towards in terms of inclusion and treating people properly.... He was a human being. It was thirteen years between the Montgomery Bus Boycott and the signing of the Civil Rights Bill. Thirteen years. Not every day was a good day for Dr. King and his folks during those thirteen years. There were a lot of times that he and his folks had to get up and dust themselves off and go out and do something else that was really tough. And not all of them survived that.

Governor Howard Dean, 2007, oil on canvas, 16" x 16"
Democratic Principles Series, No. 7

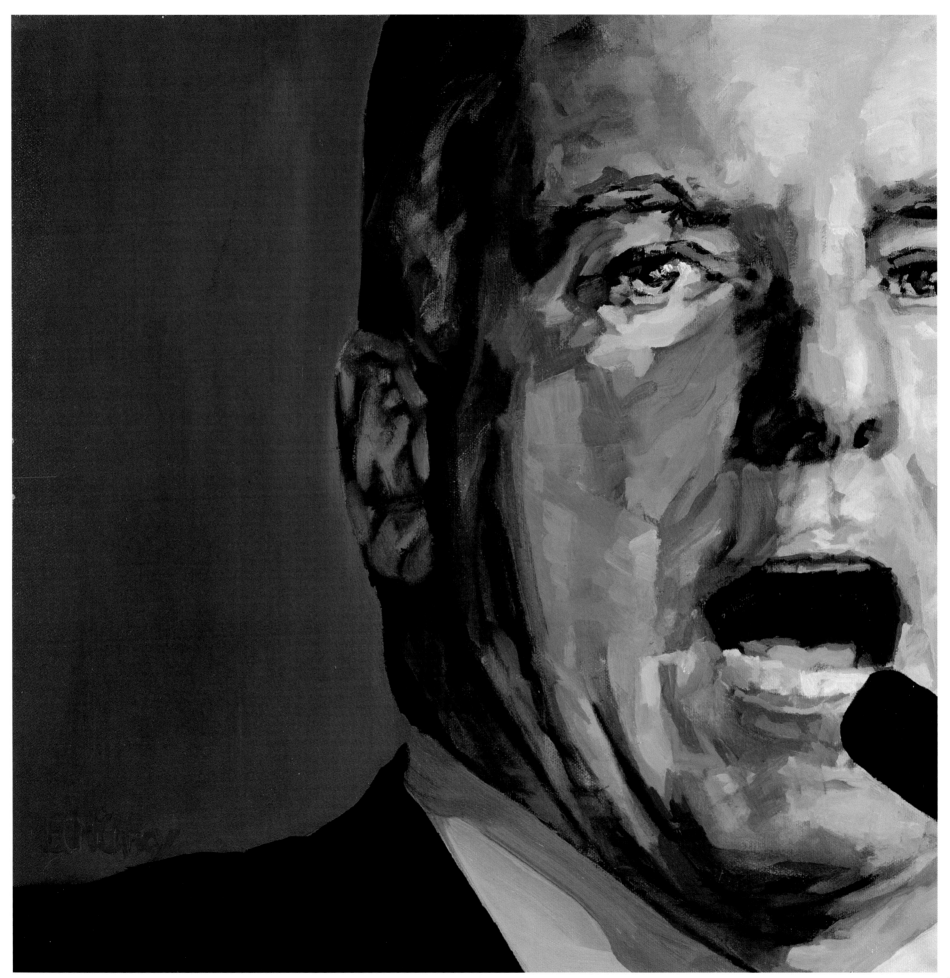

Next week marks the 42nd anniversary of the signing of the Voting Rights Act. But as you know, the Republicans believe that the fewer votes are cast, the more likely it is to benefit them. And we believe that the more votes that are cast, the better it is for the United States of America. We're the party that believes that there is something more important than our party, and that is our country.

And, so, over the last 30 years or so, we've seen roadblocks and outright attacks on the right to vote. As you know, we have paid staffers in all 50 states, and we are going to go to every single county election official, in charge of every single precinct in America, and find out how they run their elections. How they assign voter machines, to which precincts, what they do about voter ID, if it's required in their state, what they do about vote by mail, what they do about early voting, what they do about absentee voting.

The reason for this is we know that election laws are written at the state and federal level, but they are often subject to interpretation at the local level, which creates a lot of variation around the country in terms of how they are run. We will know

people who use it, we would not have a Democratic majority in the United States Senate. That is true.

So, what this Party is about is change and evolution, and that's not easy. Believe me, there are forces of resistance inside even the Democratic Party. I know that would surprise you. But this party is about evolution. This party is about the future; the other party is about the past. Look at who they have running for president. Doesn't that look like something out of the 1950s? Look who we have running for president.

The fact of the matter is, it shouldn't be true, but it is a revolutionary idea to actually have the public taking over the agenda of campaigns, and political parties better get used to it, because they are going to lose and become irrelevant if they don't get used to it.

The power in campaigns belongs as much to shifting networks of committed citizens as it does to the political establishment. And in the long run, community-built networks will have a more dramatic effect in bringing democracy to both America and to creating democracy where it doesn't exist now.

Nations run by authoritarian forces will not stop the dynamic of technologically enabled citizens working together.

in advance where the problems are going to be in terms of voting, so we can plan how to deal with those 10 months before the election, not 10 weeks or 10 days before the election.

Now, I want to say a few things about the Net. This is an extraordinary thing. And, speaking for myself, even after the campaign four years ago, I didn't realize what a powerful tool this is. This is the most extraordinary invention for empowering ordinary people since the invention of the printing press in the 1400s. It really is. It has re-democratized America. There is an enormous shift in power.

I thought the YouTube/CNN debate was sensational. For the first time since the Nixon-Kennedy debates when ordinary people, not members of the media, but ordinary people in large numbers got to ask in front of a national television audience any question that they could dream up. Put them on the spot. I thought, frankly, some of those questions were a lot tougher than what the media would have asked.

Remember, YouTube essentially did not exist when I was running four years ago. And today, without YouTube and the

I predict now, that because of the Net, and because of the extraordinary binding of the world together, that Iran and China one day will have to decide to become democracies simply because they are forced to by the extraordinary devolution of power to their citizens because of the Internet.

Nations run by authoritarian forces will not stop the dynamic of technologically enabled citizens working together. Hundreds of thousands of networking citizens will find ways to circumvent and evade government interference in the free exchange of ideas, as we have already demonstrated in the United States.

Repressive governments at the helms of nations that would become world or regional powers, face a difficult choice. They can allow democracy to evolve and flourish on the Internet, or they can destroy the technology that enables their best and brightest and most determined citizens to network, and that will cause them to fall back into third-world status.

So, we can still win the battle for a democratic world. It will not happen by sending troops to Iraq to supposedly establish

government democracy at the barrel of a gun. The truth is that the most important weapon in the struggle for world democracy is a free, open, commercially and politically unfettered Internet that empowers ordinary people from across the globe to speak and act in the interest of their own communities.

When I started as Chairman of the DNC, I said that Democrats had to show up everywhere and campaign everywhere, and ask for everybody's vote. And that includes the way we interact with communities online. In the Democratic Party we're focused on connection, empowerment, and community organizing. And I'm incredibly proud that our candidates have begun to change with the times. We are running what I call two-way campaigns. That is, we're using technology to start a dialogue and engage ordinary Americans. Traditional campaigns have relied on enormous amounts of TV advertising, 30-second spots aimed at you, telling you what we think, and what we think you ought to do. The new campaign, the two-way campaign, is we listen to you before we start talking, and we, throughout the campaign, have a dialogue between the people whose votes we're hoping to get, asking for their advice as we go through, and taking it to heart. This is not a gimmick, or a schmooze as we call it in the trade. This means real two-way campaigns where the views and opinions of the American people have an impact on the leadership, so leaders are with the people instead of seeking to lead folks that aren't interested in being led by them.

It is an extraordinary evolution. Essentially it means that politicians have to acknowledge something that's been true for a long time. Which is, power is loaned to us, we don't own the power, and we need to earn the power every two years.

Now, the Republicans are making a good-faith effort to convince the Americans that this is a do-nothing Congress, that we haven't done anything. Now look, first of all, they're filibustering everything we do. If we get it by the filibuster, then the President threatens to veto it, or he does veto it. So, let me tell you what we've done in spite of the President.

In the last six months we have accomplished more than they did in six years: increasing the minimum wage, made college more affordable, healthcare for kids is going to pass, and if the President vetoes us—vetoes it—the Republicans are going to have to atone for that on Election Day. Passing the 9-11 recommendations to make our communities safer. They talk about being strong; we actually do it, passing real ethics reform. The United States Senate is going to pass it today. Let's see if the President will sign that. Passing a balanced budget

requirement with pay-go requirements so there will be no tax cuts or new programs without saying how we're going to pay for them. We've put an end to the notion that we're going to borrow money from our grandchildren in order to pay for what we want today. I think that's a pretty good accomplishment for six months.

Now, on the matter that's at the front of most of your minds: Iraq. And the fact is we started out with 49 votes in the United States Senate on Iraq. I know how tough this is going to be, but we need to make it clear to the American people who it is that's obstructing their will on Iraq. And if George Bush wants to veto the will of the American people, and if the Republicans want to obstruct what the American people want, then we'll give Susan Collins an opportunity to vote on that. We'll give John Sununu an opportunity to vote on that again. We'll give Norm Coleman and Gordon Smith an opportunity to vote again and again and again until our troops come home from Iraq.

It is not an accident. It is not an accident that every single one of the Democrats running for President of the United States has a plan and has clearly said that they will get our troops home with a reasonable timetable. It is not an accident that every single one of the Republican candidates, with the exception of the Libertarian, wants our troops to stay in Iraq as long as George Bush does. It is not an accident that every single Republican thought it was a great idea to commute the sentence of Scooter Libby and every single Democrat did not think that was a great idea.

We are committed to ending the Republican culture of corruption that they brought to Washington, and we are committed to ending the culture of corruption in the United States Department of Justice, which fired Republican lawyers for trying to prosecute Republican Congressmen. We will do better than that.

Our men and women in uniform have bravely done their duty. We need to support our troops and bring them home. And the American people are with us.

I want to close by talking about young people. I was in Dallas about two, three months ago, and there's a gentleman down there by the name of Reverend Freddie Haines who runs a big mega church in South Dallas. And I went down to see him because he does a lot of social good works. And we're actually now in the business of reaching out to all kinds of people, and we reach out to Evangelical Christians. Why do we reach out to Evangelical Christians? Because there is a generational

change going on in America. Not just in the country as a whole but in every single community.

And the truth is that the Evangelical community is changing dramatically. There's an Evangelical preacher in Los Angeles by the name of Rick Warren. He wrote a book called *The Purpose-Driven Life*, some of you may have read it. They talk about Darfur. They talk about the environment, they talk about poverty....

And that is our commonality with the Evangelical movement, particularly with young people. That sounds like a Democratic message. I know there are going to be things that we disagree with, with our Evangelical brothers and sisters. But there are going to be some things that we agree with. And the younger

if you don't reach out to young people in every single election, you pay the price for that for 60 years, because their pattern is set, and it's very hard to get them back. So that's the first lesson.

The second [lesson] is something that is really extraordinary. It turns out that in 2004, the turnout went up a lot for young people, as I said. And they voted heavily Democratic, even more so in 2006, when they voted even more Democratic. But here's the most interesting thing that I thought, because it gives me such hope for this next generation. People in my generation, we are kind of confrontational, and young people today aren't so big on confrontation. You know, we were out in the streets, marching with signs, trying to get the establishment to change America. And they're on the Internet getting their congressman to vote for the darn H-811, to get

So, the only thing I would say to this new generation is something that we all need to understand. I don't want people to become patient. I think impatience is a good thing.

generation, Evangelical, not Evangelical, whatever they are, the younger generation expects us to set aside our differences on things we don't agree with, and get to work on the things that we do agree with, so we can make America a better place.

So, I went down to see Reverend Haines and he gave me a poll at the end of the meeting, which I read on the plane to wherever my next stop was. And, I want to tell you about it, because it is enormously hopeful for our country.

In 2004, the turnout of young people went up dramatically. And young people across the board voted for John Kerry 56% and George Bush 44%. It was the only age group that John Kerry won. In 2006, off-year election, the number of young people under 30, 18-29 who voted, went up 20% from the off-year election in 2002. And they voted 61% Democrat and 39% Republican.

Now, there are some lessons here. The first is, we know that if you vote three times in a row, you're likely to vote for the rest of your life. And the direction you vote in those three times is likely to be the direction you vote for the rest of your life. So every single election has to be about young people. We are paying the price today for not reaching out to young people in the 1980s when Ronald Reagan was running for president. That's how John Roberts ended up as the head of the Supreme Court. Every single election has to be about young people, whether you think they're important today in your particular election or not; whether they're the swing vote or not. Because

the voting machines done, and all kinds of things like that. So they're changing America in a different way.

Here's what happened, though, which I thought was really extraordinary. We did reach out, and there was a good campaign aimed at young folks in 2004. White voters under 30 went up 8%. African American voters under 30 went up 15%. Hispanic voters under 30 went up 23%.

Now, it gets better. The interesting thing about those numbers is, the increase in voting turnout is inversely proportional to the registrations of the groups as a whole. Which means that, among young people, something is going on that's very, very different than the patterns that you see in our generation.

Here's the most interesting part of this statistic. It turns out that the turnout of the young folks, people under 30, across the board for everybody was 53%. That's a very good number for young folks, it's not what 60 year olds turn out, but it's a pretty good number. It can get better, but it's a good, good number. The most interesting thing is, the number was 53% for everybody; it didn't matter if you were black, white, or brown. The number was 53% in your community. They're one generation. You target the youth vote the same, no matter their ethnicity.

The truth of the matter is that the vision that we had for America as we struggled through the Civil Rights Era, uncomfortable with each other but trying to do the right thing,

is the vision that our kids have accepted and are moving forward into the next generation with.

It makes me feel great about the future of America. In those times of agony when we see the corruption and the disrespect for the Constitution of the United States in Washington at the highest level, we can think about those under-30 people. I know that 45 years from now, they'll never elect somebody like that, because they believe in the world that we designed for them, a world where everybody is included, where equality does matter, where equal protection under the law for every single United States citizen matters, where America doesn't torture. Where America will stand up for optimism and hope again. That is the country that we hope to build.

So, the only thing I would say to this new generation is something that we all need to understand. I don't want people to become patient. I think impatience is a good thing.

But one of the things about getting to be in the older generation: I remember something my father once told me, which, of course, I resisted mightily when he told it to me, but now I'm about the age he was when he told me, so I'm going to say it, and I believe it now. He looked at me one time and he said, "You know, I have one advantage over you: I can look backwards as well as forwards."

When I was a freshman in college in 1968, Martin Luther King was killed, and Bobby Kennedy was assassinated. And I remember very much exactly where I was that day, and exactly what that was like. Now, these young folks under 30, they learn about Martin Luther King and Bobby Kennedy and John Lewis and folks like that, they learn about that in history books, but they didn't live it the way people in my generation lived it. They see it as a moment in history. It's history to them.

What I say to young folks is this: you need to remember that Martin Luther King was not just an ideal that we all worked towards in terms of inclusion and treating people properly.... He was a human being. It was 13 years between the Montgomery Bus Boycott and the signing of the Civil Rights Bill. Thirteen years. Not every day was a good day for Dr. King and his folks during those 13 years. There were a lot of times that he and his folks had to get up and dust themselves off and go out and do something else that was really tough. And not all of them survived that.

And so what I say to all Americans, but particularly young people, is this is not a one day or one election struggle. This is something we have to do every single day for the rest of our lives. Every single day for the rest of our lives. And when we get knocked down, we're going to stand up again for the core principles of America. Because America was knocked down by the far right wing of the Republican Party in the last eight years, and by God we're going to get up, and recover, and stand up for what we used to stand up for. We are going to regain the moral leadership that made America a great country, and we are going to live again in America and stand up, and lead the world to the Promised Land.

Almost a century and a half ago, Senator Stephen Douglas told Abraham Lincoln, who had just defeated him for the presidency, "Partisan feeling must yield to patriotism. I'm with you, Mr. President, and God bless you."

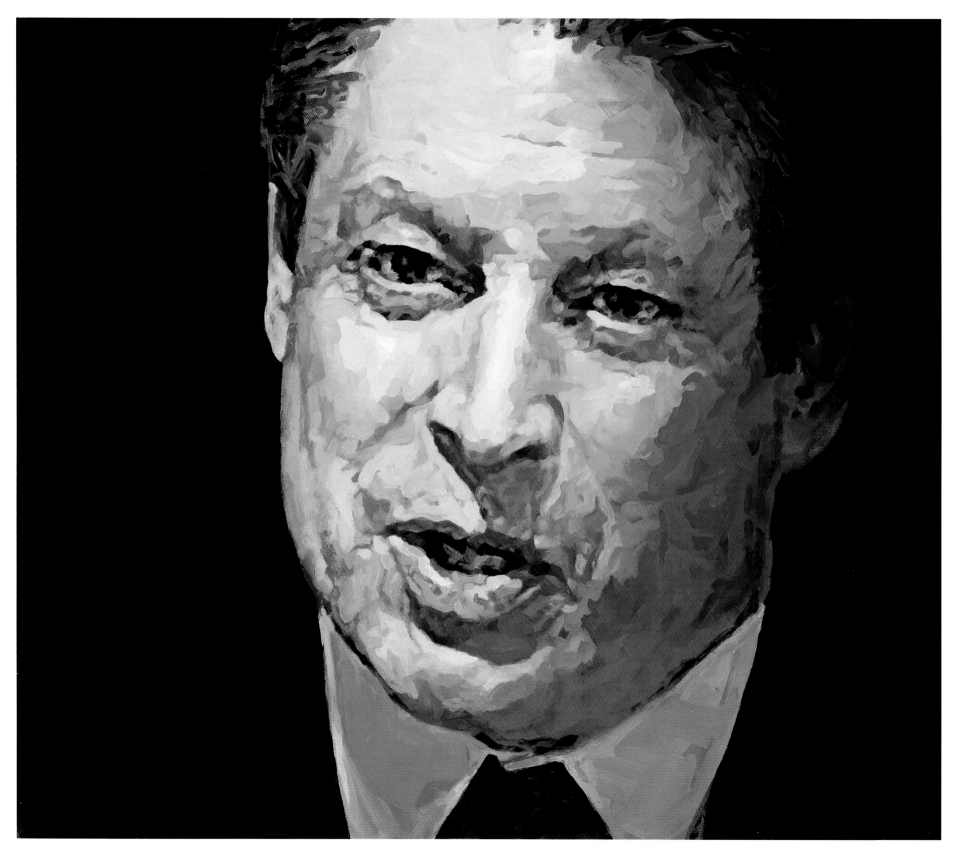

Vice President Al Gore, 2007, oil on canvas, 20" x 24"
Democratic Principles Series, No. 11

Just moments ago, I spoke with George W. Bush and congratulated him on becoming the 43rd president of the United States, and I promised him that I wouldn't call him back this time.

I offered to meet with him as soon as possible so that we can start to heal the divisions of the campaign and the contest through which we just passed.

Almost a century and a half ago, Senator Stephen Douglas told Abraham Lincoln, who had just defeated him for the presidency, "Partisan feeling must yield to patriotism. I'm with you, Mr. President, and God bless you."

Well, in that same spirit, I say to President-elect Bush that what remains of partisan rancor must now be put aside, and may God bless his stewardship of this country.

Neither he nor I anticipated this long and difficult road. Certainly neither of us wanted it to happen. Yet it came, and now it has ended, resolved, as it must be resolved, through the honored institutions of our democracy.

Over the library of one of our great law schools is inscribed the motto, "Not under man but under God and law." That's the ruling principle of American freedom, the source of our democratic liberties. I've tried to make it my guide throughout this contest as it has guided America's deliberations of all the complex issues of the past five weeks.

Now the U.S. Supreme Court has spoken. Let there be no doubt, while I strongly disagree with the court's decision, I accept it. I accept the finality of this outcome, which will be ratified next Monday in the Electoral College. And tonight, for the sake of our unity of the people and the strength of our democracy, I offer my concession.

I also accept my responsibility, which I will discharge unconditionally, to honor the new president elect and do everything possible to help him bring Americans together in fulfillment of the great vision that our Declaration of Independence defines and that our Constitution affirms and defends.

Let me say how grateful I am to all those who supported me and supported the cause for which we have fought. Tipper and I feel a deep gratitude to Joe and Hadassah Lieberman who brought passion and high purpose to our partnership and opened new doors, not just for our campaign but for our country.

This has been an extraordinary election. But in one of God's unforeseen paths, this belatedly broken impasse can point us all to a new common ground, for its very closeness can serve to remind us that we are one people with a shared history and a shared destiny.

Indeed, that history gives us many examples of contests as hotly debated, as fiercely fought, with their own challenges to the popular will.

Other disputes have dragged on for weeks before reaching resolution. And each time, both the victor and the vanquished have accepted the result peacefully and in the spirit of reconciliation.

So let it be with us.

I know that many of my supporters are disappointed. I am too. But our disappointment must be overcome by our love of country.

And I say to our fellow members of the world community, let no one see this contest as a sign of American weakness. The strength of American democracy is shown most clearly through the difficulties it can overcome.

Some have expressed concern that the unusual nature of this election might hamper the next president in the conduct of his office. I do not believe it need be so.

President-elect Bush inherits a nation whose citizens will be ready to assist him in the conduct of his large responsibilities.

I personally will be at his disposal, and I call on all Americans —I particularly urge all who stood with us—to unite behind our next president. This is America. Just as we fight hard when the stakes are high, we close ranks and come together when the contest is done.

And while there will be time enough to debate our continuing differences, now is the time to recognize that that which unites us is greater than that which divides us.

While we yet hold and do not yield our opposing beliefs, there is a higher duty than the one we owe to political party. This is America and we put country before party. We will stand together behind our new president.

As for what I'll do next, I don't know the answer to that one yet. Like many of you, I'm looking forward to spending the holidays with family and old friends. I know I'll spend time in Tennessee and mend some fences, literally and figuratively.

Some have asked whether I have any regrets and I do have one regret: that I didn't get the chance to stay and fight for the American people over the next four years, especially for those who need burdens lifted and barriers removed, especially for those who feel their voices have not been heard. I heard you and I will not forget.

I've seen America in this campaign and I like what I see. It's worth fighting for and that's a fight I'll never stop.

As for the battle that ends tonight, I do believe as my father once said, that no matter how hard the loss, defeat might serve as well as victory to shape the soul and let the glory out.

So for me this campaign ends as it began: with the love of Tipper and our family; with faith in God and in the country I have been so proud to serve, from Vietnam to the vice presidency; and with gratitude to our truly tireless campaign staff and volunteers, including all those who worked so hard in Florida for the last 36 days.

Now the political struggle is over and we turn again to the unending struggle for the common good of all Americans and for those multitudes around the world who look to us for leadership in the cause of freedom.

In the words of our great hymn, "America, America": "Let us crown thy good with brotherhood, from sea to shining sea."

And now, my friends, in a phrase I once addressed to others, it's time for me to go.

Thank you and good night, and God bless America.

That's the kind of man Reagan was—a strong competitor who wanted to win, not just for himself, but for his beliefs. He wanted to defeat his opponents, but not destroy them. Our battles on the issues might resume the next morning, but we could laugh together at the end of the day. Whatever our differences, we were all united by our love of country and its ideals.

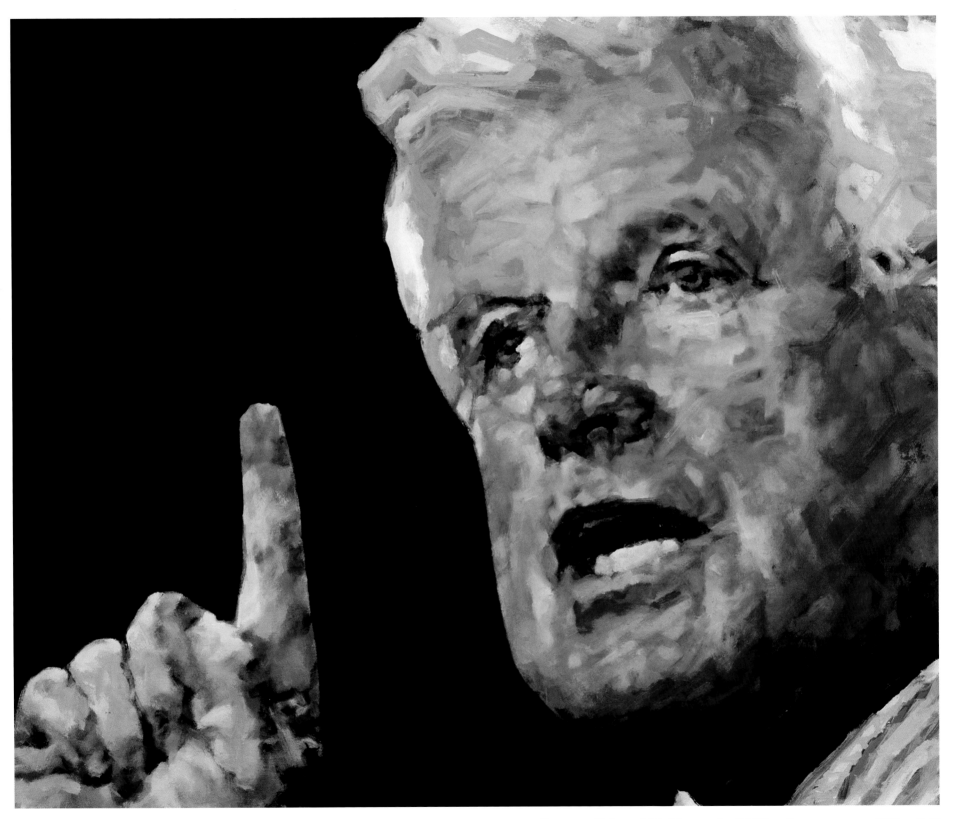

Senator Edward M. Kennedy, 2007, oil on canvas, 20" x 24"
Democratic Principles Series, No. 3

I offer special thanks to Mrs. Reagan, who so graciously invited Vicki and me to join you this evening. Time and again, Mrs. Reagan has touched the Nation's heart. She has inspired us with her dignity and compassion and joy, and she's shown true commitment and strength in times of great difficulty.

Nancy Reagan is a national treasure. And she continues to make a difference for America and the world. The day will come when millions of families, counting on the promise of medical miracles from research on stem cells, will thank Nancy Reagan for all she did in their behalf.

So thank you, Mrs. Reagan, for everything—and for asking us to share this beautiful evening here with you in Simi Valley.

I have so many wonderful memories of President Reagan, a President great in purpose who has a high place on the mountaintop of history. I recall not just the accomplishments, but the kind of man he was. He was always a good friend and a gracious foe.

I came to understand the generosity of the man just months into his Presidency when he brought the Kennedy family to the White House to present Ethel with the Congressional Gold Medal for my brother Bob. It was an early and powerful demonstration of the largeness of spirit that infused his Presidency and his life, and it was a day none of us in our family will ever forget.

A few months later, my mother came to the White House to thank President and Mrs. Reagan personally, and they were especially gracious. Mother gave him some of Jack's letters about football and Notre Dame—she knew President Reagan's background—and he made a point of showing her that he was still using the same White House desk that Jack had used as President.

Mother then mentioned that she had first visited the White House as a young girl in the 1890s, when William McKinley was President.

President Reagan didn't miss a beat. He said, "Mrs. Kennedy, when I ran against Pat Brown, he claimed I had the same platform as William McKinley!"

I started to laugh, and he immediately said: "Don't laugh, Senator. McKinley freed Cuba!"

That's the kind of man Reagan was—a strong competitor who wanted to win, not just for himself, but for his beliefs. He wanted to defeat his opponents, but not destroy them. Our battles on the issues might resume the next morning, but we could laugh together at the end of the day. Whatever our differences, we were all united by our love of country and its ideals.

I believe he always retained the essence of the idealism that inspired him long before he ran for office. In 1947, he joined Americans for Democratic Action soon after its creation. James Loeb, a union leader and one of its founders, wrote him a letter: "Dear Ronnie. It was an encouraging experience to have had a chance to talk to you and to know there are people in your position who share so completely a liberal point of view."

His point of view may have changed, but the idealism never did. And neither did his vision of hope that enabled this landmark conservative ultimately to transcend the political categories and stand as quintessentially American.

In June of 1985, in another act of generosity, President and Mrs. Reagan came to my home outside Washington for a dinner to support the new Kennedy Presidential Library in Boston.

In his remarks that evening, he made a beautiful observation about my brother, which captured Jack's spirit perfectly. He said Jack "seemed to grasp from the beginning that life is one fast-moving train, and you have to jump aboard and hold on to your hat and relish the sweep of the wind as it rushes by. You have to enjoy the journey; it's unthankful not to."

Those words apply to Ronald Reagan himself. At an age when many were slowing down, he jumped aboard the fastest train of all, not as a passenger content to watch the scenery, but as the engineer determined to lead the country on a journey to the "shining city on a hill" that was a touchstone for him as well as for President Kennedy.

In the 1980s, I was on that train, too, and it was a great ride. Much of the time, it's fair to say, I was doing what I could to steer in a different direction. We disagreed on many things. But we agreed the United States is a beacon of light for people across earth. What we had in common was far greater than what divided us. It was the idea of America.

For most of us born and raised here, it's sometimes hard to grasp what the idea of America has meant to the billions of people who have looked at us from afar throughout our history.

But President Reagan and President Kennedy understood it, honored it, enriched and advanced it.

They recognized that America's commitment to liberty, opportunity, and the rule of law is still a revolutionary idea. They each had faith that America's best days lie ahead, and that our true power in the world depended on our fealty to our country's founding ideals.

Today, we need to recapture the spirit that these two leaders personified if we are to make this new century the next American century. We live in challenging and perilous times, but that fact is hardly new in the American experiment.

Every fall semester, John Lewis Gaddis, one of our foremost historians, teaches the Cold War to undergraduates at Yale, few of whom have any memory of the days he describes. He writes, "When I talk about Stalin and Truman, even Reagan and Gorbachev, it could as easily be Napoleon, Caesar, or Alexander the Great."

To these students, the Cold War at first seems distant and quaint. They wonder, says Gaddis, how we could have had anything to fear from a power that turned out to be as weak, as bumbling, as temporary as the Soviet Union. But the more they learn about those perilous years, the more they wonder, "How did we ever make it out of the Cold War alive?"

The challenge then was enormous. After we defeated fascism in the Second World War, we were faced with a Europe in which tens of millions were close to economic and social despair.

The rise of the Soviet Union and the dawn of the nuclear age required a new definition of national security—one that for the first time in history had to deal with a potential threat to human existence itself.

We had to meet the threat with both resolve and wisdom. We had to build what President Kennedy called in his Inaugural Address a "grand and global alliance" for freedom. We had to be strong across decades—abroad and at home.

We began with the Marshall Plan and NATO. We committed our resources to the regeneration of Germany and Japan, now among the world's most vigorous democracies.

And because we knew from the start that it would take more than armed force and economic aid to preserve peace and defend liberty, we adopted the G.I. Bill of Rights to educate the veterans returning from the front lines of war. Those G.I.s became the new front lines of unparalleled prosperity. We established academic exchange programs so that young scholars from around the world could study at American universities. We built libraries and cultural centers in countries where information had been tightly controlled.

We translated the Declaration of Independence, the Constitution, and the works of America's greatest authors into dozens of languages and sent them everywhere as compelling ambassadors of the idea of America. We broadcast America's story to audiences wherever freedom was endangered or denied.

In that same spirit, President Kennedy created the Peace Corps, calling on America's youth to "sacrifice their energies and time and toil in the cause of world peace and human progress." We were a nation blessed with human and financial resources we could send across the globe to help shape a more hopeful future—and we did. Nearly 190,000 Americans have served in the Peace Corps. Today, almost 8,000 volunteers serve in 67 countries, including many on the other side of what was once the Iron Curtain. Each of them is America at its best, making better the life of the world.

As the arms race mounted, so did our unprecedented effort to inspire others to embrace our values of peace, democracy, and fundamental human dignity. Here at home, we worked to help our own nation to live up to its principles for every American. We breathed new life into the idea—and the ideal—of America.

We outlawed racial segregation; guaranteed equal access to public facilities and the right to vote; prohibited job discrimination because of age, race, or gender; opened the door to higher education for women; multiplied the middle class; acted, however imperfectly, to combat the poverty of "the other America"; and brought decent health care to tens of millions of senior citizens with the passage of Medicare.

America lifted itself up at home as it served and saved the cause of liberty in the world. The Cold War ended with the utter collapse of the Soviet Union. It had been waged as a bipartisan enterprise by Republican and Democratic Congresses and administrations from the first moment to the last. There were disagreements over tactics, to be sure, but unanimity in our resolve to contain and defeat democracy's greatest enemy. And President Ronald Reagan deserves immense credit for the success we finally achieved—the greatest victory for liberty against the gravest threat of tyranny. President Reagan foresaw

it and called for it—and Mr. Gorbachev did tear down that wall. In his farewell address to the nation in January 1989, Ronald Reagan described not only the end of the Cold War, but another of the singular triumphs of his presidency—the recovery of American morale. I believe he was right when he said, "America is respected again in the world and looked to for leadership."

Other nations understood that the best guarantee of peace and stability would be for the United States to live up to its ideals as a beacon for the rest of the planet. We were admired for our democracy and respected for our economic strength.

Today the situation is very different from the world President Reagan left us. We are sadly diminished, even in the eyes of our friends. Anti-Americanism is on the rise. We seem to have lost our way, our vision, and our confidence in the future.

Others have stopped listening to us the way they once did. We have strained the extraordinary alliances that advanced our ideals as well as our interests. At the root of much of the anti-Americanism that has surfaced in recent years is the perception of American unilateralism in international affairs.

I am astonished when some say it does not matter that so many in the world no longer respect the United States. Of course it matters. It matters to our security—and it has mattered since the first days of our Republic. In the opening paragraph of the Declaration of Independence, Thomas Jefferson acknowledged the importance of "a decent respect for the opinions of mankind." That quality is as true today as it was when our founders signed the declaration affirming it on that first Fourth of July.

To restore America's standing and strength, we must recapture that combination of realism and idealism which motivated John Kennedy and Ronald Reagan to jump aboard that fast-moving train.

We need to understand that the great challenges facing our fragile world require an abundance of hope that only a united and determined America can provide. America has to lead. America has to inspire.

The new sense of insecurity after 9/11 has led some to say all we need is to build a bristling fortress with higher walls, and shut ourselves off from the world to keep the danger out. But in an era when the oceans no longer protect us, that approach will not provide true security. We must recall and believe President Reagan's famous words in Berlin. Democracy builds bridges between peoples. It tears down walls.

In Iraq, we have acted nearly alone, and we are paying a terrible price. Yet earlier this month, tens of thousands of Iraqis marched against us, demanding an end to what they denounced as "American occupation." I opposed the war in Iraq, and have called for setting a course to end it, precisely because this war profoundly weakens America. Ending it is essential to our security and to regaining the respect of the world.

We have learned again, as President Reagan told us, that might alone cannot make America right. We cannot prescribe our own rules for the modern world. If we try to do so by force, we deprive our great nation of the moral claim that is the ground of our being and the purpose of our power.

We can and sometimes must defend democracy by force, but we cannot impose it by force. Democratic principles are universal, but democracy must find its champions within each country's culture and traditions.

We need to seek common ground with our friends and renew the alliances that kept the world safe for human rights and human survival when the threat of nuclear war was a clear and present danger. We will always defend our interests, but we put them at grave risk when we choose to act unilaterally in an interdependent era. The unconventional warfare used by our enemies mocks any conventional war strategy that we stubbornly pursue on our own.

We live in a time of enormous possibility and enormous risk, and no nation is guaranteed a limitless future of prosperity or security. We have to work for it. We have to sacrifice for it.

Presidents from Truman to Reagan defended our liberty and our security in concert with our allies—with a clear-eyed appraisal of our interests and our capacities—and with a sense of overriding principle. And they prevailed.

They understood as well that strength is not just something we exercise overseas, but something we must build here at home. And they understood that our greatest national strength is found in our people.

Building our strength here at home means providing education that will empower our people with the skills they

need to compete in the global economy. Technology has liberated highly educated workers in other lands to engage actively in the international economy. We must meet that challenge.

We must also strengthen our nation by meeting the urgent challenge presented by illegal immigration. The world is watching now to see how we respond—whether we can achieve a forward-looking reform that enriches our nation with the dedicated talent of new Americans—or whether we succumb to fear and recrimination.

There is much common ground on the issue in Congress, especially on the need to strengthen our borders and enforce our laws. What we need now is a good-faith effort to reach a larger compromise that honors our commitment to our security, to our families, and to the ideals upon which America was founded.

…Every generation of Americans has been strengthened by the spirit of hardworking immigrants from many parts of the globe. As President Reagan said so eloquently in one of his last speeches, "We lead the world because, unique among nations, we draw our people—our strength—from every country and every corner of the world. And by doing so, we continuously renew and enrich our nation. Thanks to each wave of new arrivals to this land of opportunity, we're a nation forever young, forever bursting with energy and new ideas, and always on the cutting edge, always leading the world to the next frontier. This quality is vital to our future as a nation. If we ever closed the door to new Americans, our leadership in the world would soon be lost."

President Reagan's words ring true today, not just because he understood the issue of immigration, but because he understood the idea of America.

From defeating terrorism, to competing in the new global economy, to meeting the test of immigration, to safeguarding liberty at home as we defend it abroad, that idea can and must be our everlasting touchstone. We have the examples our forebears set and the enduring ideals that guided them. We have the might if we will use it right—the economic ability, the military strength, and the power of principle to make the world, as President Reagan once put it, "new again."

His leadership was right for America and the world. So was John Kennedy's. But above all, I believe, with both of them, that America's best days are still to come.

Senator Barack Obama
Remarks from Take Back America Conference
Washington, D.C.
June 14, 2006

The sweeping changes brought by revolutions in technology have torn down walls between business and government and people and places all over the globe. And with this new world comes new risks and new dangers.... The world has changed. And as a result, we've seen families work harder for less and our jobs go overseas. We've seen the cost of health care and child care and gasoline skyrocket.... But while the world has changed around us, too often our government has stood still. Our faith has been shaken, but the people running Washington aren't willing to make us believe again.... It's the timidity— the smallness—of our politics that's holding us back right now.

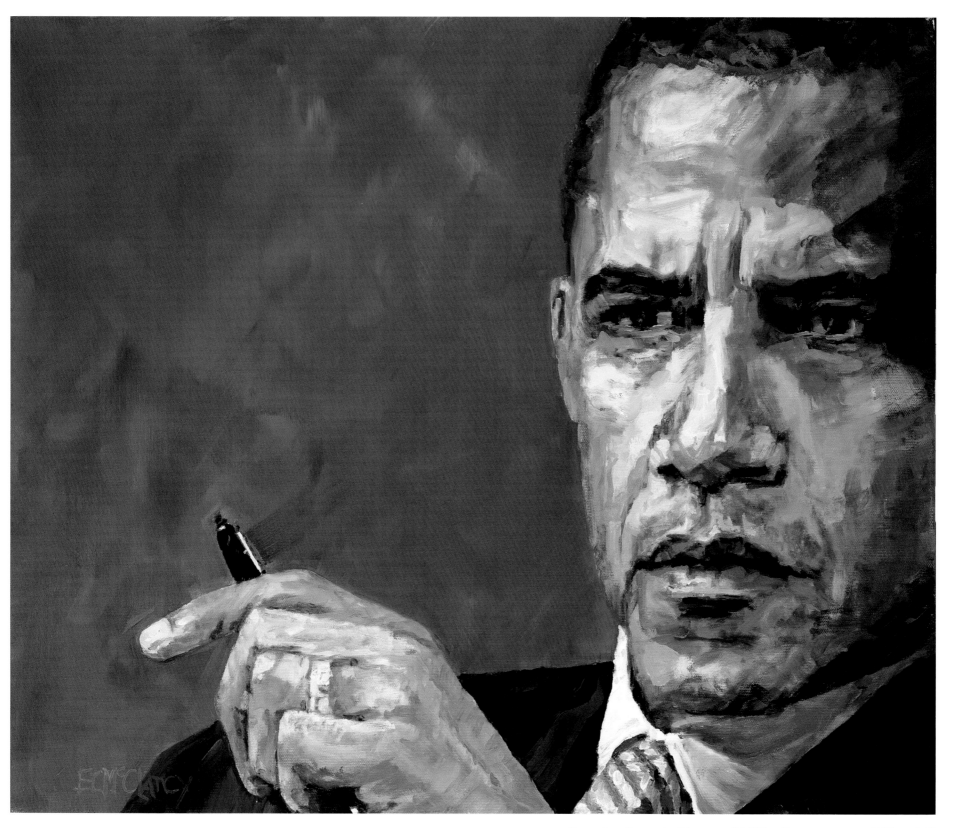

Senator Barack Obama, 2007, oil on canvas, 20" x 24"
Democratic Principles Series, No. 2

My friends, we meet here today…at a crossroads in America's history. It's a time where you can go to any town hall or street corner or coffee shop and hear people express the same anxiety about the future; hear them convey the same uncertainty about the direction we're headed as a country. Whether it's the war or Katrina or their health care or their jobs, you hear people say that we've finally arrived at a moment where something must change.

These are Americans who still believe in an America where anything's possible—they just don't think their leaders do. These are Americans who still dream big dreams—they just sense their leaders have forgotten how.

I remember when I first ran for the state Senate—my very first race. A seat had opened up, and some friends asked me if I'd be interested in running. Well, I thought about it, and then I did what every wise man does when faced with a difficult decision: I prayed, and I asked my wife.

And after consulting with these higher powers, I threw my hat in the ring and I did what every person on a campaign does— I talked to anyone who'd listen. I went to bake sales and barber shops and if there were two guys standing on the corner I'd pull up and hand them literature. And everywhere I went I'd get two questions: First, they'd ask, "Where'd you get that funny name, Barack Obama?" Because people just couldn't pronounce it. They'd call me "Alabama," or they'd call me "Yo Mama." And I'd have to explain that I got the name from my father, who was from Kenya.

And the second thing people would ask me was, "You seem like a nice young man. You teach law school, you're a civil rights attorney, you organize voter registration, you're a family man—why would you want to go into something dirty and nasty like politics?"

And I understood the question because it revealed the cynicism people feel about public life today. That even though we may get involved out of civic obligation every few years, we don't always have confidence that government can make a difference in our lives. So I understand the cynicism. But whenever I get in that mood, I think about something that happened to me on the eve of my election to the United States Senate.

We had held a large rally the night before in the Southside of Chicago, which is where I live. And in the midst of this rally, someone comes up to me and says that there's a woman who'd like to come meet you, and she's traveled a long way and she wants to take a picture and shake your hand. And so I said fine, and I met her, and we talked.

And all of this would have been unremarkable except for the fact that this woman, Marguerite Lewis, was born in 1899 and was 105 years old.

And ever since I met this frail, one-hundred-and-five-year-old African-American woman who had found the strength to leave her house and come to a rally because she believed that her voice mattered, I've thought about all she's seen in her life. I've thought about the fact that when she was born, there weren't cars on the road, and no airplanes in the sky. That she was born under the cloud of Jim Crow, free in theory but still enslaved in so many ways. That she was born at a time for black folks when lynchings were not uncommon, but voting was. I've thought about how she lived to see a world war and a Great Depression and a second world war, and how she saw her brothers and uncles and nephews and cousins coming home from those wars and still have to sit at the back of a bus. And I thought about how she saw women finally win the right to vote. And how she watched FDR lift this nation out of fear and send millions to college on the GI Bill and lift millions out of poverty with Social Security. How she saw unions rise up and a middle class prosper, and watched immigrants leave distant shores in search of an idea known as America.

She believed in this idea with all her heart and she saw this progress around her and she had faith that someday it would be her turn. And when she finally saw hope breaking through the horizon in the Civil Rights Movement, she thought, "Maybe it's my turn." And in that movement, she saw women who were willing to walk instead of ride the bus after a day of doing somebody else's laundry and looking after somebody else's children because they walked for freedom. And she saw young people of every race and every creed take a bus down to Mississippi and Alabama to register voters because they believed. She saw four little girls die in a Sunday school and catalyze a nation. And at last—at last—she saw the passage of the Civil Rights Act and the Voting Rights Act.

And she saw people lining up to vote for the first time—and she got in that line—and she never forgot it. She kept on voting in each and every election because she believed. She believed that over a span of three centuries, she had seen enough to know that there is no challenge too great, no injustice too crippling, no destiny too far out of reach for America. She believed that we don't have to settle for equality for some or opportunity for the lucky or freedom for the few.

And she knew that during those moments in history where it looked like we might give up hope or settle for less, there have always been Americans who refused. Who said we're going to keep on dreaming, and we're going to keep on building, and we're going to keep on marching, and we're going to keep on working because that's who we are. Because we've always fought to bring all of our people under the blanket of the American Dream.

And I think that we face one of those moments today.

In a century just six years old, our faith has been shaken by war and terror, disaster and despair, threats to the middle-class dream, and scandal and corruption in our government.

statistics about the stock market being up and orders for durable goods being on the rise, no one will notice the single mom whose two jobs won't pay the bills or the student who can't afford his college dreams. That if you say the words "plan for victory" and point to the number of schools painted and roads paved and cell phones used in Iraq, no one will notice the nearly 2,500 flag-draped coffins that have arrived at Dover Air Force Base.

Well it's time we finally said we notice, and we care, and we're not going to settle anymore.

You know, you probably never thought you'd hear this at a Take Back America conference, but Newt Gingrich made a

I don't think that George Bush is a bad man. I think he loves his country. I don't think this administration is full of stupid people—I think there are a lot of smart folks in there. The problem isn't that their philosophy isn't working the way it's supposed to—it's that it is.

The sweeping changes brought by revolutions in technology have torn down walls between business and government and people and places all over the globe. And with this new world comes new risks and new dangers.

No longer can we assume that a high-school education is enough to compete for a job that could easily go to a college-educated student in Bangalore or Beijing. No more can we count on employers to provide health care and pensions and job training when their bottom lines know no borders. Never again can we expect the oceans that surround America to keep us safe from attacks on our own soil.

The world has changed. And as a result, we've seen families work harder for less and our jobs go overseas. We've seen the cost of health care and child care and gasoline skyrocket. We've seen our children leave for Iraq and terrorists threaten to finish the job they started on 9/11.

But while the world has changed around us, too often our government has stood still. Our faith has been shaken, but the people running Washington aren't willing to make us believe again.

It's the timidity—the smallness—of our politics that's holding us back right now. The idea that some problems are just too big to handle, and if you just ignore them, sooner or later, they'll go away. That if you give a speech where you rattle off

great point a few weeks ago. He was talking about what an awful job his own party has done governing this country, and he said that with all the mistakes and misjudgments the Republicans have made over the last six years, the slogan for the Democrats should come down to just two words: Had enough?

I don't know about you, but I think old Newt is onto something here. I think we've all had enough. Enough of the broken promises. Enough of the failed leadership. Enough of the can't-do, won't-do, won't-even-try style of governance. Four years after 9/11, I've had enough of being told that we can find the money to give Paris Hilton more tax cuts, but we can't find enough to protect our ports or our railroads or our chemical plants or our borders.

I've had enough of the closed-door deals that give billions to the HMOs when we're told that we can't do a thing for the 45 million uninsured or the millions more who can't pay their medical bills. I've had enough of being told that we can't afford body armor for our troops and health care for our veterans and benefits for the wounded heroes who've risked their lives for this country. I've had enough of that.

I've had enough of giving billions away to the oil companies when we're told that we can't invest in the renewable energy that will create jobs and lower gas prices and finally free us from our dependence on the oil wells of Saudi Arabia.

I've had enough of our kids going to schools where the rats outnumber the computers. I've had enough of Katrina survivors living out of their cars and begging FEMA for trailers. And I've had enough of being told that all we can do about this is sit and wait and hope that the good fortune of a few trickles on down to everyone else in this country.

Now, let me say this—I don't think that George Bush is a bad man. I think he loves his country. I don't think this administration is full of stupid people—I think there are a lot of smart folks in there. The problem isn't that their philosophy isn't working the way it's supposed to—it's that it is. It's that it's doing exactly what it's supposed to do.

The reason they don't believe government has a role in solving national problems is because they think government is the problem. That we're better off if we dismantle it—if we divvy it up into individual tax breaks, hand them out, and encourage everyone to go buy your own health care, your own retirement security, your own child care, their own schools, your own private security force, your own roads, their own levees....

It's called the Ownership Society in Washington. But in our past there has been another term for it—Social Darwinism—every man or woman for him or herself. It allows us to say to those whose health care or tuition may rise faster than they can afford—life isn't fair. It allows us to say to the child who didn't have the foresight to choose the right parents or be born in the right suburb—pick yourself up by your bootstraps. It lets us say to the guy who worked twenty or thirty years in the factory and then watched his plant move out to Mexico or China—we're sorry, but you're on your own.

It's a bracing idea. It's a tempting idea. And it's the easiest thing in the world.

But there's just one problem. It doesn't work. It ignores our history.

Yes, our greatness as a nation has depended on individual initiative, on a belief in the free market. But it has also depended on our sense of mutual regard for each other, of mutual responsibility. The idea that everybody has a stake in the country, that we're all in it together and everybody's got a shot at opportunity.

Americans know this. We know that government can't solve all our problems—and we don't want it to. But we also know that there are some things we can't do on our own. We know that there are some things we do better together.

We know that we've been called in churches and mosques, synagogues and Sunday schools to love our neighbors as ourselves; to be our brother's keeper; to be our sister's keeper. That we have individual responsibility, but we also have collective responsibility to each other.

That's what America is.

And so I am eager to have this argument not just with the President, but the entire Republican Party over what this country is about. Because I think that this is our moment to lead. The time for our party's identity crisis is over. Don't let anyone tell you we don't know what we stand for and don't doubt it yourselves. We know who we are. And in the end, we know that it isn't enough to just say that you've had enough.

So let it be said that we are the party of opportunity. That in a global economy that's more connected and more competitive, we are the party that will guarantee every American an affordable, world-class, top-notch, life-long education—from early childhood to high school, from college to on-the-job training.

Let it be said that we are the party of affordable, accessible health care for all Americans. The party that won't make Americans choose between a health care plan that bankrupts the government and one that bankrupts families. The party that won't just throw a few tax breaks at families who can't afford their insurance, but modernizes our health care system and gives every family a chance to buy insurance at a price they can afford.

Let it be said that we are the party of an energy independent America. The party that's not bought and paid for by the oil companies. The party that will harness homegrown, alternative fuels and spur the production of fuel-efficient, hybrid cars to break our dependence on the world's most dangerous regimes.

Let it be said that we will conduct a smart foreign policy that battles the forces of terrorism and fundamentalism wherever they may exist by matching the might of our military with the power of our diplomacy and the strength of our alliances. And when we do go to war, let us always be honest with the American people about why we are there and how we will win.

And let it be said that we are the party of open, honest government that doesn't peddle the agenda of whichever lobbyist or special interest can write the biggest check. The party who believes that in this democracy, influence and access should begin and end with the power of the ballot.

If we do all this, if we can be trusted to lead, this will not be a Democratic agenda, it will be an American agenda. Because in the end, we may be proud Democrats, but we are prouder Americans. We're tired of being divided, tired of running into ideological walls and partisan roadblocks, tired of appeals to our worst instincts and greatest fears. Americans everywhere are desperate for leadership. They are longing for direction. And they want to believe again.

A while ago, I was reading through Jonathan Kozol's new book, *Shame of a Nation*, which tells of his travels to underprivileged schools across America. At one point, Kozol tells about his trip to Fremont High School in Los Angeles, where he met a girl who tells him that she'd taken hairdressing twice, because there were actually two different levels offered by the high school. The first was in hairstyling; the other in braiding.

Another girl, Mireya, listened as her friend told this story. And she began to cry. When asked what was wrong, she said, "I don't want to take hairdressing. I did not need sewing either. I knew how to sew. My mother is a seamstress in a factory. I'm trying to go to college. I don't need to sew to go to college. My mother sews. I hoped for something else."

I hoped for something else.

I've often thought about Mireya and her simple dream and all those before her who've shared that dream too. And I've wondered—if [Mireya] is lucky enough to live as long as 105-year-old Marguerite Lewis, if she someday has the chance to look back across the twenty-first century, what will she see? Will she see a country that is freer and kinder, more tolerant and more just than the one she grew up in? Will she see greater opportunities for every citizen of this country? Will all her childhood hopes be fulfilled?

We are here tonight because we believe that in this country, we have it within our power to say "yes" to those questions—to forge our own destiny—to begin the world anew.

Ladies and gentlemen, this is our time. Our time to make a mark on history. Our time to write a new chapter in the American story. Our time to leave our children a country that is freer and kinder, more prosperous and more just than the place we grew up.

And then someday, someday, if our kids get the chance to stand where we are and look back at the beginning of the twenty-first century, they can say that this was the time when America renewed its purpose. They can say that this was the time when America found its way.

They can say that this was the time when America learned to dream again.

Senator Charles E. Schumer
Government's Responsibility to Citizens
January 4, 2007

They come to us with a message, and I don't think the message is left, right, or center.... The message is to keep your eyes focused on the average family. All too often we in Washington get lost in the world of Washington. Too often politics here seems to be a minuet, shadow boxing, sometimes real boxing, where each party and each individual is seeking advantage over the other, and the focus on getting something done—something done for the American people—gets lost.

Senator Charles E. Schumer, 2007, oil on canvas, 24" x 20"
Democratic Principles Series, No. 6

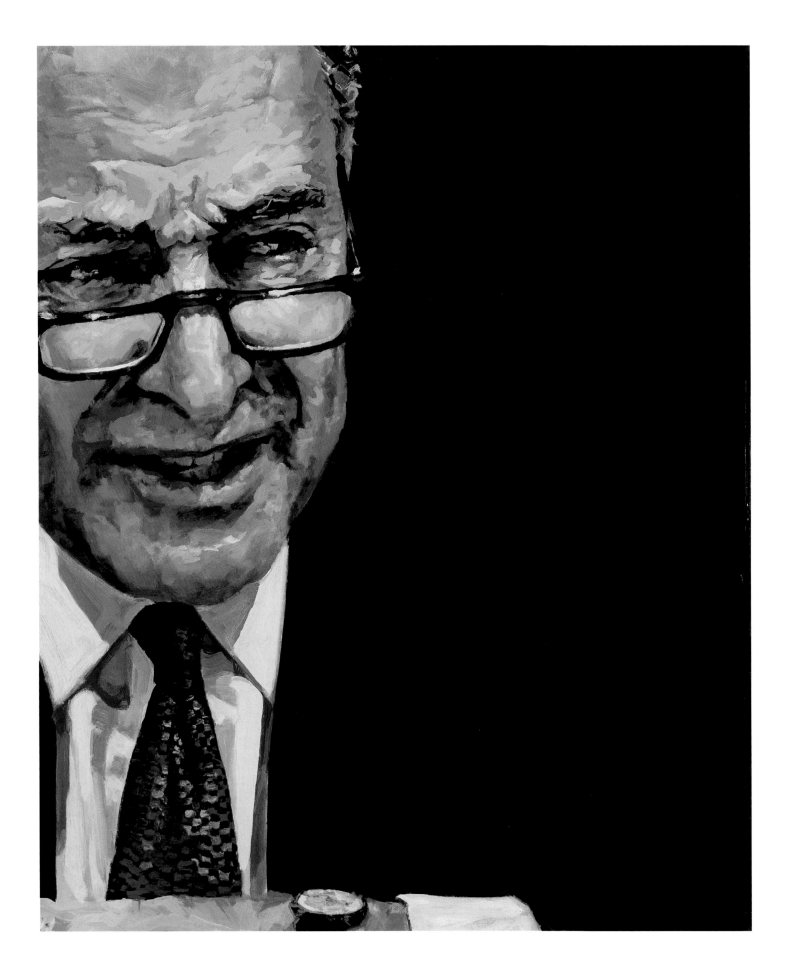

Mr. President, I rise as well to speak about our priorities that Senator Reid has introduced. First, I compliment him for his vision and drive toward shaping these priorities, and his leadership that will ensure the Senate makes the concerns of the average American family our top priority.

I thank my colleague from Illinois, Senator Durbin, who, as always, is able to articulate in a very smart way, but also a way the average person can understand, how important these priorities are to us.

I also, in advance, thank my colleague Senator Murray for being here, and who again, in her usual wise and thoughtful way, will help us let the American people know what our priorities are.

Now, I wore a blue suit today, naturally, because we are all excited over the election in November. But in our excitement, we have to remember that we are here because of the people who sent us here, and to realize their desire for change, to make their lives better. We know a bipartisan approach is the best and perhaps the only way we will get this done.

If all our exultation and happiness today—and, believe me, I stood there with pride watching the new Members in particular be sworn in, knowing how fine they are, what a diverse group of people they are—the thing they share in common is coming from the bosom of the people of their State. Each one, each of the new Representatives, each of the new Senators represents the people of their State.

They come to us with a message, and I don't think the message is left, right, or center, as some of the pundits have said. The message is to keep your eyes focused on the average family. All too often we in Washington get lost in the world of Washington. Too often politics here seems to be a minuet, shadow boxing, sometimes real boxing, where each party and each individual is seeking advantage over the other, and the focus on getting something done—something done for the American people—gets lost.

If there was one message that this election had, I think that is it. The American people were pleading with us, crying out to us with a strong but plaintive voice: Help us. The world is changing, and we see that world change in every way. Technology has dramatically affected everything we do, whether it is terrorism, where technology has enabled small groups of bad people to hurt us; whether it is jobs, where we now have a one-world labor market, and our workers, our kids in the third grade today are going to be competing not simply against the kids in the third grade across the hallway but the kids in the third grade in China, India, and Brazil; or whether it is the technology that has allowed us to live longer.

I read somewhere that a little girl born today, if she lives in the early months and up to a year old, could well live to be 100. That is incredible. What that means is new problems for Social Security and Medicare. It also means that our whole lifestyle changes as people get married later, have children later, and retire and have many years of leisure in life. So technology is changing everything.

The old messages—whether they be the old Democratic New Deal message or the old Reagan Republican message—just don't work anymore. Voters, in November, didn't tell us to adopt a certain ideology or philosophy or even party. Their message to Washington was to stop fighting with each other and finally get something done for average Americans. Americans are in more need of help now as the world changes quickly and dramatically.

The average American wants us to get to work on issues that matter to them on a daily basis: making them more secure, lifesaving medical research, fair wages, comprehensive immigration reform, energy independence, and affordable education and prescription drugs. They want us to go to work for them again. That is what we are going to do.

The ten bills we have introduced are all aimed right at the heart of the average American in the sense of saying to the average American: We do know what you need, what you have asked us to do, and we are going to do our best to help you.

Make no mistake; overall, families are doing quite well, but they are beginning to hurt in certain ways: high gas prices, skyrocketing tuition, prescription drugs. These are all things the average person worries about that they probably didn't worry about 10 years ago. These first 10 bills that we are going to introduce represent the Democratic priorities for the Senate and the country. These bills take aim at making education and prescription drugs more affordable. They address our goals for energy independence, better homeland security, innovative medical research, a modernized military, and comprehensive immigration reform—priorities that have been neglected for far too long.

I first want to express my enthusiastic support for our bill to address college affordability, S. 7, which my colleagues will also address. We know we must make it easier for families to send their kids to college, but as tuition costs rise, it gets harder and harder. As college becomes more of a necessity, it also becomes less affordable. That is the dilemma we face. We are facing a critical time with this challenge coming, when a college education is vital not only to one's individual future but to our Nation's prosperity and independence.

We are competing now in a global market connected by technology, and we need a well-educated workforce. That is why, upon arriving in the Senate, I introduced a bill to permit a college tuition tax deduction. I have worked to support it ever since. We must ensure that this deduction does not expire, as it nearly did in December, by making it permanent. And we must do more. Just getting by is not enough when it comes to sending our kids to college. We must address other aspects of college costs, including Pell grants, loans, and lowering interest payments on loans. I know my colleague, Senator Kennedy, has big plans for addressing these issues. Just as I will work hard on the Finance Committee on the tuition issue, he, in the HELP Committee, will be leading many of my colleagues on those issues there.

What I have been asked to spend a few minutes to talk about is S. 4, a bill to implement the recommendations of the national commission on terrorist acts, the 9/11 Commission. It has now been over 5 years since the tragedy and devastation of September 11. On that day, our Nation changed irrevocably with the knowledge that terrorist forces, motivated by hatred, have the determination and ability to threaten America on our own soil. My own city of New York knows this devastation and tragedy well. On that day, and in the days following, we lost thousands of our friends and family members, including hundreds of brave firefighters and police officers who died trying to save others. We owe it to all those who lost their lives on that day to take up and implement the commission's recommendations.

On that day, it was clear that much needed to be done to improve the security of our homeland. The President and Congress responded in part by establishing the 9/11 Commission. This bipartisan commission did its work thoroughly and well, devising 41 core recommendations to prevent, defend against, and respond to the threat of future terrorist attacks. Each one of the recommendations was a vital part of the Commission's charge to Congress and the President. Yet Americans have not just been gravely disappointed but also endangered by the failure to implement all of the recommendations of the 9/11 Commission. It is high time for this failure to be rectified.

S. 4 expresses the sense of Congress that we must immediately work toward passage of legislation that will, after far too long, implement the solutions carefully crafted at our request. As the committee puts together a final detailed bill, S. 4 will serve as an important symbol of our priority for securing our Nation by implementing the recommendations. We have made some improvements since 9/11, but we still have so far to go.

America simply cannot wait any longer to fully protect our homeland. Whether it is improving communications between first responders, ensuring that law enforcement shares information about threats, or securing our transportation systems, which I know my colleague from Washington has worked on, we have a whole lot to do. We cannot wait longer for decisive action to stop weapons of mass destruction from falling into the hands of terrorists entering our country or being built by those who would destroy us. We cannot wait any longer to better combat the violent extremism that is growing around the globe.

This is only the beginning of the work that remains to be done. We have heard so much talk about homeland security in the years and days since 9/11, but in all this time we have seen far too little action. In the 110th Congress, at last that shameful state of affairs must and will come to an end.

In conclusion, the voters in November gave us great honor but humbling responsibility. We must now rise to meet that responsibility by returning the focus of our work to the basic needs of American families. Today is the first and important step toward meeting that responsibility.

So as we start this new Congress, I look forward to working with our Republican colleagues and the President to deliver these priorities for American families. Our families deserve no less.

"Ensure
Domestic
Tranquility..."

Will we leave them lush forests teeming with wildlife and fresh air and clear streams? Will our grandchildren know the thrill of holding their child's hand watching with excitement a towering snow-capped mountain or awesome, calving glaciers? Will they be lucky enough to catch a glimpse of a polar bear diving from ice floes into a bone-chilling sea? Will they have plentiful food and ample water, and be able to wiggle their toes in the same beach sand their grandparents played in? Will our generation leave them a climate that supports the awe-inspiring diversity of Creation?

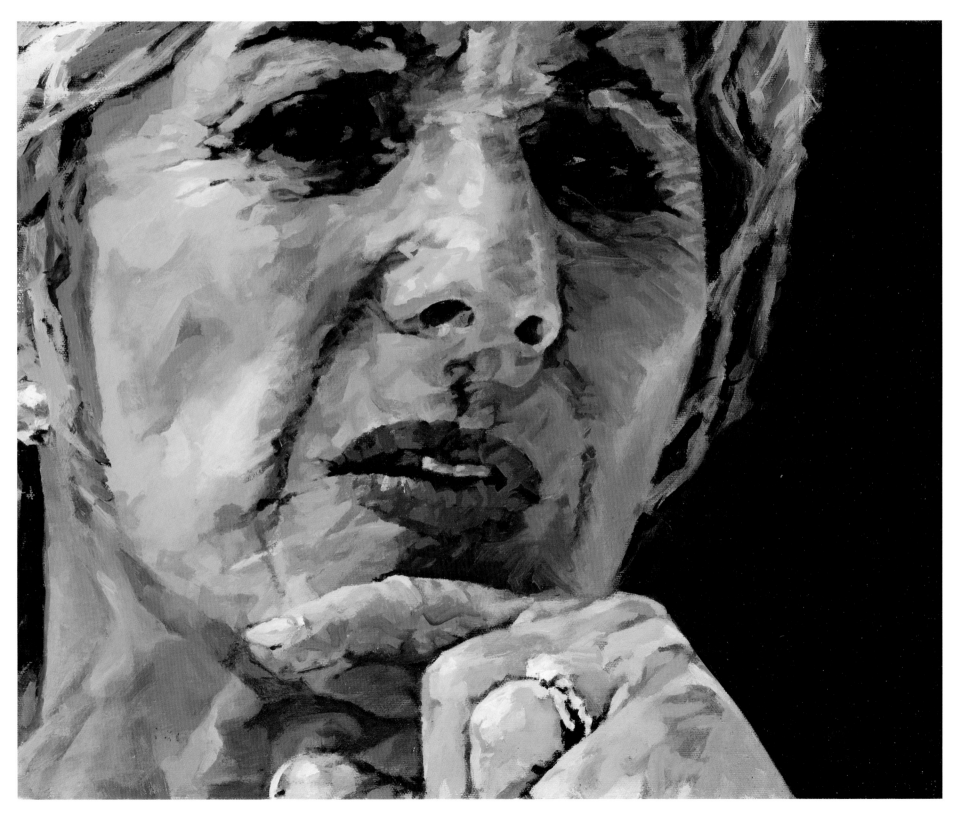

Senator Barbara Boxer, 2007, oil on canvas, 14" x 18"
Democratic Principles Series, No. 9

I wanted to speak with you today about combating global warming, because the warming of our earth is more than an inconvenient truth; it is the challenge of our generation. It is a challenge we should meet with hope, not fear, and a challenge that will make us stronger as a nation and as a people if we meet it head-on. The leading scientists of the world tell us clearly that global warming is happening now and human activities are the cause.

Now, Senators are not climate scientists. But we are policy makers. Just as our nation took action based on scientific consensus before, we must take action now. Today, I will outline some of the steps we can take—starting immediately—to confront the problem.

In the past, our nation has swiftly responded to scientific consensus, and solved major problems. For example, in 1952 a polio epidemic in the U.S. peaked with 58,000 cases. Scientists determined that a massive immunization campaign was needed. By 1964, we had only 121 cases of polio—more than a 99 percent reduction. We didn't walk away from the challenge.

When scientists told us that the reason the Cuyahoga River caught fire in Ohio in 1969 was because toxic pollution was accumulating there, we didn't walk away from the challenge: we passed the Clean Water Act. When scientists told us why the air had become so polluted we could see it and were choking on it, we didn't walk away from the challenge; we passed the Clean Air Act in 1970.

When scientists told us that contaminated tap water was causing widespread waterborne disease and exposing people to cancer, we didn't walk away from the challenge: we passed the Safe Drinking Water Act in 1974. There are many other examples—the Superfund program, the Brownfields program, the Endangered Species Act. In none of these cases have we walked away from the challenge and in every one of these cases, we are the better for it.

Our generation faces a choice. Will we, in the stirring words of the 2004 Nobel Peace Prize laureate, give our children "a world of beauty and wonder?" And I ask: Will we leave them lush forests teeming with wildlife and fresh air and clear streams? Will our grandchildren know the thrill of holding their child's hand watching with excitement a towering snow-capped mountain or awesome, calving glaciers? Will they be lucky enough to catch a glimpse of a polar bear diving from ice floes into a bone-chilling sea? Will they have plentiful food and ample water, and be able to wiggle their toes in the same beach sand their grandparents played in? Will our generation leave them a climate that supports the awe-inspiring diversity of Creation?

I have a vision for my eleven-year-old grandson and for my new grandson who is expected in a few weeks. My vision is that these children and yours will grow up and be able to know the gifts of nature that we saved for them. That they will understand we made the right choice for them— we protected the planet that is their home. That because of our action they will not be shackled into fighting wars over the last drops of water or oil or remaining acres of arable cropland.

They will not have to spend their last treasure building higher flood walls, bigger levees, and fortified cities to escape rising seas and angrier hurricanes. Their cars will run on clean renewable fuels that do not pollute the air they breathe. The United States will lead in exporting clean technologies and products that are the engine of a new green economy. We will lead the world in showing the way to live well, in a way that respects the earth.

To make this vision a reality, we must face our challenge in a way that overcomes our differences, and that defies our party affiliations.

What struck me about the Kerry/Gingrich debate is that they both had great ideas. Capping and trading greenhouse gases, tax incentives and research all make sense. The most important thing about that debate is that they both agreed that global warming is urgent and action must be taken now. Nearly four decades ago, the founder of Earth Day, U.S. Senator Gaylord Nelson of Wisconsin, had grown frustrated with the lack of action in Washington to save the earth. He wrote: "Evidence of environmental degradation was appearing everywhere and everyone noticed except the political establishment."

The political establishment is awakening to this challenge of global warming, but there needs to be a strong, steady, insistent alarm, not a soft, soothing wake-up call. We are running out of time—scientists tell us we have about ten years, or the effects of our global warming emissions may become

irreversible. Many have pointed to India and China and suggested that we should wait for them before we act. I say the United States needs to be the world leader. When have we ever waited for other countries to lead?

If the United States leads, other nations like India and China will follow. I asked President Bush to convene a summit of the top 12 emitting nations to discuss global warming. And today I asked him again to do so. From Al Gore who put this issue on the nation's agenda, to Colin Powell who said, "We can no longer deny that global warming is a problem facing our children and grandchildren," to 11 National Academies of Sciences, to hundreds of the world's leading scientists.

This issue is bigger than any person, any party. We all must join together to solve it. As Thomas Friedman wrote [on Sunday] in *The New York Times*, "Green is geo-strategic, geo-economic, capitalistic and patriotic."

California has moved with the leadership of our Democratic legislature and our Republican governor. Other states have

And recently, key leaders of our national security community, who some people are calling "Green Hawks," have been strongly urging us to wean ourselves from oil, and are urging us to combat global warming as well. A study released this week by a group of retired high-ranking generals and admirals commissioned by the government-funded Center for Naval Analysis, warns us that we may face very real national security risks and global political instability from floods, disease, conflicts over water and food, and mass migrations that could be caused by unbridled global warming.

The federal government is late to this issue and it's time to show up. That's what the committee that I chair—the Environment and Public Works Committee, or EPW—has done this year. We showed up with an "open mike," where a third of the Senate expressed their views on global warming. Then we invited scientists and wildlife experts, business and environmental leaders, and state and local leaders. We heard from New Jersey Governor Jon Corzine—who is in all of our thoughts and prayers today—as well as California and Washington State leaders who have already acted.

The political establishment is awakening to this challenge of global warming, but there needs to be a strong, steady, insistent alarm, not a soft, soothing wake-up call.

done it with Democrats and Republicans working side by side to develop programs to reduce greenhouse gas emissions. Many in the business community are also stepping up. The U.S. Climate Action Partnership has come together to call for a mandatory greenhouse gas "cap-and-trade" program. This group includes business giants like Alcoa, BP, Caterpillar, Dupont, and GE, Lehman Brothers, electric utilities including PG&E in California, PNM in New Mexico, and Florida Power and Light, and leading environmental groups. Business leaders see a promising future for America as we move our economy away from the old, often inefficient and polluting ways of doing business, and toward global-warming–friendly technologies.

Religious leaders are also joining the fight against global warming. Groups as diverse as the Catholic Church, the Evangelical Climate Initiative, the Coalition on the Environment and Jewish Life, the Evangelical Environmental Network, and the National Religious Partnership for the Environment are rolling up their sleeves in interfaith groups. They are fighting for what many call "Creation Care," the protection of the gifts we have inherited from our Creator.

We have held members' briefings twice with the leading scientists in the world, from the United Nations Intergovernmental Panel on Climate Change, or IPCC. Recently, these scientific experts told us that as many as 20 to 30 percent of the species on earth may be at risk of extinction from global warming, a deeply distressing thought. And of course, we had a very important hearing where former Vice President Al Gore made a compelling case for us to act on global warming.

At the end of March, I was joined by Senator Inhofe, the Bush Administration, and the entire Committee in passing legislation that will require up to 8,000 buildings owned or leased by the federal government to install state-of-the-art, energy-efficient lighting and other technologies to slash their energy use by 20 percent within 5 years. We also set up a grant program to help local governments make their buildings more energy efficient. These actions will substantially cut global warming emissions caused by these buildings.

We are also leading the way by example. Just this week, we started installing new lighting technologies in our Committee's

offices, which will cut our electricity use for lighting by about 50 percent, and reduce our carbon footprint. Now our Committee's plans are as follows. We will hear from members of the religious community and more business leaders from the recreational industry, and EPA and former EPA officials. We will mark up green buildings legislation. Whenever I have the votes, I will report strong global warming bills to the Senate floor.

I know we all want to move forward on global warming as soon as possible. Every day we move closer to that reality. I have been informed by Senators Carper, Alexander and Sanders, who are all members of my Committee, that they will soon introduce bills to cap pollution from powerplants, including global warming pollution. Powerplants are a big part of the problem and can also pose a huge threat to public health. Of course, Senator Sanders and I and Senator Lieberman have introduced economy-wide bills. So these bills represent real progress in our Committee, on a bipartisan basis. In a real breakthrough, the Supreme Court has weighed in on the side of the environment and our people. They say that right now, without one more law, EPA can begin to regulate greenhouse gas emissions under the Clean Air Act. What does

the power EPA has had all along to address global warming, and has refused to use. The Supreme Court has left this Administration with no excuses for further delay. I also look forward to hearing from Carol Browner and William Reilly, former EPA Administrators, at that same hearing. Both urged the Supreme Court to hold that EPA already has the authority to control global warming. Again, without one new piece of legislation, the EPA can act on many fronts.

We know that roughly 30 percent of greenhouse gas emissions in America comes from transportation, 40 percent from power plants, and 30 percent from industry, residential, and commercial emissions. Therefore the path for us is clear. We know what we have to do. We must reduce carbon emissions enough so that we can stabilize greenhouse gases in the atmosphere at 450 parts per million (ppm) to hold temperatures rises to less than 2 degrees Fahrenheit from today's levels.

In order to achieve this goal, we need to cap and eventually, reduce our greenhouse gas emissions by at least 80 percent below 1990 levels by 2050. This will require action by all

I have a vision of a nation driven by innovation, energy efficiency, and green technology exported around the world. I see a strong American economic base, with entrepreneurs and businesses thriving—a people united by a challenge in their daily lives and as a society. And in the process, I believe we will find a common purpose.

this mean? It means that right now, EPA can and should let California and other states go forward with global warming pollution standards for cars. That's a 30 percent reduction from cars in California. It means that EPA can and should set strong nationwide global warming standards for cars as well, meeting California's standards. That would mean at least a 30 percent reduction from cars, which are about a third of our emissions. It means that EPA can and should require strong global warming pollution limits for new and upgraded coal-burning power plants immediately. That way, we won't be saddled for the next half-century with vast quantities of global warming pollution from coal-fired power plants that don't use the latest clean technologies. Powerplants are a large share of the problem, and EPA can act now to reduce their emissions dramatically.

When EPA Administrator Steve Johnson comes before my committee on April 24th [2007], I will challenge him to use

sectors of our economy. First, we must become far more energy efficient. This saves money, makes us more competitive, and reduces pollution and greenhouse gas emissions.

Power plants must look to renewable energy sources like wind and solar power, or capture and sequester their global warming emissions. Cars, trucks, and other modes of transportation must move towards green, renewable fuels such as environmentally clean biofuels or electricity. Our industries and buildings must become state-of-the-art energy savers.

Again, stepping up to this challenge in the right way will transform and invigorate our country, not devastate it.

I have a vision of a nation driven by innovation, energy efficiency, and green technology exported around the world. I see a strong American economic base, with entrepreneurs and businesses thriving—a people united by a challenge in their

daily lives and as a society. And in the process, I believe we will find a common purpose.

Failure to act would result in a huge economic cost. According to Sir Nicholas Stern, one dollar spent now will save five dollars later in avoided costs. Individuals can help too.

To help provide information for individuals who want to make a difference, I want to call your attention to our new "carbon footprint" website…. Here's how it works: log onto our Environment and Public Works Committee website at epw.senate.gov, and go through a short questionnaire. You will find out how much global warming pollution you are responsible for, and can learn about ways to reduce your "carbon footprint."

There is so much interest from our people on this. The polls show they want to act now. Just this morning, a poll on behalf of the Center for American Progress was released on what Americans think about global warming. Americans believe that the second most important domestic priority is to "reduce dependence on oil and coal to stop global warming." Fully three-quarters of Americans say global warming effects are apparent now. By nearly 3 to 1, the public wants to "move quickly to expand the production of clean, alternative energy and reduce our use of oil and coal."

Here is what I want to leave you with.

Each of us grows up in our own way and in our own time. But at its center, growing up means being responsible, being accountable and planning for the future. We in the Senate, right now must muster the maturity and wisdom to rise to the challenge of addressing global warming. We need to be responsible, accountable and plan for the future of our planet.

When we were children, our home was our entire world. That home met all our needs. As we grew older our home expanded to include our community, our city, our state, our nation and the world. Now we must take it a step further. If we don't expand the limits of our vision to include planet earth as our home, then we may lose our home as we know it.

I will do everything I can as a citizen of this great country and as the Chairman of a great committee that has always led the way on the environment. Just as we lift our children up to feed them, to comfort them and to protect them from any manner of harm, just as we would never leave them trapped in a locked car in the hot sun, we must protect them from global warming. As the ancient religious writings say: "See to it that you do not destroy my world, for there is no one to repair it after you." [Midrash Ecclesiastes Rabbah 7:13]

Today, for us it should be simple. Working together we can reverse global warming. We must lead on this, not follow.

It's our job. I truly believe when we do our job, our country and our families will be better and stronger and the world safer.

President Jimmy Carter
at the Coretta Scott King Funeral
February 10, 2006
and Nobel Lecture
December 10, 2002

The struggle for equal rights is not over. We only have to recall the faces of those in Louisiana, Alabama, and Mississippi—those who were most devastated by Katrina—to know that there are not yet equal opportunities for all Americans. It is our responsibility to continue their crusade.

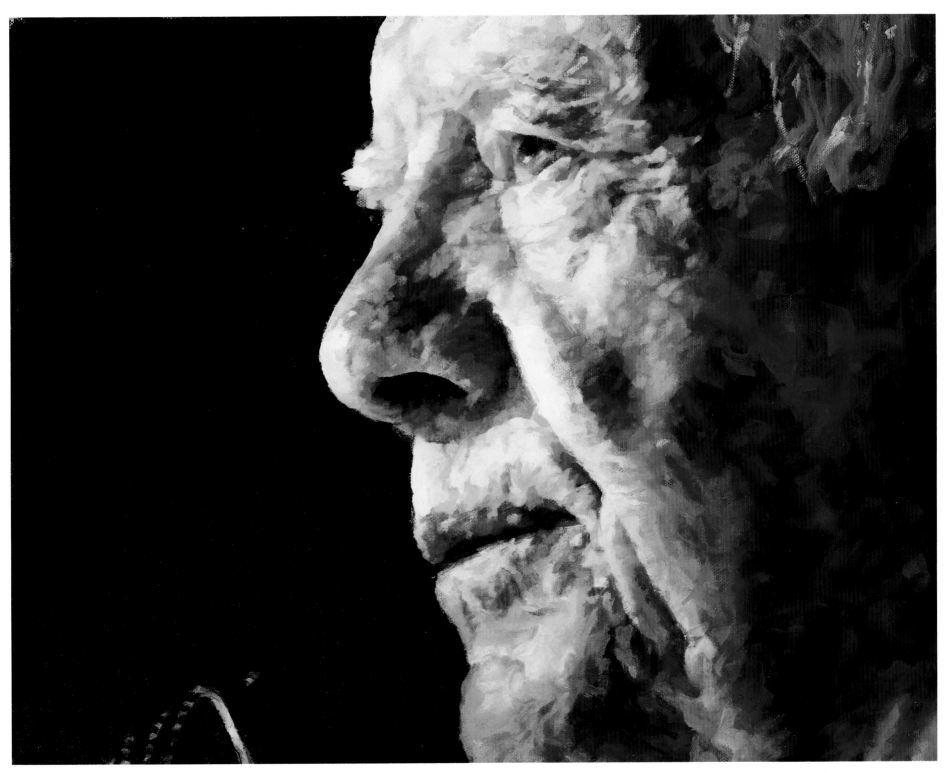

President Jimmy Carter, 2007, oil on canvas, 14" x 18"
Democratic Principles Series, No. 18

Since we left the White House, my wife and I have visited more than 125 nations in the world. They've been mostly nations where people are suffering. Almost 45 of them are in Africa, and we have found in those countries a remarkable gratitude for what Martin and Coretta [King] have meant to them, no matter where they live. It's interesting for us Americans to realize that we do not have a monopoly on hunger for democracy and freedom…the essence of human ambitions that binds us all together.

Coretta and Martin and their family have been able to climb the highest mountain and to realize the essence of theology and political science and philosophy. They overcame one of the greatest challenges of life—to be able to wage a fierce struggle for freedom and justice and to do it peacefully.

It was a difficult time for them personally, with the civil liberties of both husband and wife violated as they became the targets of secret government wiretapping, other surveillance, and, as you know, harassment from the FBI.

When Coretta and Daddy King adopted me in 1976, it legitimized a Southern governor as an acceptable candidate for President. Each of their public handshakes to me was worth a million Yankee votes! In return, they had a key to the White House while I was there, and they never let me forget that I was in their political debt. They were not timid in demanding payment—but always for others who were in trouble, never for themselves.

In 1979, when I was President, I called for making January 15 a national holiday honoring Martin Luther King Jr., and Coretta was by my side. And the following year, we established the Martin Luther King Jr. National Historic Site. When I awarded the Presidential Medal of Freedom in 1977, Coretta responded to this honor for her husband, and I quote, "This

They led a successful battle to alleviate the suffering of blacks and other minorities, and, in promoting civil rights in our country, they enhanced human rights in all nations.

…Martin and Coretta were able to demonstrate to the world that this correlation was possible. They exemplified the finest aspects of American values and brought upon our nation the admiration of the entire world.

This beautiful and brave woman helped to inspire her husband and has been a worthy successor in carrying forward his great legacy. [Together,] they led a successful battle to alleviate the suffering of blacks and other minorities, and, in promoting civil rights in our country, they enhanced human rights in all nations. At the same time, they transformed the relationships among us Americans, breaking down the racial barriers that had separated us one from another for almost two centuries.

My life has been closely intertwined with that of the King family. Our first public ceremony together was in 1974 when, as Governor, I dedicated Martin's portrait in the Georgia capitol—Joseph Lowery and others were there. [That event] was surrounded outside with chanting members of the Ku Klux Klan, who had too much support from other Americans. The efforts of Martin and Coretta to change America were not appreciated even at the highest level of our government.

medal will be displayed with Martin's Nobel Peace Prize in the completed Martin Luther King Jr. Center for Social Change, his official memorial in Atlanta. It will serve as a continuous reminder and inspiration to young people and unborn generations that [Martin Luther King's] dream of freedom, justice, and equality must be nurtured, protected, and fully realized, that they must be the keepers of the dream."

This commemorative ceremony this morning and this afternoon is not only to acknowledge the great contributions of Coretta and Martin, but to remind us that the struggle for equal rights is not over. We only have to recall the faces of those in Louisiana, Alabama, and Mississippi—those who were most devastated by Katrina—to know that there are not yet equal opportunities for all Americans. It is our responsibility to continue their crusade.

I would like to say to my sister Coretta that we will miss you, but our sorrow is alleviated by the knowledge that you and your husband are united in glory. Thank you for what you have meant to me and to the world.

I thought often during my years in the White House of an admonition that we received in our small school in Plains, Georgia, from a beloved teacher, Miss Julia Coleman. She often said: "We must adjust to changing times and still hold to unchanging principles."

When I was a young boy, this same teacher also introduced me to Leo Tolstoy's novel, *War and Peace*. She interpreted that powerful narrative as a reminder that the simple human attributes of goodness and truth can overcome great power.

She also taught us that an individual is not swept along on a tide of inevitability but can influence even the greatest human events.

These premises have been proven by the lives of many heroes, some of whose names were little known outside their own regions until they became Nobel laureates: Albert John Lutuli, Norman Borlaug, Desmond Tutu, Elie Wiesel, Aung San Suu Kyi, Jody Williams, and even Albert Schweitzer and Mother Teresa. All of these and others have proven that even without government power—and often in opposition to it—individuals can enhance human rights and wage peace, actively and effectively.

generally accepted goals of society are peace, freedom, human rights, environmental quality, the alleviation of suffering, and the rule of law.

During the past decades, the international community, usually under the auspices of the United Nations, has struggled to negotiate global standards that can help us achieve these essential goals. They include: the abolition of land mines and chemical weapons; an end to the testing, proliferation, and further deployment of nuclear warheads; constraints on global warming; prohibition of the death penalty, at least for children; and an international criminal court to deter and to punish war crimes and genocide. Those agreements already adopted must be fully implemented, and others should be pursued aggressively.

We must also strive to correct the injustice of economic sanctions that seek to penalize abusive leaders but all too often inflict punishment on those who are already suffering from the abuse.

The unchanging principles of life predate modern times. I worship Jesus Christ, whom we Christians consider to be the Prince of Peace. As a Jew, he taught us to cross religious boundaries, in service and in love. He repeatedly reached out and embraced Roman conquerors, other Gentiles, and even the more despised Samaritans.

The bond of our common humanity is stronger than the divisiveness of our fears and prejudices. God gives us the capacity for choice. We can choose to alleviate suffering. We can choose to work together for peace. We can make these changes—and we must.

The Nobel Prize also profoundly magnified the inspiring global influence of Martin Luther King, Jr. On the steps of our memorial to Abraham Lincoln, Dr. King said: "I have a dream that on the red hills of Georgia the sons of former slaves and the sons of former slave owners will be able to sit down together at a table of brotherhood."

The scourge of racism has not been vanquished, either in the red hills of our state or around the world. And yet we see ever more frequent manifestations of his dream of racial healing. In a symbolic but very genuine way, at least involving two Georgians, it is coming true in Oslo today.

I am not here as a public official, but as a citizen of a troubled world who finds hope in a growing consensus that the

Despite theological differences, all great religions share common commitments that define our ideal secular relationships. I am convinced that Christians, Muslims, Buddhists, Hindus, Jews, and others can embrace each other in a common effort to alleviate human suffering and to espouse peace.

...At the beginning of this new millennium I was asked to discuss...the greatest challenge that the world faces. Among all the possible choices, I decided that the most serious and universal problem is the growing chasm between the richest and poorest people on earth. Citizens of the ten wealthiest countries are now seventy-five times richer than those who live in the ten poorest ones, and the separation is increasing every year, not only between nations but also within them. The results of this disparity are root causes of most of the

world's unresolved problems, including starvation, illiteracy, environmental degradation, violent conflict, and unnecessary illnesses....

Most work of The Carter Center is in remote villages in the poorest nations of Africa, and there I have witnessed the capacity of destitute people to persevere under heartbreaking conditions. I have come to admire their judgment and wisdom, their courage and faith, and their awesome accomplishments when given a chance to use their innate abilities.

But tragically, in the industrialized world there is a terrible absence of understanding or concern about those who are enduring lives of despair and hopelessness. We have not yet made the commitment to share with others an appreciable part of our excessive wealth. This is a potentially rewarding burden that we should all be willing to assume.

...The bond of our common humanity is stronger than the divisiveness of our fears and prejudices. God gives us the capacity for choice. We can choose to alleviate suffering. We can choose to work together for peace. We can make these changes—and we must.

As we become ever more diverse, we must work harder to unite around our common values and our common humanity. We must work harder to overcome our differences, in our hearts and in our laws. We must treat all our people with fairness and dignity, regardless of their race, religion, gender or sexual orientation, and regardless of when they arrived in our country; always moving toward the more perfect union of our founders' dreams.

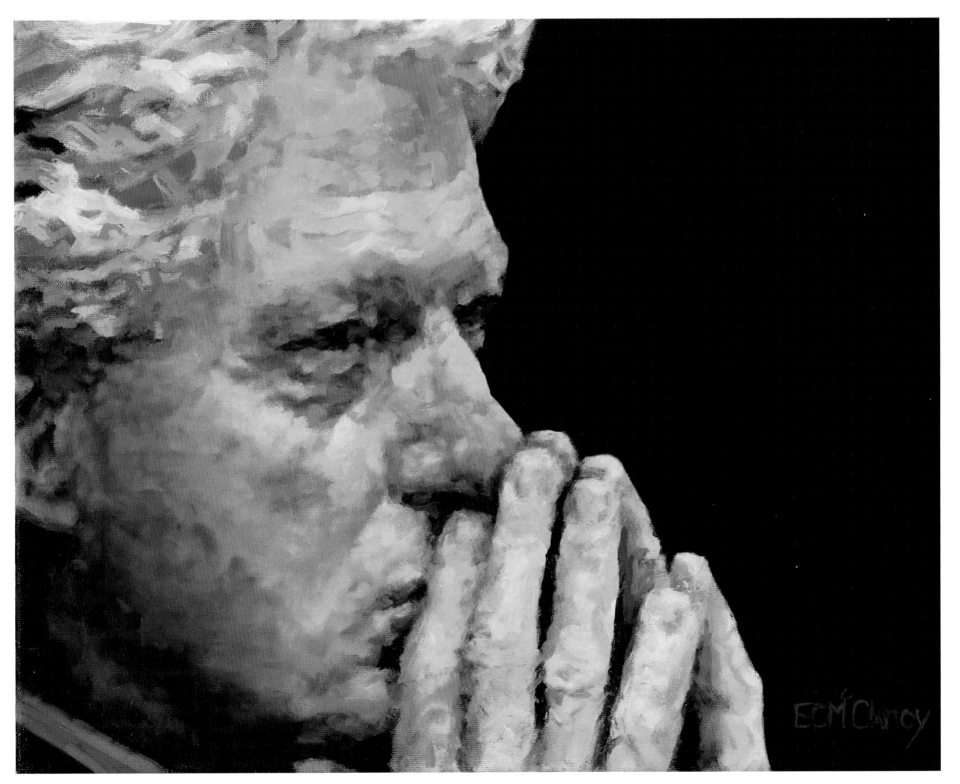

President Bill Clinton, 2007, oil on canvas, 14" x 18"
Democratic Principles Series, No. 15

My fellow citizens, tonight is my last opportunity to speak to you from the Oval Office as your President. I am profoundly grateful to you for twice giving me the honor to serve—to work for you and with you to prepare our nation for the 21st century.

And I'm grateful to Vice President Gore, to my Cabinet Secretaries, and to all those who have served with me for the last eight years.

This has been a time of dramatic transformation, and you have risen to every new challenge. You have made our social fabric stronger, our families healthier and safer, our people more prosperous. You, the American people, have made our passage into the global information age an era of great American renewal.

In all the work I have done as President—every decision I have made, every executive action I have taken, every bill I have proposed and signed—I've tried to give all Americans the tools and conditions to build the future of our dreams in a good society, with a strong economy, a cleaner environment, and a freer, safer, more prosperous world.

I have steered my course by our enduring values—opportunity for all, responsibility from all, a community of all Americans. I have sought to give America a new kind of government, smaller, more modern, more effective, full of ideas and policies

More than 3 million children have health insurance now, and more than 7 million Americans have been lifted out of poverty. Incomes are rising across the board. Our air and water are cleaner. Our food and drinking water are safer. And more of our precious land has been preserved in the continental United States than at any time in a hundred years.

America has been a force for peace and prosperity in every corner of the globe. I'm very grateful to be able to turn over the reins of leadership to a new President with America in such a strong position to meet the challenges of the future.

Tonight I want to leave you with three thoughts about our future. First, America must maintain our record of fiscal responsibility.

Through our last four budgets we've turned record deficits to record surpluses, and we've been able to pay down $600 billion of our national debt, on track to be debt-free by the end of the decade for the first time since 1835. Staying on that course will bring lower interest rates, greater prosperity, and the opportunity to meet our big challenges. If we choose wisely, we can pay down the debt, deal with the retirement of the baby boomers, invest more in our future, and provide tax relief.

Second, because the world is more connected every day, in every way, America's security and prosperity require us to

We must remember that America cannot lead in the world unless here at home we weave the threads of our coat of many colors into the fabric of one America.

appropriate to this new time, always putting people first, always focusing on the future.

Working together, America has done well. Our economy is breaking records, with more than 22 million new jobs, the lowest unemployment in 30 years, the highest home ownership ever, the longest expansion in history.

Our families and communities are stronger. Thirty-five million Americans have used the Family Leave law; 8 million have moved off welfare. Crime is at a 25-year low. Over 10 million Americans receive more college aid, and more people than ever are going to college. Our schools are better. Higher standards, greater accountability and larger investments have brought higher test scores and higher graduation rates.

continue to lead in the world. At this remarkable moment in history, more people live in freedom than ever before. Our alliances are stronger than ever. People all around the world look to America to be a force for peace and prosperity, freedom and security.

The global economy is giving more of our own people and billions around the world the chance to work and live and raise their families with dignity. But the forces of integration that have created these good opportunities also make us more subject to global forces of destruction—to terrorism, organized crime and narco trafficking, the spread of deadly weapons and disease, the degradation of the global environment.

The expansion of trade hasn't fully closed the gap between those of us who live on the cutting edge of the global economy

and the billions around the world who live on the knife's edge of survival. This global gap requires more than compassion; it requires action. Global poverty is a powder keg that could be ignited by our indifference.

In his first inaugural address, Thomas Jefferson warned of entangling alliances. But in our times, America cannot, and must not, disentangle itself from the world. If we want the world to embody our shared values, then we must assume a shared responsibility.

If the wars of the 20th century, especially the recent ones in Kosovo and Bosnia, have taught us anything, it is that we achieve our aims by defending our values, and leading the forces of freedom and peace. We must embrace boldly and resolutely that duty to lead—to stand with our allies in word and deed, and to put a human face on the global economy, so that expanded trade benefits all peoples in all nations, lifting lives and hopes all across the world.

Third, we must remember that America cannot lead in the world unless here at home we weave the threads of our coat of many colors into the fabric of one America. As we become ever more diverse, we must work harder to unite around our common values and our common humanity. We must work harder to overcome our differences, in our hearts and in our laws. We must treat all our people with fairness and dignity, regardless of their race, religion, gender or sexual orientation, and regardless of when they arrived in our country; always moving toward the more perfect union of our founders' dreams.

Hillary, Chelsea and I join all Americans in wishing our very best to the next President, George W. Bush, to his family and his administration, in meeting these challenges, and in leading freedom's march in this new century.

As for me, I'll leave the presidency more idealistic, more full of hope than the day I arrived, and more confident than ever that America's best days lie ahead.

My days in this office are nearly through, but my days of service, I hope, are not. In the years ahead, I will never hold a position higher or a covenant more sacred than that of President of the United States. But there is no title I will wear more proudly than that of citizen.

Thank you. God bless you, and God bless America.

This American Dream Initiative is a series of proposals to renew and strengthen the middle class, and to help pave the way for the poor to work their way out of poverty. It focuses on policies here at home. It reflects our belief that a strong, vibrant middle class is at the core of the American dream. Nothing speaks more to the promise of America than the idea that if you work hard, you and your children can succeed in our great country.

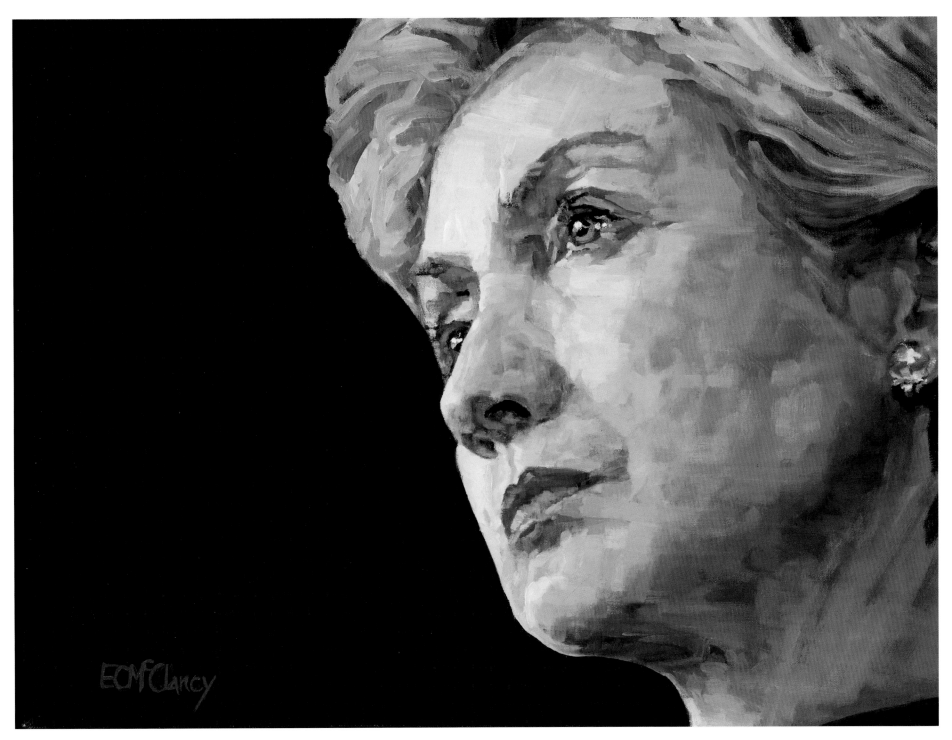

Senator Hillary Rodham Clinton, 2007, oil on canvas, 18" x 24"
Democratic Principles Series, No. 4

Well, I'm back, and I'm glad to be back, and to have this opportunity to make this report to you. You know, I knew that the—Tom Vilsack would do a great job chairing the DLC because he sure isn't shy about handing out assignments. I don't think that Evan Bayh had finished his farewell handshakes before Tom asked me to work with my friend and colleague, Tom Carper, to lead this American Dream Initiative, to collaborate with a broad cross-section of progressive think tanks and progressive thinkers, about how to renew the American dream.

We sought 21st-century solutions to 21st-century challenges. And I want to thank everyone who worked hard to make this American Dream Initiative a reality, certainly and foremost the Democratic Leadership Council, the Progressive Policy Institute, the Center for American Progress, the Hope Street Group, NDN, and Third Way.

This American Dream Initiative is a series of proposals to renew and strengthen the middle class, and to help pave the way for college tuitions under control, to address the rising costs of gas prices, to cut middle-class taxes and reward companies that create jobs here at home. The Democrats did it before and we can do it again.

We all know that the Republicans have made a mess out of the country's finances. With federal spending up, deficits up, debt rising out of control, and this year once again they cut taxes by $70 billion for the wealthiest Americans. But the average middle-class households got just $20. Now, that is not even enough for seven gallons of gas. Democrats know we must stop passing on debts to our children and start doing what is best for our country and our children, by getting deficits under control. The Democrats did it before and we can do it again.

You know, to paraphrase the historic 1992 campaign, it's the American dream, stupid. And if it is the American dream, then it is, as it should be, the American middle class. The simple fact is America's middle class is the core of America's greatness.

With all due respect, rich people did not make America great. Every society throughout history has had the rich and the poor. It was America's destiny to create something new, a middle class that provided upward mobility for the poor and opportunity for the many.

the poor to work their way out of poverty. It focuses on policies here at home. It reflects our belief that a strong, vibrant middle class is at the core of the American dream. Nothing speaks more to the promise of America than the idea that if you work hard, you and your children can succeed in our great country.

So this is a positive agenda for change. It is an agenda that we hope will unite Democrats and help elect Democrats across the country this November. As Americans, we know what is wrong with the other side. They are not taking care of America. They are bankrupting our country and failing to address the problems of Americans, from high gas prices to rising healthcare costs and college tuition bills. Once again, America needs to work for everyone, not just the privileged and the powerful. Democrats can be the change agents our country needs.

Incomes have been stagnant for five years. Everywhere I go across my state, I meet people who are under great financial pressure. But the Republicans say that the economy is great for everyone. They have done nothing about these costs that are eating away at the paychecks of hardworking Americans. Democrats will work to get healthcare costs down, to get college tuition bills.

With all due respect, rich people did not make America great. Every society throughout history has had the rich and the poor. It was America's destiny to create something new, a middle class that provided upward mobility for the poor and opportunity for the many. Our strength, our economy, our values derive from the promise of America, the promise of lifting yourself up through hard work in a society that rewarded results.

Now, almost a century ago, American industry began offering millions of workers the chance to earn their way into the middle class, just as Governor Granholm described. And what did American workers do? They responded with the most extraordinary work ethic. They lifted up the American economy. They won two world wars against fascism, the Cold War against communism, and oversaw the largest expansion of human freedom this world has ever seen.

Now, our middle class is not only the foundation of America's economic success, American consumers carry the global economy as well. American businesses drive innovation, and American workers set the bar for productivity. The American

middle class is America's competitive advantage—hard work, fair play, the basic bargain that you will have a chance to live out your dreams.

Now, when I was growing up, we used to call those middle-class values. So like many Americans, I can look back and know that those values were lived out in my family. My four grandparents didn't finish high school. My father's father started work in the Scranton Lace Company at the age of 11 before the turn of the last century. But he sent his three boys to college, my father on a football scholarship to Penn State.

My mother never had the chance to attend college. That motivated her throughout her life, and thankfully she is still with me at 87, to take courses at local colleges. She expected me to go to college and encouraged me to get the best education I could. And like tens of millions of post-war families, when my father finished his service in the Navy during World War II, he came home to start a business, a very small business, but his piece of the American dream.

He would put my mother, my brothers and me to work in that small business. It was a drapery fabric business, and he actually printed the drapery fabrics. And if you have ever been in a print plant, you may have images of large machines with bulks of fabric, but in our little print plant, there were long tables, where the fabric was laid out, and where you had squeegees that you put the paint in the screen and by hand pushed it across to make the imprint on the fabric, picked it up, moved it, put it down, and do it all over again.

He and my mother moved to the suburbs eventually so that their children could have the best schools and best recreational opportunities. And, you know, my father had a middle-class attitude summed up by this refrain, when you work, work hard; when you play, play hard, but don't confuse the two. He and my mother achieved a comfortable life. But they not only had high expectations for their family, they had high expectations for their community and their country.

My story of hard work that lifts self, family, and community is the American story. We ended the last century with America's economic might at its peak, with Americans at their most optimistic, and with opportunities for almost everyone who wanted to work hard to make the most of their God-given abilities. We got there in large part because of the Democratic Party's philosophy of governing. We asked individuals to take responsibilities for themselves, and also chip in and help in their communities. And in return, we expected, and we asked people to expect that their government would take responsibility for

spending those hard-earned tax dollars and ensuring the underpinnings of fairness and opportunity for all.

Now, I don't need to tell you that over the past five years, we have gone in a very different direction. A policy of fiscal discipline and budget surpluses was abandoned for one that racked up debt and proclaimed that deficits don't matter, and a policy that focused on helping the middle class get bigger and stronger was replaced by one that helped the strong get stronger and the rich get richer in the mistaken belief that the rest of the country would eventually get their share.

For the [first] time ever, we have had four straight years of rising productivity and falling incomes. Americans are earning less while the costs of a middle-class life have soared: college costs up 50 percent in five years; healthcare, 73 percent; gasoline, more than 100 percent; rising home costs have pushed people farther and farther from their work. A lot of Americans can't work any harder, borrow any more or save any less. And those same costs of healthcare, retirement, transportation, energy are impacting our businesses as well.

It's time for a new direction. For five years we have lived with deficits. This agenda will help bring back fiscal responsibility. For five years we have lived with stagnating wages. This plan will make the basics of life in the middle class, healthcare, education, and retirement affordable for those who take responsibility. For five years we have allowed the rest of the world to overtake our higher education system. This plan puts [us] on the road to universal college and lifelong training.

For five years, the doors of opportunity and ownership have been closing for too many Americans. This agenda will open those doors to everyone who is ready to work and walk through. For five years, we have seen poverty increase for millions of Americans. These ideas will make sure every American will get a fair wage, access to college and home ownership, and a path out of poverty and into the middle class.

We have seen what it is like to have a Republican leadership that puts middle-class Americans last, and ignores the real challenges we are facing: globalization, stagnation wages, higher energy costs. There is a better way. It is time for Democrats to show how an agenda for change can turn this country around and bring the American dream back within reach.

This American Dream Initiative points the way forward to an agenda that eases the fears of middle-class families and sustains the hopes of families struggling to make it into the middle

class. Now, this is a broad, inclusive agenda that is missing one key ingredient, a Democratic Congress to enact it.

And I believe we can do something about that, too. This new opportunity agenda can help Democrats as they campaign around the country. This can be the basis for a discussion about the challenges that middle-class Americans and our country face here at home. We can tell voters that we are for renewing and securing the American dream, of a college degree, a home, healthcare, a secure retirement, and the chance to get ahead in a growing economy where rising bottom lines mean rising incomes for all workers. We can replace trickle-down economics with rise-up economics, and we can make sure that everyone has a chance to rise up and fulfill their dreams for the future.

Now, in order to expand opportunity for all—we need a new ethic of responsibility from both the public and the private sectors. So we call for cutting the deficit through specific actions, making long-term investments to grow the economy, and reining in corporate abuses through shining a light on CEO pay and increasing accountability and oversight over pensions and mutual funds.

It's time for a new direction on the economy, a policy that focuses on Main Street as well as Wall Street. In fact, that is what I have tried to do in New York, try to bring people together from Main Street and literally Wall Street in a program called New Jobs for New York, where [we] have connected up New York City capital with upstate businesses and farms, and we have come together with our universities looking for new ways to incentivize economic growth and new job creation. I believe it's possible we have done that without much of a policy or plan from the federal government, and there is an eagerness out there to invest again in America, to do what we can to grow good jobs here.

And I am so sympathetic when I hear Governor Gramholm talk about the challenges Michigan faces because much of Upstate New York faces the same. Before I came out to speak, I met with the New Yorkers who are here, many of them elected officials, serving from Long Island to Buffalo, and they know very well that we have to pull together in our state that we provide the best climate for job creation and business growth while we take care of those who are vulnerable among us.

The starting point for the American dream is a growing economy that benefits workers as well as CEOs. America lives out its best values when wealth is growing for everyone. And a clear distinction between Democrats and Republicans in this election is our focus on the government's responsibility to help the private sector and the middle class grow, and to make sure that economic growth is broadly shared. When our companies are highly profitable, as many are right now, it is in everyone's interests that workers share in that success. So incomes rise and middle class grows, and the whole economy is lifted.

But that isn't happening and it's time to start asking why. The national government needs a strategy to create an economic climate in which the private sector can generate jobs, raise incomes and increase wealth. To unleash the power of innovation and enterprise, we need to restore fiscal responsibility, open new markets, enforce trade laws, and make smart economic investments such as in broadband, scientific research including stem cell research, alternative fuels and an advanced research project agency for energy that will spur the creation of new highways, and jobs, and exports from America to the rest of the world.

With a smart energy policy we can create millions of new good jobs, ease the burden on middle-class pocketbooks, and lead the way against climate change all at the same time, to say nothing of enhancing our security in an increasingly dangerous world.

To put the United States at the cutting edge of new energy-efficient technologies, we should create a strategic energy fund that will sponsor research into the potential of cellulosic ethanol and bio-diesel and other flexible fuels, support the development of plug-in hybrids, clean-burning diesel and other high-mileage vehicles, and launch an advanced research project agency like we did after Sputnik went up in the Defense Department. And the research there did lead to the Internet, the microprocessor, and so much else.

For five years the Bush administration has given special tax breaks to the privileged few and increased the middle class's share of the burden. We need a new economic formula of Democratic capitalism. The way to ensure prosperity is to build an expanding middle class, not a shrinking one, and to give the members of the middle class a stake in that prosperity. The American Dream Initiative proposes letting employees and investors draw their own conclusions about inflated CEO salaries by asking the Securities and Exchange Commission to require that corporations disclose full CEO compensation, and how that relates to profitability and average worker pay.

It is also long past time for a raise for hard-working Americans. In the last seven years, Congress has voted to raise its own

salary by over $30,000 while refusing to raise the minimum wage. Now, economic arguments and appeals to conscience haven't worked. So I introduced legislation to prohibit Congress from giving itself another raise until it raises the minimum wage.

Now, I would like to go even further: No pay raise for Congress or the executive branch until the incomes of average Americans start to rise again.

The most important asset most Americans will ever own is their home, but a home as we know is not just a financial asset; it's a symbol of security, of family and of community, of a stable middle-class life. The American Dream Initiative suggests several ways to expand the chance to own a home. One is to make the home mortgage deduction available for everyone, not just the half of American homeowners [who] itemize deductions on their taxes. Homeowners' subsidies aren't even reaching the people who need them the most, families with incomes below $50,000. I think that is

education beyond high school. Today a college graduate earns twice as much as a high school graduate. That is a million-dollar bonus over the working lifetimes of today's college seniors. We used to rank first in the world in our percentage of young people with a post-secondary degree; now we have fallen to seventh, not because our young people don't try but because too many don't finish. Think of that.

The most overwhelming obstacle to finishing college is the expense. College costs have increased faster than inflation for 25 years in a row. The result is that college graduation rates have stayed flat for years. About 70 percent of Americans own their own home. About 85 percent have healthcare. About 42 percent own retirement accounts, but only 30 percent have a college degree. Just because many of us from this room think everybody we know has a college degree, that is not the case. The percentage is higher for Americans under 35, but it is still less than half.

And the Washington Republicans are making it even harder,

We need a new ethic of responsibility from our leaders. Our families can't get away with runaway spending, creative accounting, and wasteful subsidies to their friends. Americans have the right to expect responsibility, discipline, and honesty from their leaders....

backwards, and we ought to fix it by giving an additional 10 million Americans a tax incentive to invest in their own home.

We need to give every child a shot at getting into the middle class and building his or her own stake in America. Today the chance to get ahead depends more and more on the family to which you are born. That wasn't the way in America in the past. It really depends upon whether your family has the assets to take advantage of opportunities. That is why the American Dream Initiative proposes that our country follow Britain's lead by providing a baby bond to each of the 4 million children born in America every year, a $500 savings bond at birth and again at age 10. It signals louder than words and rhetoric that America is investing in its children, and it provides an incentive to encourage parents, even low-income parents, to invest more in their own child's future.

But eventually that child is going to have to decide whether he or she can afford to go to college. It is past time to make college affordable for every American.

If homeownership is the most visible symbol of the American dream, the most important doorway into the middle class is

cutting student assistance, raising interest rates on student loans. Now, America's success in the global economy depends on the skills and education of our people, so we need a bold strategy to provide 1 million more college and community college graduates a year by 2015.

Within a decade, more than half of our young people could finish college with a degree, and any student willing to work part time or perform community service to go to a four-year public college practically free, because we propose a new performance-based American dream grant that will award states money each year based on the number of students that attend and graduate from their [colleges] and universities. And we propose combining all of the confusing existing tax breaks for college into a single refundable $3,000 tuition and training tax credit.

With these additional new funds, colleges should be held more accountable for their students' success. We should start by asking colleges to publish complete data on their graduation rates, and to practice truth in tuition that will set multiyear tuition and fee levels so incoming freshmen will know how much four years of college will cost them.

We need a new direction also toward a secure retirement for every American who is willing to save. No one's dream ought to end in a nightmare in your older years. Just 50 years ago, more than half of senior citizens lived below the poverty line, but Social Security, pension plans, and rising incomes combine to change that. And all of us who have watched our parents get older and worried about them getting the care they need are profoundly grateful.

But as incomes have stagnated, families are having to put off saving for retirement so they can pay the bills today. Only one half of American workers are offered a savings plan, and a

about Canada, and countries that offer no insurance. That is a terrible place for American business to find itself.

And our citizens are seeing healthcare expenses eat up their disposable income, or they are simply doing without. We need action from Washington to stop the spiral of healthcare costs and offer every family the chance to give their children a healthy start on their dreams. It is time to pass a small employers health benefit plan, like the federal employers health benefit plan, that would put small businesses across America into one purchasing pool, giving their employees access to the same quality of affordable care that members of Congress enjoy.

Lincoln understood that who we are in the world begins with how we live at home. And during the darkest days of that war he said, "My dream is of a place and a time where America will once again be seen as the last best hope of earth."

quarter of them turn it down because they don't think they can afford it. Fewer and fewer employers offer traditional pension plans, and more and more are trying to get out of their obligation to fully fund the ones that are left. Our tax code is upside down, giving the most benefit to wealthy families who don't need an incentive to save and too little benefit to families where the money will make a new difference.

We need a new bargain that provides retirement security in this mobile workplace. The Republicans have a plan; yes, they still have a plan to privatize Social Security if they get the chance again. The Democrats will protect Social Security and people's retirement.

That is why the American Dream Initiative proposes American Dream accounts, which require every employer to open retirement accounts for its workers, and make those pensions portable when workers change jobs. Tax credits would minimize the cost and administrative burden to employers. And a permanent refundable savers' credit could give middle class and working families a 50-percent matching contribution for their retirement savings.

And of course we need a new direction in healthcare. Coming from me, that is no surprise. I still believe in universal coverage. And we know that no single factor does more to ruin the dreams of Americans and hold back the growth of our economy than the soaring costs of healthcare. Our businesses must compete against countries that offer national health insurance, such as the example Governor Granholm gave

And the Institute of Medicine reports that patients can expect one prescription error for every day they stay in the hospital. That is bad for patients and that is bad for our costs. It's time to use 21st-century information technology to cut down on those life-threatening errors while we save money. And it's time to extend health insurance to every child, give Americans the tools they need to make healthy choices, and make a national commitment to finding cures for diseases that are sapping individuals and our economy.

We need a new ethic of responsibility from our leaders. Our families can't get away with runaway spending, creative accounting, and wasteful subsidies to their friends. Americans have the right to expect responsibility, discipline, and honesty from their leaders, and we have some suggestions for how to do that. Restore the pay-as-you-go rule so Congress can't enact new spending programs or tax cuts without showing how they will pay for them.

Eliminate $200 billion of unnecessary and wasteful corporate subsidies over 10 years and cut 100,000 unnecessary federal consultants. These actions will help pay the costs of the proposals we are making. And we need a Congress that will use its investigative powers to look at the no-bid contracts for Halliburton, how $9 billion in U.S. Government cash went missing in Iraq, what role our oil companies are playing in Iraq, and why are troops struggled to get bandages and body armor.

The American Dream Initiative agenda focuses on policies here at home, but we will not let the president and the Republicans

off the hook for the mistakes they have made and the disastrous policies they have followed abroad. We will hold them accountable every bit as much for national security and homeland security as for their failure to provide Americans with economic security.

So this agenda is all about restoring the American dream, but there is nothing dreamlike about it. Every single item is something a Democratic Congress could begin putting in place in January 2007. This is a Democratic agenda for the 21st century. But as we were working on it, I found myself thinking often of a 19th century president, Abraham Lincoln, who I secretly believe would be a Democrat were he here right now. President Lincoln led America into the industrial age, and gave birth to the possibility of a new American dream for millions of our citizens. His administration gave the land grants that set up our system of public higher education, still the world's finest. It also supported an audacious plan to build a railroad all the way across our great continental nation, a huge step for economic growth. And all of this while the country was embroiled [in a] painful civil war.

Lincoln understood that who we are in the world begins with how we live at home. And during the darkest days of that war he said, "My dream is of a place and a time where America will once again be seen as the last best hope of earth." That is still a dream we all share. It is a dream that begins with making America work for its people, and making its people proud to work for America.

Democrats stand ready to lead again. We believe in evidence-based decision making, not ideology; performance-based governing, not photo-ops; hope and fairness, not fear and favoritism. We have the ideas and we have the will. That is what this new opportunity agenda stands for.

Now, all we have to do is win elections, starting in November by uniting the Democratic Party in the name of victory on behalf of our country, and by convincing a majority of Americans we are on their side, that we get it; we too want a new direction at home and abroad, and that if Americans give us their trust and their votes, we will work our hearts out to reclaim the future and renew the American dream for generations to come.

The truth is nobody succeeds in America alone. They succeed thanks to America—thanks to what was written. They succeed because America protects private property. They succeed because America has public schools and universities that give everyone the tools to get ahead. And yes, they succeed because of three very important virtues: hard work, self-discipline, and responsibility. But nobody goes it alone, and everybody has a responsibility to help everyone else get ahead.

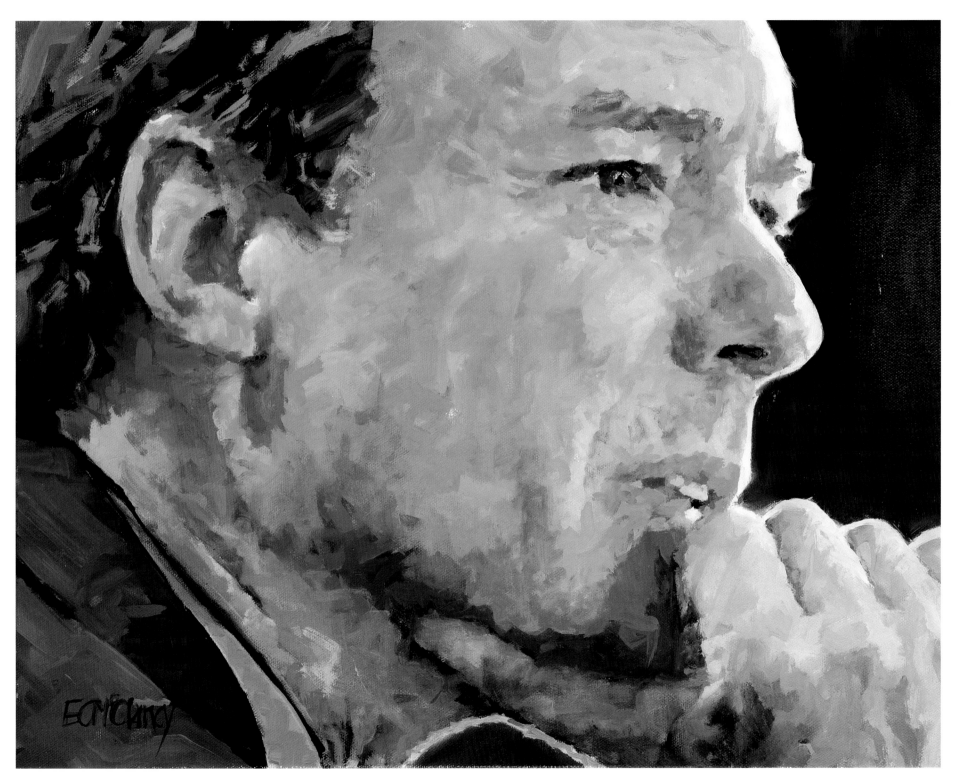

Senator John Edwards, 2007, oil on canvas, 14" x 18"
Democratic Principles Series, No. 16

You know, most people who graduate from law school are worried about different things. You might be nervous about starting that new job. Perhaps you're overwhelmed with the loan you must repay. You know what I thought about as the graduation speaker went on and the names were called? Getting married. The first thing I did after law school was walk down the aisle and marry Elizabeth.

Today, I am blessed to have my best friend and the love of my life by my side. And it matters who's with you on this journey. It does. So many times life is going to be hard. It's going to seem that heartache and struggle just won't go away. So it matters whose hand you reach out to, whose advice you rely on, and whose kindness you depend on, to get through the day. And all of that—it matters even more for the joy that will grace your lives.

So what we are reminded of today is that no one succeeds alone in this world. Think about how you got here. Did your mom work an extra job to help pay for it? Did your high

America is a place that believes in ascension. That one person can rise from very little to transform this world. It comes from that eternal belief that we all have the same worth—that a doctor and a bus driver both matter the same in America. They just have different jobs, but their hard work and dignity can lift up this world.

This is what we believe. But the best evidence of America not living up to its ideals is the more than 36 million Americans who live in poverty every day. There are children who have no real hope simply because of where they're growing up. There are people who are working two jobs and they still can't make rent. And too many families will spend the night in shelters across this country.

It doesn't have to be this way, and that's why I am here today.

I am here to ask you to join me in working to eradicate poverty in America. It is time for you—our young people—to lead us in a cause that's bigger than ourselves. If we are all truly equal

No matter how hard, how difficult, or how insurmountable the challenge may seem, we must end poverty in America. It is a challenge we must face because the content of our nation's character is at stake. The poverty of one American limits the prosperity of all Americans.

school teacher yell that you'd fail in life, so you worked even harder? And who held your hand to get through contract law—someone has to, right? You're graduating because of your hard work, but you succeeded because of the care and support of others.

And you succeeded because of what was written—that all people are created equal, and that we are endowed with certain unalienable rights: life, liberty and the pursuit of happiness.

This is what we started more than two centuries ago—a great experiment in the history of mankind. Ordinary citizens gathered in their churches, in their stores, in their homes to pursue a greater good, both civic in its promise and human in its hope.

It gave the farmer the same rights as the president. It gave the blacksmith the same chance as the ship merchant. And it gave the men and women who said that we had not honored our ideals the right to speak out in the great cause of change.

in the eyes of the Lord and the Law; if we are all given an equal chance to rise to our full potential; if we believe that there is dignity in hard work, then poverty has no place in America.

Think about what was written.

Is it a "life" to work two jobs and still know that every night you have to send your child to bed hungry?

Is it "liberty" to be unable to visit your sick child in the hospital because you can't leave work?

Is it "the pursuit of happiness" to stand on the street and open your palm and ask for change?

No matter how hard, how difficult, or how insurmountable the challenge may seem, we must end poverty in America. It is a challenge we must face because the content of our nation's character is at stake. The poverty of one American limits the prosperity of all Americans.

In Little Washington, North Carolina, I met a woman who had been living in a shelter. She told me how she wanted to work. If she walked into this graduation, you wouldn't think anything of it. But when she walked into the local laundromat to get warm, she said she was told to "Get out of here. Anybody living in the shelter's got to be trash."

The truth is, "there but for the grace of God."

Some leaders today want us to believe that each of us is out there on our own. If you make it, that's your success. If you don't, that's your failure.

But we know that's not true. The truth is nobody succeeds in America alone. They succeed thanks to America—thanks to what was written. They succeed because America protects private property. They succeed because America has public schools and universities that give everyone the tools to get ahead. And yes, they succeed because of three very important virtues: hard work, self-discipline, and responsibility. But nobody goes it alone, and everybody has a responsibility to help everyone else get ahead.

I know this from my own life. My father had to borrow $50 to get me out of the hospital after I was born. He took me home to a mill village. He worked hard, my mother worked hard, and I worked hard. Eventually I was the first in my family to go to college. I continued to work and save and I was able to achieve success I never thought possible.

But for other young people who grew up with me, I saw things turn out differently. They worked just as hard and they just had things break the other way. A layoff meant they had to sell the house. An illness wiped out their savings, and they had to close the business. And one tragedy after another meant they could never build something better for their kids.

The American people believe in the dignity that comes from hard work. And they understand that some people do everything right and the decks are still stacked against them. They believe that this is wrong and they want to make it right.

But you know why you have to end poverty in America? Because it's wrong.

In a nation of our wealth and our prosperity, to have millions of Americans working full time and living in poverty, is wrong. They are doing everything right, and they're still struggling.

This is what we must change and this is what I am asking you to do today.

People make choices in their lives about what they want to do and how they want to spend their time. Most people don't spend a lot of time thinking about those who are struggling unless they have to—unless they are. I am asking you to think about your neighbor in need. Don't turn your back on them. Open your door and let them in. Because your service can mean the difference between a life of promise or a life of poverty.

I am asking you to do four things to help eradicate poverty in America.

- First, let's shine a bright light on this problem. Let's talk about it again. Good people from all different backgrounds and beliefs care about this issue. And we need to put poverty back on the national agenda.

- Second, let's make work pay again. What we know and understand in our soul is that hard work built America. Men and women who worked with their hands and their heads—who still do—don't want a free ride; they want a fair chance. That's why you have to fight to raise the minimum wage in this country.

- Third, let's strengthen the foundation for families that work. That means health care for everyone and child care for parents who need it.

- And finally, let's make sure that families aren't just getting by, but getting ahead. Today, more than 25 percent of America's working families are living on the edge of poverty. They can't survive more than three months if something happens to their income. Let's help them save, get an education, and buy a house.

So there are very real and fundamental ways in which we can prevent families from falling into poverty.

Now when the skeptics say that we can't end poverty in America, you tell them that we've made a difference before. Social Security lifted millions of seniors out of poverty. Medicare and Medicaid provide our seniors and most vulnerable with the health care they need. And Head Start alone has enrolled more than 20 million children.

...Equal opportunity and the chance to begin life in America on equal ground are at the heart of Head Start. And personal responsibility helped jumpstart lasting reform of welfare.

The road has been bumpy, and we've made mistakes. Sometimes we failed to honor our values like work and responsibility. Sometimes we gave money to bureaucracies, not people. Sometimes our good intentions led us astray. But we know we can change lives and the course of the country when we do something about poverty.

So don't look away from the poverty that exists around us. Look at it with open eyes, knowing that you can end it.

The truth is that so many times in our country's history it's been you—our young people—who have made lasting change. I saw young people lead the fight for civil rights and who spoke out against the war in Vietnam. It was the idealism, the passion, and the belief that they were part of something bigger than themselves that transformed a generation and this country.

It's you who can ensure that "life" means working hard and never having to send your child to bed hungry. That "liberty" means being able to visit your child in the hospital without losing your job. And that "the pursuit of happiness" is never again diminished to begging for change.

And today, I'm asking you to do the same. No matter where you live or what path you choose in life, you can do something to end poverty in America. It's you who can ensure that "life" means working hard and never having to send your child to bed hungry. That "liberty" means being able to visit your child in the hospital without losing your job. And that "the pursuit of happiness" is never again diminished to begging for change.

This is what is possible. This is what you can do. For the will of one can change the world, and the might of millions can lift up mankind.

Each person must lend their voice to this great call for change. Soon after, these voices will form a symphony which stirs the souls of millions to silence this injustice. And they will silence it with their service, with their grace, and it will be done.

Senator Dianne Feinstein
Statement in Support of
Embryonic Stem Cell Research
Floor of the United States Senate
April 10, 2007

Just as important are the millions of Americans who may not have a famous face, but put everything they have in us in the hope that we will do the right thing. The right thing is pretty simple. It is to give them a chance to live—to live. That is what we are talking about. I don't think there is any other piece of legislation that more involves the right to life than this piece of legislation.

Senator Dianne Feinstein, 2007, oil on canvas, 18" x 14"
Democratic Principles Series, No. 8

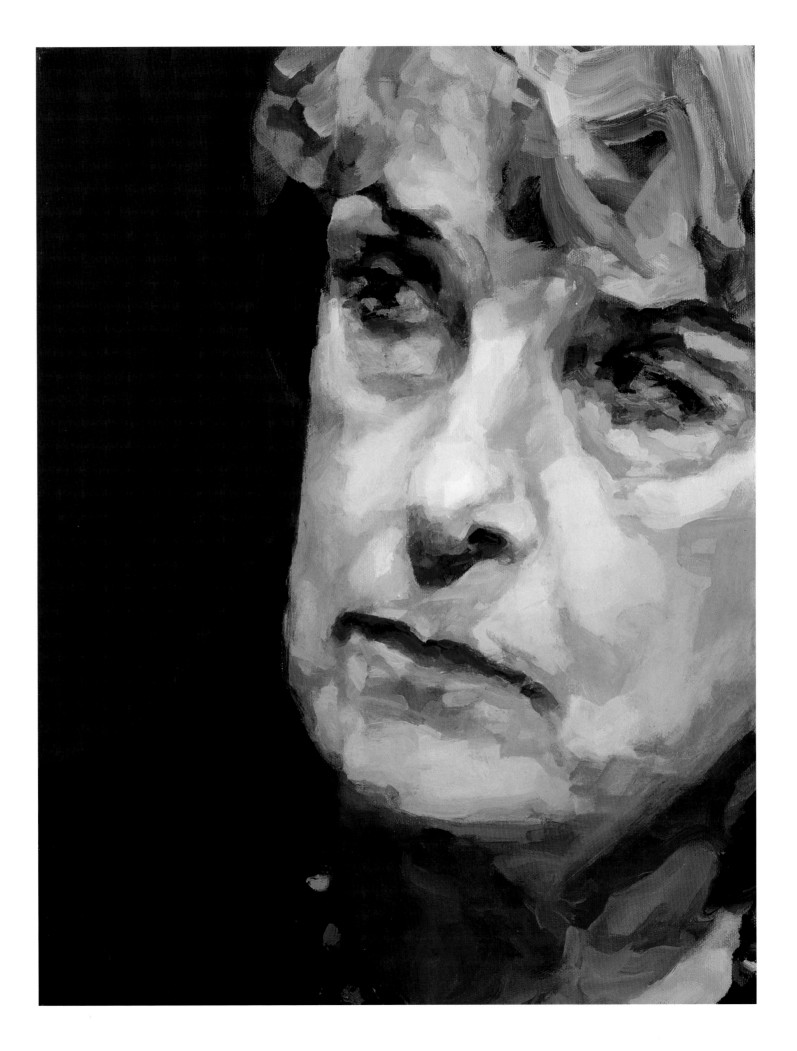

Mr. President, I rise in support of the Stem Cell Research Enhancement Act of 2007 that is known as S. 5. It is really the only bill of the two that will allow scientists to fully pursue the promise of stem cell research.

I want to particularly thank Senators Harkin [D] and Specter [R], Kennedy [D], and Hatch [R], who have been in the leadership of this issue for the past several Congresses. I also want to point out, in the case of the distinguished [Republican] Senator from Utah, he is very pro-life. I have listened to him over these many years. I have listened to the real wisdom he has espoused on this issue. I hope more people will pay attention to him because I think he is right with respect to this issue.

On August 9, 2001—that is six years ago—President Bush limited federal research funding to 78 stem cell lines already in existence. Nearly six years have passed, and in that time two things have happened.

First, most of these 78 stem cell lines are no longer available for scientific work. Many lines developed abnormalities and mutations as they aged. Only 21 lines are available today, and these [21] lines are all contaminated with mouse feeder cells and therefore are useless for research in humans. They do not have the diverse genetic makeup that is necessary to find cures that benefit all Americans, and researchers cannot use them to examine rare and deadly genetic diseases. It is now clearly established: that policy does not work, that policy is moribund…federal research on stem cells cannot go forward.

Secondly, public support for stem cell research—full-blown stem cell research—has grown. Sixty-one percent of Americans responding to a poll in January of this year support embryonic stem cell research.

This is also a bipartisan issue. Fifty-four percent of Republicans in an ABC News poll also support embryonic stem cell research. The majority of the American public support this bill.…The current policy is handcuffing our scientists and is not allowing this research to move forward.

The solution is obvious: we should pass this bill. I think the time has come for the President to come to this realization, and it is my hope he will see he has been mistaken.

The bill we are debating today offers a compromise. This bill will not destroy any embryo that would not otherwise be destroyed or discarded. It will allow promising research to move forward. It would end the [legislative] impasse. It would take off the handcuffs.

My colleagues and I made a commitment that we would raise this issue again and again—as long as it takes. Today we are fulfilling that promise. We know this bill will one day become law—if not this year, then next year; if not next year, then the following year.

The majority of the American people, the majority of the scientific community, other nations, many of our states have embraced the promise of stem cell research. With every passing week, the inevitability of this legislation grows clearer. Officials from this administration have acknowledged the shortcomings of the current policy. More research has demonstrated the unique promise of pluripotent, multipurpose stem cells. States and private institutions are forging ahead without federal support.

Finally, and importantly, more Americans are waiting for cures and treatments for catastrophic diseases. This is a very large lobby indeed. So today we have another opportunity to move hope forward.

The two bills before us today present a very stark choice. Only one bill, S. 5, the Stem Cell Research Enhancement Act, embraces all forms of stem cell research. This legislation provides a simple and straightforward way to provide American scientists and researchers with immediate access to the most promising stem cell lines. It states that embryos to be discarded from in vitro fertilization clinics may be used in federally funded stem cell research, no matter when they were created.

While opponents have suggested this bill will lead us down a slippery slope, the parameters created by the bill are numerous and, in fact, strict. Let me give you some examples.

- The embryos must be left over following fertility treatment.
- The people donating the embryos must provide written consent.
- The donors may not be compensated for their donation.
- Finally, it must be clear that the embryos would otherwise be discarded.

This legislation will not allow federal funding to be used to destroy embryos. With restrictions in place, over 400,000 embryos could become available, while ensuring that researchers meet the highest of ethical standards.

Let's be clear. We are talking about embryos that will be destroyed whether or not this bill becomes law. It is an indisputable fact, and everyone would agree these embryos have no future.

In terms of the basic ideology of the President's earlier policy, …the life-or-death decision has already been made with respect to these particular embryos. These will never be implanted. They will never be adopted. They will never be used.

This bill has not been held up because it is flawed. There is nothing wrong with this bill. The bill has been held up because of ideology, not policy.

There is a clear scientific consensus on this issue. Embryonic stem cell research has been endorsed by 525 organizations and 80 Nobel Prize laureates. These groups and these experts represent the entire panoply of American health care, the young and the old: the American Association of Retired Persons, which we know as AARP, the Society of Pediatric Research, and the American Geriatrics Society. They represent a wide range of medical experts—the American Medical Association and the American Academy of Nursing support this bill.

They are from varying regions in the country: the University of California system, the University of Kansas, the University of Arizona, the University of Chicago, and the Wisconsin Alumni Research Foundation.

The Senate and the President should listen to the scientists who best understand this issue, and give them access to the stem cell lines that successful research demands. Jennifer McCormick of Stanford University's Center for Biomedical Ethics has said: "The United States is falling behind in the international race to make fundamental discoveries in related fields." It is time to address and reverse that sentiment.

In a letter to President Bush, Nobel laureates called the discoveries made thus far by stem cell researchers "a significant milestone in medical research." They go on to say that "Federal support for the enormous creativity of the United States biomedical community is essential to translate this discovery into novel therapies for a range of serious and currently intractable diseases."

They are not alone. Paul Berg of Stanford, George Daley of Harvard, and Laurence S. B. Goldstein of the University of California at San Diego recognize the promise and the need for embryonic stem cell research. These esteemed researchers have said: "We want to be very clear. The most successful demonstrated method for creating the most versatile type of stem cells capable of becoming many types of mature human cells is to derive them from human embryos."

Federal support for the enormous creativity of the United States biomedical community is essential to translate this discovery into novel therapies for a range of serious and currently intractable diseases.

They represent patients struggling with a wide variety of afflictions: the Christopher Reeve Foundation, the Lung Cancer Alliance, the Arthritis Association, the ALS Association, and the Juvenile Diabetes Research Foundation.

They represent a variety of religious faiths, including the Episcopal Church and the National Council of Jewish Women.

These groups represent a variety of patients, medical disciplines, and religious faiths. They are from all over this country, and they all support expanding stem cell research. This consensus now even includes Bush administration officials.

Last month, NIH Director Dr. Elias Zerhouni testified: "From my standpoint as NIH director, it is in the best interest of our scientists, our science, and our country that we find ways and the nation finds a way to go full-speed across adult and embryonic stem cells equally." That is a pretty unambiguous statement from the man who heads the Institutes of Health.

This is the science.

You can quote a scientist here or a scientist there who will differ with that, but the bulk of people in this field worldwide believe as this statement reflects. As Lucian V. Del Priore of Columbia University said: "[This] is important and exciting work." It is time we use the wisdom of these respected scientists and embrace the promise of biomedical research using embryonic stem cells.

Scientists have learned more about stem cells—how they work, how they may one day be used for cures—since we last considered this issue, I guess some 10 months ago. This past August, scientists from the University of Edinburgh used embryonic stem cells from an African claw frog to identify a protein that is critical to the development of liver cells and insulin-producing beta cells. This could lead to a better understanding of diabetes and liver disease as well as new treatments.

Then during the next month or two, in October, scientists at Novocell, a San Diego biotech company, announced the development of a process to turn human embryonic stem cells into pancreatic cells that produce insulin. This could be another significant step toward using stem cells to treat diabetes.

In September last, researchers used human embryonic stem cells to slow vision loss in rats suffering from a genetic eye disease that is similar to macular degeneration in humans. Macular degeneration is the leading cause of blindness in people aged 55 and over in the world. It affects more than 15 million Americans. This research means stem cells could one day be used to restore vision in many of these patients. Just

reproductive cloning, something we can all agree is immoral and unethical.

Over $158 million in research grants has now been approved, making California the largest source of funding for embryonic stem cell research in America. Promising projects include creating liver cells for transplantation at the University of California at Davis; developing cellular models for Parkinson's disease and Lou Gehrig's disease (ALS) at the Salk Institute. This will give a better understanding of how these diseases work and yield possible treatments, as will work at Stanford to more effectively isolate heart and blood cells from embryonic stem cells.

We want to be very clear. The most successful demonstrated method for creating the most versatile type of stem cells capable of becoming many types of mature human cells is to derive them from human embryos.

think of that: 15 million people who are surely going to go blind, and that blindness might be stopped.

In March, a team at the Burnham Institute in La Jolla, CA, used embryonic stem cells in mice to a treat rare degenerative disorder called Sandhoff's disease. This condition, which is similar to Tay-Sachs disease, destroys brain cells. The mice treated with stem cells enjoyed a 70-percent longer lifespan, and the onset of their symptoms was delayed. The stem cells migrated throughout the brains of the mice and they replaced damaged nerve cells. No one ever thought that could be done before. This suggests that embryonic stem cells may effectively treat this disease as well as other genetic neurological conditions, including Tay-Sachs.

So, all of this work is just beginning. Scientists will now work to translate these promising advances into cures for humans, and such a feat will almost certainly require access to viable lines of human stem cells. Without access to additional stem cell lines, the cures and treatments will never move from mice to humans. Many states, frustrated with federal gridlock and the loss of their best scientific minds, are moving forward. I am particularly proud of my state of California. In 2004, California voters, by a whopping margin, approved Proposition 71 and created the California Institute of Regenerative Medicine. That institute is spending $3 billion over 10 years supporting promising research conducted in California. This work will be done with careful ethical oversight. It also bans human

One might say: All right, why not let the private sector and the states address this problem? Why do we need federal research? I want to concentrate a few moments on that. The actions of California and the actions of other private and public institutions do not substitute for federal funding and a standardized national policy.

Much of this debate focuses on stem cell lines themselves, but scientists need much more to succeed. They need expensive equipment and lab space in which to work and collaborate, and there is the rub. For scientists working on embryonic stem cells, this means taking great care not to intermingle their work on approved stem cell lines with those that are not approved.

If federal funds, for example, built a lab or bought a freezer, a Petri dish, or a test tube, these resources cannot be used on research involving lines not included in the President's policy. As I said, there are no lines left in the President's policy. Therefore, they can't be used. This has created a logistical nightmare.

The duplication and careful recordkeeping required are enormous disadvantages faced by the U.S. stem cell scientists. Many have gone to extreme lengths to ensure they follow these regulations. The stakes are high: Any mistake could result in the loss of federal grants for a researcher's lab. Let me give a few examples.

University of Minnesota researcher Meri Firpo buys one brand of pens for her lab that receives Government money and another brand of pens for use in her privately funded lab. This helps her ensure that a ballpoint pen purchased with federal grant money is not used to record results in her lab that works with stem cell lines not covered by the President's policy.

UCLA is using a complex accounting system to allocate Federal and private dollars in careful proportion to the amount of time a researcher spends working on either approved or unapproved stem cell lines.

A stem cell researcher, Jeanne Loring at the Burnham Institute in La Jolla, CA, designed labels for all her equipment: Stem cells in a green circle denote equipment that can be used with all stem cell lines, while equipment bought with federal funds is marked with a red circle with a slash through it.

At the University of California in San Francisco, biologist Susan Fisher worked for 2 years to cultivate stem cell lines in a privately funded makeshift lab. Unfortunately, the power—the electricity—in her lab failed. She couldn't move her lines into the industrial-strength freezers in the other lab because they were federally funded. The stem cell lines on which she had worked for two years melted and were gone. So two years of work was out the window because of this ridiculous situation.

Money that could otherwise be devoted to research is instead used to build labs and purchase duplicate equipment, and the cost is significant. Scientists at the Whitehead Institute for Biomedical Research in Cambridge, MA, didn't want to fall behind international stem cell leaders, so they established a second lab. They had to buy a $52,000 microscope, two incubators that cost $7,500, and a $6,500 centrifuge. They already owned this equipment. They had the equipment, but they couldn't use it because that equipment was purchased with federal dollars.

To me, this makes no sense. [We cannot] afford this kind of wasteful duplication with what are very precious research dollars. Our scientists should be focused on investigating disease, not worrying about who pays for their pens or their test tubes.

So bottom line: We need a reasonable federal policy that includes funding for viable stem cell lines. I don't need to tell my colleagues about the famous faces and the average people who are behind this legislation. It is nearly 70 percent of the population.

I don't have to tell my colleagues about Michael J. Fox, who showed the nation the true face of Parkinson's disease. I don't have to tell my colleagues about First Lady Nancy Reagan, who has spoken out in support of this and other legislation, or Christopher Reeve, who lived his life refusing to accept that his spinal cord injury would never be healed, or Dana Reeve, who stood by her husband and then tragically lost her own battle with cancer.

Just as important are the millions of Americans who may not have a famous face, but put everything they have in us in the hope that we will do the right thing. The right thing is pretty simple. It is to give them a chance to live—to live. That is what we are talking about. I don't think there is any other piece of legislation that more involves the right to life than this piece of legislation.

These are people who are going to die. They live with catastrophic, often terminal diseases; they suffer immeasurably. Suddenly, there might well one day be a cure, or their disease might be put in remission. The kind of research might be done that can mend a broken spinal cord.

How can we look at the facts and *not* support this?

Life or death is not [at issue] for the embryos that would be used here. This legislation [gives researchers precious access to] embryos that have no chance at life. All we ask is that they be put to work—to protect human life. It seems to me that is not too much [to ask].

I hope this bill not only will pass here by a substantial margin but that some way, somehow, the 67 votes we need in this body to overturn a Presidential veto will be present. I think the American people demand no less.

We can do much better as a country. We should not focus just on how to grow our economy, but we should focus on how we can grow the quality of our lives, and how we can grow the quality of our life as a nation. We must foster a new atmosphere where values become sensitive to public policy. And we must build a nation, a community where no person, no neighborhood, and no community feels left behind.

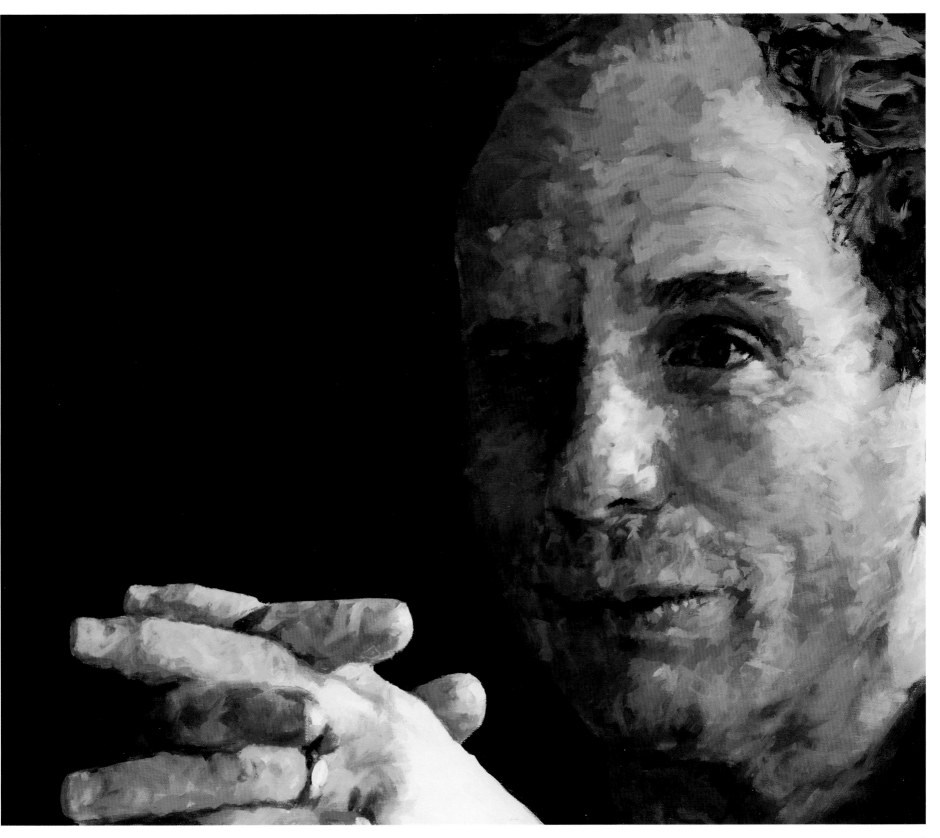

Senator Paul Wellstone, 2007, oil on canvas, 20" x 24"
Democratic Principles Series, No. 14

I've been thinking about the kind of advice, since you've given me this chance, that I'd like to give to you. I think that the best thing that I ever said to students at Carleton —and I taught over twenty years—was this: you will be more credible to yourselves and therefore more credible to others if you do not separate the lives that you live from the words that you speak. I do not come here today to tell you what to think, you'd probably run me out of here if I tried to. But I do believe that it is really important to think about not just how to make a living, but, as Ella Baker, who was a great civil rights activist, used to say, about how to make a life.

And I would say to you that if you can take some time away from loved ones and away from family—and I would never

our marriages, the intelligence of our public debate, or the intelligence or integrity of our public officials. It measures neither wit nor courage. Neither our vision, our wisdom, nor our learning. Neither our compassion nor devotion to our country. It measures everything, in short, except that which makes life worthwhile. And it can tell us everything about America except why we are proud that we are Americans.

We can do much better as a country. We should not focus just on how to grow our economy, but we should focus on how we can grow the quality of our lives, and how we can grow the quality of our life as a nation. We must foster a new

You will be more credible to yourselves and therefore more credible to others if you do not separate the lives that you live from the words that you speak.

want you to make your loved ones casualties of your community activism—but if you can take some time away from loved ones, some time away from family, and give it to the community, give it to our country, give it to our world, I think you will make a huge difference, an enormous difference, and I hope you will do that.

…If you were to think for a moment about how you got to this [day], I don't think that the word would be independence; I think the key word would be interdependence. Think of parents, think of family, think of relationships with other students, think of friendships, think of the bond that so many of you have with one another. And so I raise this question, why not in our country? Why not the same focus on the ways that we are interdependent? Why not the same focus on relationships? On how to treat one another. Why not define a community where we all do better—when we all do better? I think that that's the direction our country needs to go.

I bring a reading here today. It was taken from a book that was just published. The title, *Make Gentle the Life of this World: The Vision of Robert F. Kennedy*. It was sent to me by one of his sons, Max Kennedy, who now lives in Boston. I quote from Robert Kennedy. This was a speech that Bobby Kennedy gave March 18, 1968, to students at Kansas University. And I quote,

> The gross national product does not allow for the health of our children; the quality of their education; or the joy of their play. It does not include the beauty of our poetry or the strength of

atmosphere where values become sensitive to public policy. And we must build a nation, a community where no person, no neighborhood, and no community feels left behind.

How can it be that in the United States of America, today, at the peak of our economic performance, we are still being told that we cannot provide a good education for every child? We are still being told that we cannot provide good health care for every citizen. We are still being told that people can't look forward to jobs that they can support themselves and their children on. We're still being told that we cannot achieve the goal of having every five-year-old come to kindergarten ready to learn, knowing the alphabet, knowing how to spell her name, knowing colors, shapes, and sizes, having been read to widely with that wonderful readiness to learn. How can it be that we are being told that we cannot do this at the peak of our economic performance? I say to you today that it is not right. It is not acceptable. We can do much better, and if not now, when? If we don't do this now, when will we do it as a nation?

On Friday, on my way back from Minnesota, I went down to the Mississippi Delta. I had been there a year earlier, and I had promised to come back. I was at a community gathering with an African-American teacher, Robert Hall, who probably makes $22,000 to $23,000 a year. Incredibly dedicated teacher. …I was a teacher, and so I came to speak at the high school. I got off the plane, and I was met at the airport, and as we were driving to Tunica, Mississippi, a man said to me, "First we're going to go to the elementary school, and you will address the third and fourth graders on the last day of class." I said,

"Address? On the last day of school?" But I said okay, and we went there. I'll address them, I'm a teacher.

I said to them, do you like school? Do you like education? What's important about it? And one young girl said, "It's important because I can be what I want to be." And I said, well, what do you want to be? And there were 40 hands up, and the rest of the hour was students talking about what they want to be. One of them wanted to be a psychiatrist. I thought that was interesting. Or a doctor. Or a professional wrestler. Or a professional basketball player. Or a teacher. Or an artist. Or a business person, on and on and on. Those children had hope.

If you take that spark of learning that those children have, and you ignite it, you can take a child from any background to a lifetime of creativity and accomplishment. But if you pour cold water on that spark of learning, it is the cruelest and most short-sighted thing we can do as a nation. We pour cold water on that spark of learning for too many children. Another question I pose, and I'm going to keep asking this question and asking this question, keep pressing this with this question. How can it be in a country I love so much, and a country that's doing so well economically, a country at the peak of its economic performance, that one out of every four children under the age of three is growing up poor in America? One out of every two children of color under the age of three is growing up poor in America. We have a set of social arrangements in our country that allow children to be the most poverty-stricken group.

I wanted to start our trip in a neighborhood in the Mississippi Delta. And then we went to East L.A., and then we went to Chicago in the Pilsen neighborhood, a Latino community, and then public housing projects—the Robert Taylor Homes and Ida Wells. And then we went to inner-city Baltimore, and then we went to Appalachia. I can tell you that we met a lot of heroines and heroes who give lie to the argument that nothing can be done. If I had the hours, I would celebrate their worth. We can do so much at the community level if people have the resources. Everywhere we went, what people were saying was, "What happened to our national vow, our vow as a nation, that there should be equal opportunity for every child? Not in our community. And where are the jobs or the business opportunities so that we can do well economically and we can give our children the care we know they need and deserve?"

And then we traveled to other parts of our country, and when we did, it was the same:

Senator, my daughter is twenty-four. She graduated from college. She's a diabetic. She now will be off our health insurance plan. I know that the insurance companies are no longer allowed to deny her coverage, but it's going to cost her ten thousand dollars a year, and she won't be able to afford it.

Senator, I want you to meet my husband Joe. You met him a year ago. I told you he only had two months to live, but he's a fighter. Joe's now in a wheelchair. He's a fighter. Please come over and say hello. And so I did. And then she takes me aside and she says, Every day it's a nightmare. I'm on the phone battling with some of these insurance companies because I don't know what they'll cover.

Senator, I'm a student at Moorhead State University in Minnesota. It's taken me six years to graduate. I've been working for forty hours a week for the last six years.

Senator, I sell plasma at the beginning of the semester in order to be able to buy textbooks.

Senator, I'm a single parent. I'm one of the welfare mothers you hear about, but I'm in the community college. I want to be independent, but now I'm being told, in the name of welfare reform, that I have to leave school and take a job, but the job pays six dollars and fifty cents an hour and I won't have health care in a year and I'll be worse off. Please let me finish my schooling, my education, so I can support my children.

Senator, we're both thirty, our combined income is thirty-five thousand dollars a year, but it costs us twelve thousand dollars in child care for our two children.

Senator, my dad is a Vietnam vet. He took a shower last week, but when he came out of the shower he wouldn't talk to anybody any longer. We're told that he suffers from post-traumatic stress syndrome. But we don't have any compensation, how do we get him the care?

Can't we do better?

I don't think politics has anything to do with the left, right, or center. It has to do with trying to do well for people.

> Senator, we're disillusioned by politics, we think both parties are run by the same investors, we don't have any faith any longer, we think the special interests dominate the process, we have so little confidence in politics, and we don't think politics is very important.

…People say community service is good, but involvement in politics is unsavory. We need you. We need you involved in community service, we need you to be the really great teachers of the future, we need you involved in community service, we need you to be mentors and tutors—and many of you have been—and to help children and families battle the odds. We need you to volunteer at community health care clinics, and above and beyond whatever you do during your workdays, we need you as business people and lawyers to do community work.

But we also need you to care about public policy, to be the citizens speaking out for better public policy and more integrity in politics, and for you to believe that government and public policy can make a difference. That politics is not just about power and money games, politics can be about the improvement of peoples' lives, about lessening human suffering in our world and bringing about more peace and more justice.

And I say to you, as a political scientist and a United States senator, that in the last analysis, politics is what we create—by what we do, by what we hope for, by what we dare to imagine. Here's what I dare to imagine…a country where [all the children] I hold in my hands are God's children—regardless of the color of their skin, regardless of whether they're boy or girl, regardless of religion, regardless of rich or poor, regardless of urban or rural; [and] that every child I hold in my hands will have the same chance to reach her full potential or his full potential. That is the goodness of our country. That is the American dream.

…I do not believe the future will belong to those who are content with the present. I do not believe the future will belong to the cynics, or to those who stand on the sideline. The future will belong to those who have passion and to those who are willing to make the personal commitment to make our country better. The future will belong to those who believe in the beauty of their dreams.

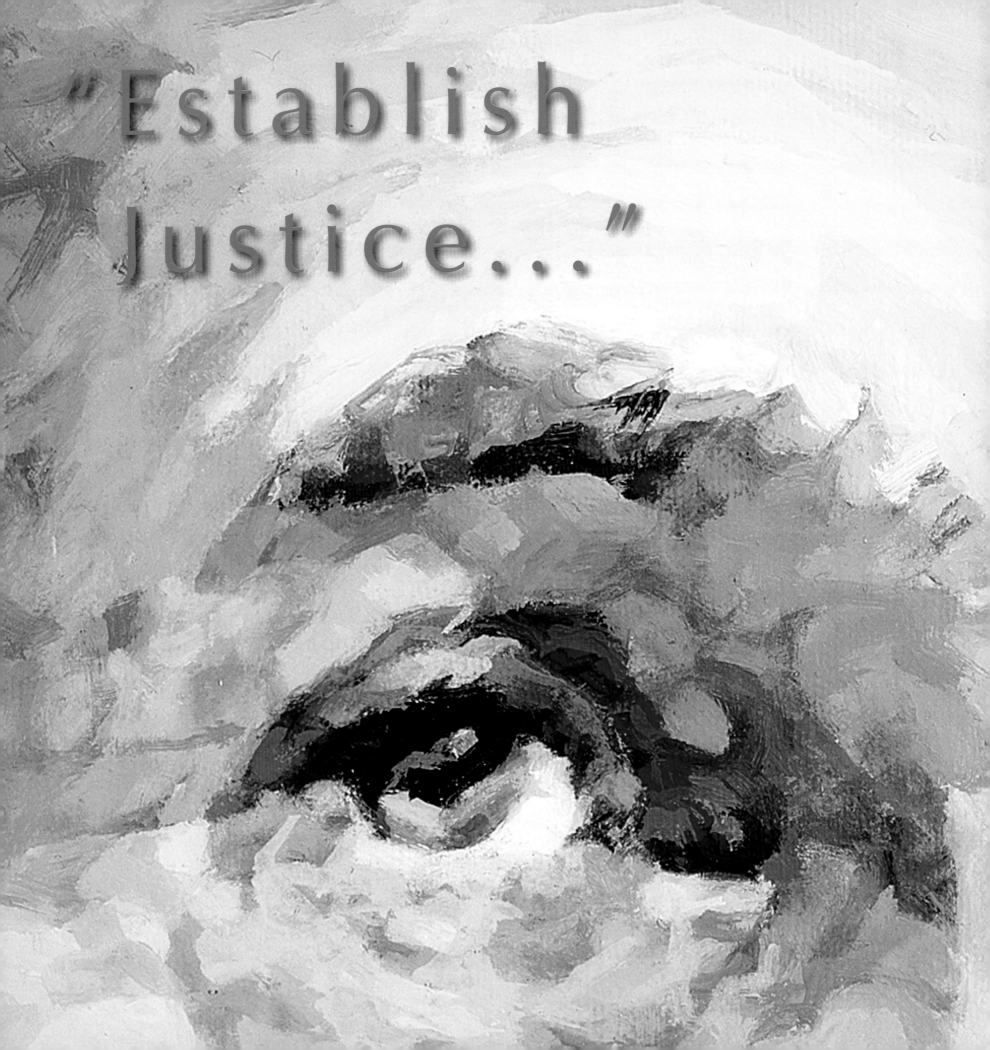

"Establish Justice..."

By permitting torture, kidnapping, and the operation of secret prisons, these policies have squandered the support of the world and the opportunity to lead it. By rejecting the rule of law, they have made us less safe from both tyranny and terrorism. And by condoning spying on American citizens and detaining individuals without access to courts, they have undermined our national values.

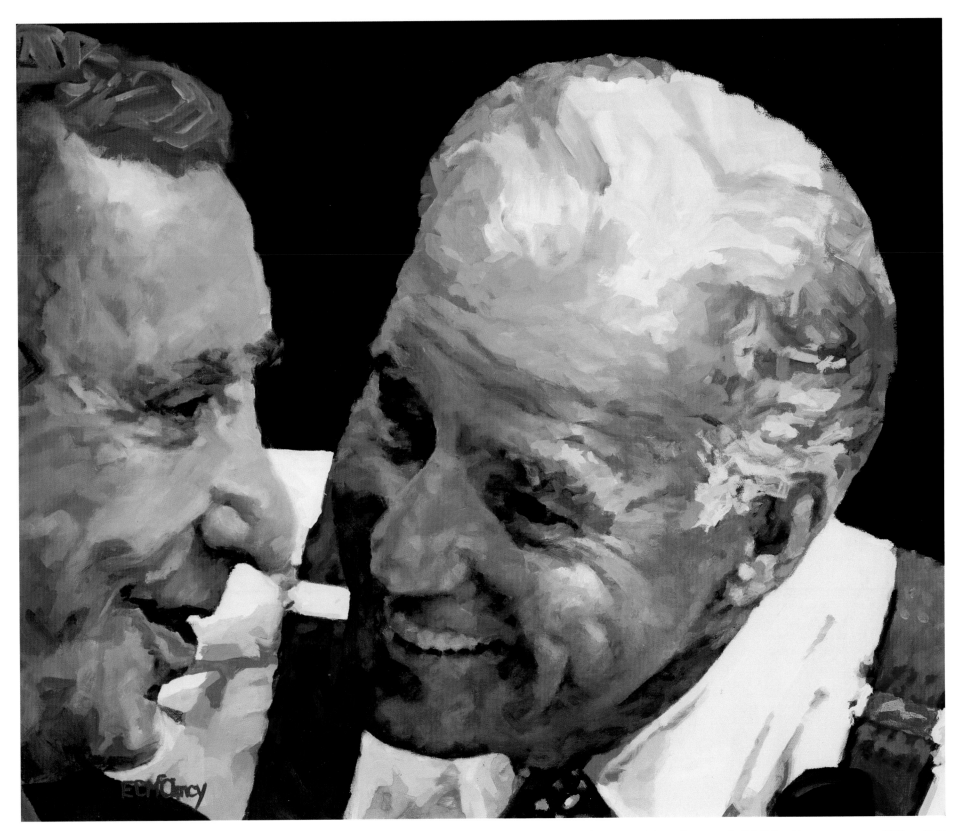

Senator Joseph R. Biden, Jr. & Colleague (Senator Arlen Specter), 2007, oil on canvas, 20" x 24"
Democratic Principles Series, No. 12

Since before our founding, the United States has been set apart by its uncompromising commitment to the rule of law and individual rights and civil liberties. The values embodied in our constitutional government have been the pole star by which the world has set its moral compass. They have given us the moral authority to lead our allies and to defeat fascism and communism.

In the aftermath of September 11, as the world mourned with us, we had an opportunity to lead again. The world looked to us to form a new coalition to face the threat of international terrorism and defend the very values the terrorists had attacked.

On September 11, I cautioned that we would squander this opportunity to lead and hand the terrorists a victory they could never achieve on their own if we betrayed the rule of law and abandoned our civil liberties. We need not change our national character in order to defeat terrorism. As a matter of fact, we are already defeated by the terrorists if we change our character.

That warning fell on deaf ears. Since September 11, at least five discrete policies promulgated by the executive branch to combat terrorism have subverted our constitutional principles and made us less safe at home and weaker abroad: the acceptance of what amounts to torture, the practice of extraordinary rendition, the operation of secret prisons, the unwarranted surveillance of Americans, and the revocation of habeas corpus.

By permitting torture, kidnapping, and the operation of secret prisons, these policies have squandered the support of the world and the opportunity to lead it. By rejecting the rule of law, they have made us less safe from both tyranny and terrorism. And by condoning spying on American citizens and detaining individuals without access to courts, they have undermined our national values.

Torture

Historically, the United States has advocated outlawing torture. We played a central role in drafting the Geneva Conventions and negotiating the Convention Against Torture. And we have enacted domestic laws to severely punish those who torture. And with good reason beyond the obvious moral imperative. Our efforts to outlaw torture were designed to protect the

hundreds of thousands of Americans soldiers overseas by giving us the moral authority to demand that those who are captured be treated humanely.

After September 11, the executive branch promulgated two pillars of a new policy regarding torture premised on a sophistic legal analysis by the Justice Department. The first pillar narrowed the definition of torture to conduct that causes "serious physical injury, such as organ failure, impairment of bodily function, or even death." It created a wide class of permissible mistreatment that "though [it] might constitute cruel, inhumane, or degrading treatment…failed to rise to the level of torture."

The second pillar exempted the President, as Commander-in-Chief, from these laws and allowed him to use torture, even though illegal, if he deemed it necessary. Emboldened by this analysis, the President allowed his Administration to engage in practices that the rest of the world regarded as torture but he had defined as permissible.

An American soldier who had recently witnessed the mistreatment of detainees in Afghanistan and Iraq sent the following statement to a senator: "Some argue that since our actions are not as horrifying as Al Qaeda's, we should not be concerned. When did Al Qaeda become any type of standard by which we measure the morality of the United States? We are America, and our actions should be held to a higher standard. I would rather die fighting than give up even the smallest part of the idea that is 'America.'"

In light of this policy, what moral authority do we have now to demand humane treatment of our soldiers and civilians who may be detained as they serve American interests around the globe?

It's time for us to stop this behavior and comply with our domestic law and our international treaty obligations. It's time for us to conform our policy to our national values. It's time for us to send a clear message that torture, inhumane and degrading treatment of detainees is unacceptable and is not permitted by U.S. law. Period.

Extraordinary Rendition

Like the executive branch policy regarding torture, its policy regarding "extraordinary rendition"—the practice of kidnapping a suspect and transporting him to a country that we know to use torture or secret site for interrogation—is anathema to our

national values. As one expert noted, "Every country to which the United States has rendered a terrorism suspect since 9/11 has been [recognized by the State Department as] a persistent and egregious violator of human rights." Although there is a place in the war on terror for rendition to justice, where a suspect is sent to another country to face trial, the use of extraordinary rendition is counterproductive and violates domestic law and international treaty obligations.

Pursuing a policy of extraordinary rendition, rather than rendition to justice, unconstrained by review by our courts or oversight by Congress, has diminished our moral stature and sapped popular support for the United States around the world. Shortly after Italy indicted 25 CIA agents for a 2003 rendition, Italian citizens took to the streets to protest the expansion of an American military base. A Canadian government commission censured the United States for its extraordinary rendition policy, and Canada has been reluctant to share intelligence with us ever since. Germany issued arrest warrants for 13 CIA agents allegedly involved in renditions. Switzerland, the United Kingdom, the European Union, and the Council of Europe are all investigating U.S. renditions within their jurisdictions.

There is also strong evidence that our extraordinary rendition policy has strengthened the position of oppressive and anti-democratic security services in countries like Syria and Egypt. If our own security services engage in extra-legal kidnapping, detention, and mistreatment, how can we criticize foreign security services that use the same tactics to suppress democratic reform? This must stop.

Secret Prisons

Some of those rendered are not turned over to brutal foreign regimes, but are held by American security services in secret prisons or "black sites" hidden from the American people and from the world. These facilities are located abroad to place them beyond the reach of U.S. law. Yet, as legal experts have opined, these prisons often violate the laws of the countries in which they are located.

Some who have been released from black sites and several international human rights organizations have alleged that the CIA uses brutal techniques at these sites, including "waterboarding."

What kind of example are we setting for the world with such base behavior?

As the existence of these black sites, and the techniques used in them, have become known, they have become one of Al Qaeda's most effective recruiting tools. According to unclassified reporting on last year's National Intelligence Estimate, the abuses that occur at these secret prisons and at Abu Ghraib and Guantanamo Bay have stoked the jihad movement. We must close the "black sites" that are a black stain on the name of America; close Guantanamo; and bulldoze Abu Ghraib to the ground.

Warrentless Wiretapping & National Security Letters

The policy allowing warrantless wiretapping of Americans' conversations promulgated after September 11 also violates the rule of law and threatens Americans' privacy. The Fourth Amendment guarantees freedom from unreasonable government searches and seizures and permits a judge to issue a warrant only after finding probable cause. It stands as a bulwark against arbitrary government invasions of our privacy, and America's leadership is bound by it—even as we fight terrorism.

We won't defeat terrorism by destroying the Bill of Rights. In 1928, Justice Brandeis warned that other instruments of executive power were "but puny instruments of tyranny and oppression when compared with wire tapping." Justice Holmes described wiretapping as a "dirty business." They were prescient.

In 1976, a Senate committee chaired by Frank Church uncovered shocking civil liberties abuses that had occurred during decades of extra-legal surveillance. To ensure that this would never happen again, the Church Committee recommended reforms. In 1978, as a member of the Judiciary and Intelligence Committees, I helped fashion the Foreign Intelligence Surveillance Act, which enacted many of the Committee's recommendations. Ninety-four colleagues from both sides of the aisle voted to pass FISA.

FISA ensured that the President would retain the necessary tools to protect national security and collect foreign intelligence without violating Americans' civil liberties. In other words, we created a framework for protecting national security and Americans' privacy. FISA established a court that could examine classified evidence and issue wiretap orders. We tailored the standard for FISA wiretaps to the national security threat. Instead of showing probable cause, FISA required the government to show that the subject of the warrant was a suspected terrorist or spy.

To ensure national security, we included exceptions: one allows the President to wiretap a terrorist suspect in an emergency prior to obtaining a warrant, as long as he obtains a warrant within 72 hours, and a second suspends the warrant requirement for 15 days after a congressional declaration of war. We also took pains to make clear FISA was the exclusive means by which the President could conduct national security surveillance; FISA unambiguously prohibits all such surveillance not authorized by statute.

Through strong congressional oversight, we need to ensure that the FISA court retains jurisdiction over all the President's surveillance programs. We must fight terrorism without destroying the very values we're fighting to preserve. We must create robust and effective intelligence authorities that respect Americans' privacy.

Depriving Terror Detainees of Habeus Corpus

Finally, executive branch policies since September 11 have sought to deprive terrorism detainees of the most cherished right in our constitutional system—habeas corpus. *Habeas corpus* is a Latin term, meaning to render or "give over the body." It was conceived to prevent someone from being locked up erroneously or illegally, with no chance to contest his imprisonment. But let's be clear: it is not a get-out-of-jail-free card, and it will not result in the release of dangerous terrorists. Habeas corpus is a judicial safeguard that predates our constitutional democracy. It was among British subjects' chief demands of King John on the field at Runnymede in 1215, as reflected in the Magna Carta. Alexander Hamilton described habeas corpus in the Federalist Papers as among the "greatest securities to liberty and republicanism that the Constitution contains." While the Framers relegated most individual rights to subsequent amendments in the Bill of Rights, they included habeas corpus in the body of the Constitution itself.

In a war where many of our detainees were not captured on a battlefield by U.S. forces and were not wearing military uniforms, habeas corpus is an indispensable safeguard against erroneous detention.

But perhaps most importantly, habeas corpus ensures that if the United States detains someone, it does so with full respect for the Constitution and the rule of law. Efforts to deprive detainees of habeas [corpus] have been repudiated three times by a Supreme Court dominated by Republican nominees. Nations around the world view Guantanamo not as a facility necessitated by the war on terror, but as a symbol of American disregard for the rule of law.

Our enemies have used it and Abu Ghraib to recruit additional terrorists. These prisons have become symbols of American duplicity, not beacons of American justice.

We should not wait for another Supreme Court decision. We should immediately move to restore habeas corpus.

Conclusion

It is time for Congress to reassert our constitutional role and exercise strict oversight over the executive branch's policies.

It is time to reestablish our moral stature in the world and to mend our most important foreign relationships. It is time to send a clear message to our citizens, to our men and women in uniform, and to people around the world, that we are a nation [ruled by] law. We condone neither torture, nor kidnapping suspects and sending them to other countries to be tortured. In America, we do not choose between security and liberty, we demand both.

Sending this message will be the first step toward restoring our constitutional balance, reaffirming our individual rights and liberties, and renewing our moral leadership in the world.

Senator Robert Byrd
Seeking the Truth on Spying
on Americans at Home
February 15, 2006

I plead with the American public to tune in to what is happening in this country. Please forget the political party with which you may usually be associated, and, instead, think about the right of due process, the presumption of innocence, and the right to a private life. Forget the now tired political spin that, if one does not support warrantless spying, then one may be less than patriotic. Focus on what's happening to truth in this country.

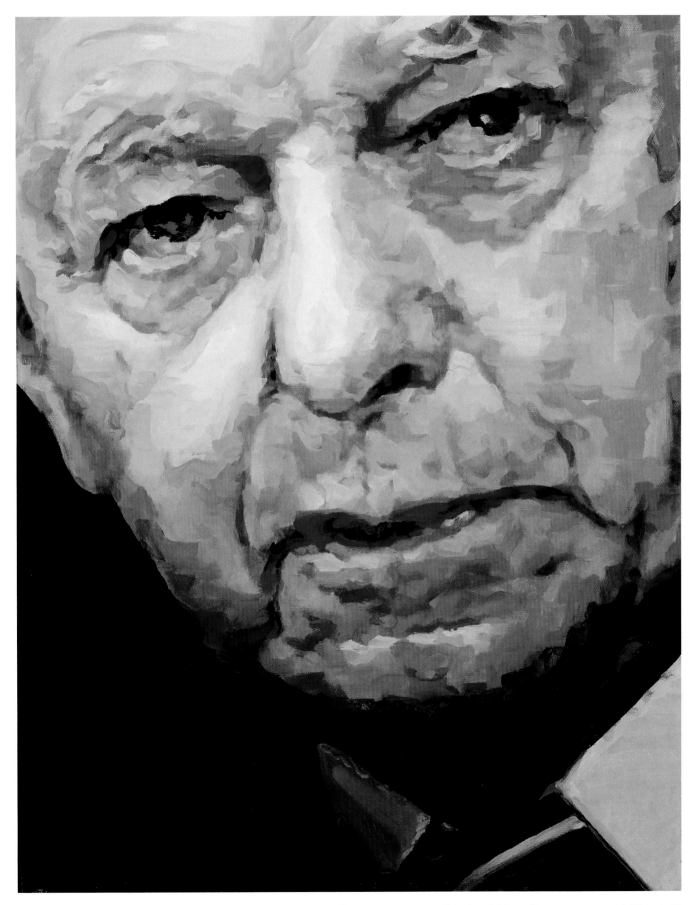

Senator Robert Byrd, 2007, oil on canvas, 18" x 14"
Democratic Principles Series, No. 5

In June of 2004, 10 peace activists outside of Halliburton, Inc., in Houston gathered to protest the company's war profiteering. They wore paper hats and were handing out peanut-butter-and-jelly sandwiches, calling attention to Halliburton's reported overcharging on a food contract for American troops in Iraq.

Unbeknownst to them, they were being watched. U.S. Army personnel at the top-secret Counterintelligence Field Activity, or CIFA, saw the protest as a potential threat to national security.

CIFA was created 3 years ago by the Defense Department. Its official role is "force-protection," that is, tracking threats and terrorist plots against military installations and personnel inside the United States. In 2003, then Deputy Defense Secretary Paul Wolfowitz authorized a fact-gathering operation code-named TALON, which stands for Threat and Local Observation Notice, that would collect "raw information" about "suspicious incidents" and feed it to CIFA.

In the case of the peanut butter demonstration, the Army wrote a report on the activity and stored it in its files. Newsweek magazine has reported that some TALON reports may have contained information on U.S. citizens that has been retained in Pentagon files. A senior Pentagon official has admitted that the names of these U.S. citizens could number in the thousands.

Is this where we are heading in the land of the free? Are secret government programs that spy on American citizens proliferating? The question is not "Is Big Brother watching?" It is "How many Big Brothers have we?"

Ever since the *New York Times* revealed that President George W. Bush has personally authorized surveillance of American citizens without obtaining a warrant, I have become increasingly concerned about dangers to the people's liberty. I believe that both current law and the Constitution may have been violated—not once, but many times—and in ways that the Congress and the people may never know because of this White House and its penchant for control and secrecy.

We cannot continue to claim that we are a nation of laws and not of men if our laws and, indeed, even the Constitution of the United States itself, may be summarily breached because of some determination of expediency or because a President says "trust me."

The Fourth Amendment reads clearly, "The right of the people to be secure in their persons, houses, papers, and effects, against unreasonable searches and seizures, shall not be violated, and no warrants shall issue, but upon probable cause, supported by oath or affirmation, and particularly describing the place to be searched, and the persons or things to be seized."

The Congress has already granted the executive branch rather extraordinary authority with changes in the Foreign Intelligence Surveillance Act that allow the government 72 hours after surveillance has begun to apply for a warrant—a program to eavesdrop upon known terrorists in other countries who are conversing with Americans. Then there should be no difficulty in obtaining a warrant within 72 hours. One might be tempted to suspect that the real reason [to authorize] warrantless surveillance is because there is no need to have to bother with the inconveniences of probable cause. Without probable cause as a condition of spying on American citizens, the National Security Agency could and can, under this President's direction, spy on anyone and for any reason.... And one must be especially wary of an administration that seems to feel that what it judges to be a good end, always justifies any means. It is, in fact, not only illegal under our system, but morally reprehensible to spy on citizens without probable cause of wrongdoing.

...What is the message we are sending to other countries...? In the name of "fighting terror" are we to sacrifice every freedom to a president's demand? How far are we to go? Can a President order warrantless house-by-house searches of a neighborhood, where he suspects a terrorist may be hiding? Can he impose new restrictions on what can be printed, broadcast, or even uttered privately, because of some perceived threat to national security? Laughable thoughts? I think not. For this administration has so traumatized the people of this nation—and many in the Congress—that some will swallow whole whatever rubbish that is spewed from this White House, as long as it is in some tenuous way connected to the so-called war on terror.

And the phrase, "war on terror," while catchy, certainly is a misnomer. Terror is a tactic used by all manner of violent organizations to achieve their goals. It has been around since time began, and will likely be with us on the last day of planet

Earth. We were attacked by Bin Laden and by his organization Al Qaeda. If anything, what we are engaged in should more properly be called a war on the Al Qaeda network. But that is too limiting for an administration that loves power as much as this one. A war on the Al Qaeda network might conceivably be over some day. A war on the Al Qaeda network might have achievable, measurable objectives, and it would be less able to be used as a rationale for almost any government action. It would be harder to periodically traumatize the U.S. public, thereby justifying a reason for stamping secret on far too many government programs and activities.

Why hasn't Congress been thoroughly briefed on the President's secret eavesdropping program, or on other secret domestic monitoring programs run by the Pentagon or other government entities? Is it because keeping official secrets prevents annoying congressional oversight? Revealing this program in its entirety to too many members of Congress could certainly have unmasked its probable illegality at a much earlier date, and may have allowed members of Congress to pry information out of the White House that the Senate Judiciary Committee could not pry out of Attorney General Gonzales, who seems genuinely confused about whom he works for—the public or his old boss, the President.

Attorney General Gonzales refused to divulge whether or not purely domestic communications have also been caught up in this warrantless surveillance, and he refused to assure the Senate Judiciary Committee and the American public that the administration has not deliberately tapped Americans' telephone calls and computers or searched their homes without warrants. Nor would he reveal whether even a single arrest has resulted from the program.

And what about the First Amendment? What about the chilling effect that warrantless eavesdropping is already having on those law-abiding American citizens who may not support the war in Iraq, or who may simply communicate with friends or relatives overseas? Eventually, the feeling that no conversation is private will cause perfectly innocent people to think carefully before they candidly express opinions or even say something in jest.

Already we have heard suggestions that Freedom of the Press should be subject to new restrictions. And who among us can feel comfortable knowing that the National Security Agency has been operating with an expansive view of its role since 2001, forwarding wholesale information from foreign intelligence communication intercepts involving American citizens, including the names of individuals, to the FBI, in a departure from past practices, and tapping some of the country's main telecommunications arteries in order to trace and analyze information.

...I plead with the American public to tune in to what is happening in this country. Please forget the political party with which you may usually be associated, and, instead, think about the right of due process, the presumption of innocence, and the right to a private life. Forget the now tired political spin that, if one does not support warrantless spying, then one may be less than patriotic. Focus on what's happening to truth in this country.

Congress must rise to the occasion here and demand answers to the serious questions surrounding warrantless spying. And Congress must stop being spooked by false charges that unless it goes along in blind obedience with every outrageous violation of the separation of powers, it is soft on terrorism. Perhaps we can take courage from the American Bar Association which, on Monday, February 13, denounced President Bush's warrantless surveillance, and expressed the view that he had exceeded his constitutional powers.

There is a need for a thorough investigation of all of our domestic spying programs. We have to know what is being done, by whom, and to whom. We need to know if the Federal Intelligence Surveillance Act has been breached, and if the constitutional rights of thousands of Americans have been violated without cause. The question is, can the Congress, under control of the President's political party, conduct the type of thorough, far-ranging investigation that is necessary? It is absolutely essential that Congress try, because it is vital to at least attempt the proper restoration of the checks and balances.

I want to know how many Americans have been spied upon. I want to know how it is determined which individuals are monitored and who makes such determinations. I want to know if the telecommunications industry is involved in a massive screening of the domestic telephone calls of ordinary Americans. I want to know if the United States Post Office is involved. I want to know, and the American people deserve to know, if the law has been broken and the Constitution has been breached.

Historian Lord Acton once observed that "Everything secret degenerates, even the administration of justice."...In order to protect this open society are we to believe that measures must be taken that in insidious and unconstitutional ways close it down? I believe that the answer must be an emphatic "no."

We have to understand that the hostility to America and to our values that feeds the jihadist threat is the product of many decades of repressed debate within the Middle East. We've become the convenient excuse for the failures of rulers, and a convenient target for the frustrations of the ruled. And frankly, we've made that possible by signaling Arab regimes that we don't much care what they do so long as they keep pumping the oil and keep the price low. That attitude has to end—not only end, it must be reversed.

Senator John Kerry, 2007, oil on canvas, 18" x 14"
Democratic Principles Series, No. 10

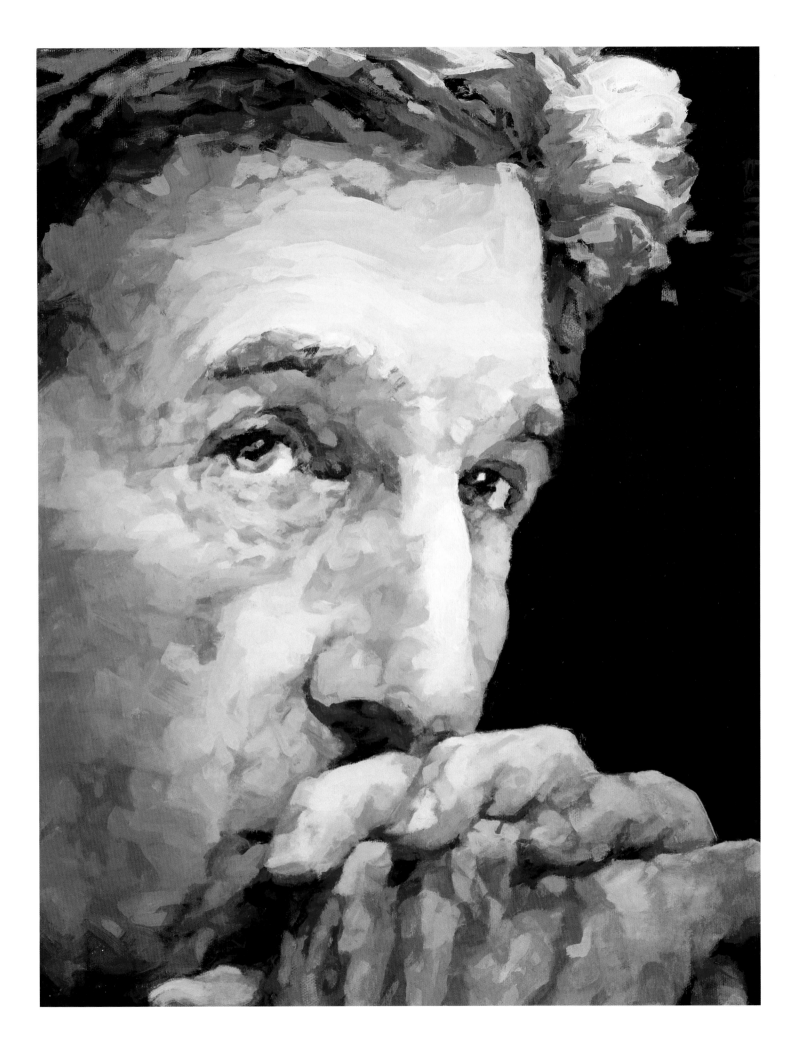

So much of what we used to take for granted in national security policy has now been called into question. We used to know that despite our differences in philosophy and in perspective, our two great parties could cooperate to craft international policies in our national interest.

We used to understand that the vast and unique role of the United States in world affairs required a far-sighted and multi-faceted approach to protecting our people and our interests.

We used to value as a national treasure the international alliances and institutions that enhanced our strength, amplified our voice, and reflected our traditions and our ideals in maintaining a free and secure world.

We used to measure America's strength and security by our moral authority, our economic leadership, and our diplomatic skills, as well as by the power of our military.

And we used to say politics stopped at the water's edge.

We used to call on our people to share in the sacrifices demanded by freedom, and our leaders used to raise hopes and inspire trust, not raise fears and demand blind faith.

So where do we go from here? Well, I wish we could have a real debate—a real council of war that brings senators and congressmen of both parties together to forge a winning strategy for America. That's what I think we should do. But since the current administration confuses examination of failed policies with an admission of weakness, and debate with division, that's not possible today. So those of us who want our country to win the war on terror must take advantage of opportunities like these to show the road not taken, and the right path to success.

For all their rhetoric about democracy, human rights, the hateful ideology of our adversaries, and international coalitions against terrorism, the President and his advisers have shown time and again that they really do conceive the war on terror...almost exclusively as a military operation. That's why they've been so willing to bend every relationship and international institution, and bend, in fact, our own values and respect for norms of behavior that America has long championed.

Make no mistake, we are united in our commitment to track down and kill the evil men who would harm us. But that alone will not win the real war on terror. The real war on terror is an

Democratization also cannot be a crusade. If it is seen as the result of an army marching through Muslim lands, it absolutely will fail. But more importantly, that's not the way democracy works. Democracy spreads with patient but firm determination....

All of that has changed in a remarkably brief period of time. And in recalling what we've lost, I'm not looking back to the Greatest Generation of World War II, or to the leaders who shaped our Cold War policies and wore down the threat of totalitarian communism. I'm not talking about 30 or 40 or 50 years ago—I'm talking about what we had just four short years ago.

After September 11th, the American people, elected officials from both parties, and much of the whole world, offered the President of the United States their loyal support when he announced our intention to wage a global war on terror. Not since the bombing of Pearl Harbor has a president enjoyed a greater reservoir of moral and political capital, or more material and diplomatic resources, at the beginning of a war.

Four years later, our resources have been diminished and our goodwill has been squandered. Washington is failing to take the basic steps necessary to make us safe. It is an inexplicable abdication of responsibility.

even bigger challenge. It is a war that has drawn us smack into the middle of an internal struggle in the Islamic world. It is fundamentally a war within Islam for the heart and soul of Islam, stretching from Morocco east to Indonesia. It leads, ultimately, to a struggle for the transformation of the Greater Middle East into a region that is no longer isolated from the global economy, no longer dependent on despotism for stability, no longer fearful of freedom, and no longer content to feed restive and rising populations, alarming rising rate of populations among young people, to feed them a diet of illusions, excuses, and dead-end government jobs.

We have to understand that the hostility to America and to our values that feeds the jihadist threat is the product of many decades of repressed debate within the Middle East. We've become the convenient excuse for the failures of rulers, and a convenient target for the frustrations of the ruled. And frankly, we've made that possible by signaling Arab regimes that we don't much care what they do so long as they keep pumping

the oil and keep the price low. That attitude has to end—not only end, it must be reversed.

Energy independence is not a pie-in-the-sky concept. It's not just a dream. It's a domestic priority for our country, obviously, but is much more. It is essential to our national security, because our reliance on their oil limits our ability to move them towards the needed reforms and actually props up decaying and sometimes corrupt regimes, including those that support terrorist groups.

Any long-term strategy for winning the war on terror therefore must include a much more determined effort to reduce our dependence on petroleum. So many opportunities, stunning opportunities, stare us in the face. But none, not even in this recent energy bill, have been seized with the urgency that our security demands.

These efforts also have to be international in nature, linked to the rapid emergence of new technologies, in order to ensure that economies like China and India don't just replace us as the enabler of Middle East autocrats.

So this is the long-range mission in the war on terror. One, make sure the right side wins the war of ideas within the Islamic world; two, build up diversified economies and civil society and bring the region into the global economy; and, three, end the empire of oil. These three challenges make it abundantly clear that this is not a war the United States should or can fight alone.

We must also start treating our moral authority as a precious national asset in the war on terror. We play into the hands of our enemies, and we lose credibility when the Vice President of the United States lobbies for the right to torture, even after the Abu Ghraib disaster, when the chairman of the Joint Chiefs of Staff has to publicly remind the Secretary of Defense that our troops have an obligation to stop torture when they see it, or see others doing it, and when we continue to hold detainees indefinitely in a legal no-man's land.

We must counter the teaching of hatred in madrases by pressing regimes more consistently and effectively to teach tolerance in schools throughout the Middle East and Central Asia, but also to broaden the educational opportunities. We have to work with moderate Muslims, especially clerics, to permanently discredit the belief that the murder of innocents can be justified in the name of God, race or nation. The people of the Middle East need to learn that—they need to learn who we are from direct experience with Americans, not from watching a failed Madison Avenue campaign. And democratic values and openness should be championed not simply as Western values but as the universal values that they are—the uniting values that they are.

Democratization also cannot be a crusade. If it is seen as the result of an army marching through Muslim lands, it absolutely will fail. But more importantly, that's not the way democracy works. Democracy spreads with patient but firm determination, led by individuals of courage who dream of a better day for their country. Viktor Yushchenko had that dream in the Ukraine. Hamid Karzai had that dream in Afghanistan. Lech Walesa had that dream in Poland. We need to create the conditions where this dream can become a reality in the Arab world. And if we're serious about spreading democracy and fighting a real war on terror, then, quite simply, our resources must match our rhetoric.

We must do everything possible to promote economic, social and political transformation in the Middle East, especially among Sunni Arabs. Nations like Jordan, Qatar and Bahrain are not only moving towards political freedom and pluralism, but they're also trying to build real economies built on the talents of their own people rather than trying to simply pump prosperity out of the ground. Every move in that direction in this critical region should not only be praised, but it ought to be rewarded tangibly as a role model. And there's no way to overemphasize the importance of ensuring that the Greater Middle East does not continue its long trajectory towards a region where an exploding young population collides with dysfunctional isolated economies, producing instability and, ultimately, more and more terrorism. Majority populations under the age of 18 without jobs or futures are a certain recipe for disaster.

In the end, these many steps will open a region that for too long has been closed to opportunity, progress, modernized governments and societies that can better meet the needs of their citizens and respond to grievances and provide a more hopeful alternative to the dark ideology of terror.

Now, of course, there will be times, like in Afghanistan, when direct military engagement will be necessary. And that requires reshaping our military for those missions ahead: a larger infantry and more special forces; more personnel trained and equipped to perform post-conflict reconstruction missions; a Guard and a Reserve force that meets the nation's needs overseas and at home. But let me tell you, because this is a long-range war, we have to do now a better job, even, of destroying terrorist cells and preventing terrorist attacks here at home.

The fact is that al Qaeda has morphed into a global hydra of hidden terrorists who often share nothing more than a common hatred. To disrupt and destroy their networks before they can attack, we really can do much more to improve and overhaul our intelligence and law enforcement capabilities by the acceleration, for instance, of the creation of a true domestic counterterrorism capability within the FBI, and greatly increasing our overseas clandestine intelligence capacities. And to be truly effective in the global conflict, we need to leverage greater assistance, even, from foreign intelligence agencies, expand the Anti-Terrorism Assistance Program, and increase exchange programs and liaison relationships.

Finally, we must adapt international institutions to meet today's threats. Of course we have to end corruption and inefficiency at the United Nations. We understand that. But we must not lose sight of its continuing importance to our own security. We should be leading the negotiations of a meaningful Convention Against Terrorism so that the world in one voice united finally condemns terrorism and the groups that use it. In other words, at home, in the Middle East and around the world, we have to convince a whole bunch more people that the war on terror is in fact a common fight against a threat to our collective security, not just America's fight against terrorists. And that is an approach that restores a distinctly American tradition.

election days. And at the end of one great war against totalitarianism and at the beginning of another, Harry Truman presided over the greatest era of bipartisan, multilateral foreign policy our country or the world has ever seen, and it brought us great fruit. It's time for the president to put a little more Harry Truman in his foreign policy. And if he won't, then those of us who admire Harry Truman will keep up the fight here at home in order to win the fight against terrorism around the world. And we'll be joined by other Americans, and I hope by leaders in organizations like this who understand this is a fight we dare not lose. More than that, it is a fight we must win.

What has always made America exceptional in the history of the great powers is that we have not sought conquest or empire when those temptations were within our reach.

Some say that the preference for unilateral action reflects American exceptionalism. But I say what has always made America exceptional in the history of the great powers is that we have not sought conquest or empire when those temptations were within our reach. Our confidence in our own greatness led us to build an international order of mutual respect and cooperation. That's why America emerged from the 20th century as the unquestioned leader in the world's march towards freedom as the authors of a global consensus linking our self-interest as a nation for the common interests of all nations. That is the real tradition of American exceptionalism that we must understand and embrace.

Within living memory, we had another president who prided himself on simple virtues and unshakable resolve. Harry Truman was an uncomplicated man, yet he was also a man who believed that he should be held personally accountable for every decision, every judgment, every day, not just on

One of the reasons the image of this country has been so damaged during recent years is because the world believed that we stood for something better. They hold us to a higher standard, and they want us to live up to our own ideals, as do we all. When we fall short of that standard, it is not only our reputation that suffers—the cause of justice everywhere also suffers. And the hope of oppressed and suffering people everywhere dims whenever we dim our beacon of human rights leadership.

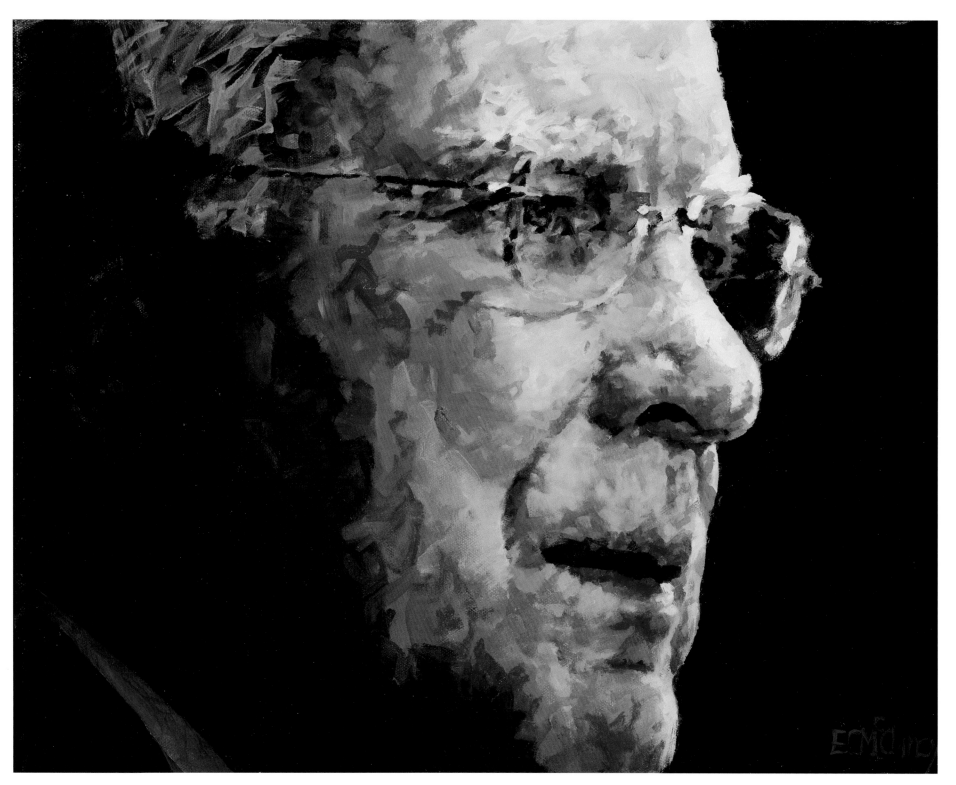

Senator Patrick Leahy, 2007, oil on canvas, 14" x 18"
Democratic Principles Series, No. 17

Subcommittee on Human Rights and the Law

One of our first actions in the Judiciary Committee in this new Congress was to establish, for the first time, a new subcommittee whose focus is human rights and the law. Our new Human Rights and the Law Subcommittee is being chaired by another Georgetown Law Center graduate, Senator Dick Durbin of Illinois, and we held our first hearing on the subject of genocide.

It is our intention that our new subcommittee will closely examine some of the vital, often difficult, and sometimes controversial legal issues that increasingly have landed on the Judiciary Committee's doorstep. Many derive from actions taken by this Administration over the last five years. Its policies of declaring persons enemy combatants, indefinitely imprisoning them incommunicado in isolated and dehumanizing conditions without charge, and denying them access to legal counsel or to the courts—until forced to do so by the Supreme Court—make our work particularly timely and increasingly necessary.

The United States played the key role in the creation of the Universal Declaration of Human Rights. Our Bill of Rights and our independent judiciary have been models for other nations for more than 200 years. Justice Jackson's role at the Nuremberg trials, and our support for war crimes tribunals for perpetrators of genocide and crimes against humanity in the former Yugoslavia, Rwanda, and Sierra Leone, are part of a tradition of which we can be proud.

During the last five years, America's reputation has suffered tremendously, and along with it so has our constructive influence in the world. Abu Ghraib, Guantanamo, and also, I believe, our refusal to join the International Criminal Court—after we played a central role in the negotiations on the Rome Treaty that established it—have tarnished that tradition. The secret prisons that the President confirmed last year and this administration's role in sending people to other countries where they would be tortured have led to condemnation by our allies, legal challenges, and criminal charges. Just last week, our government declined to join 57 other countries that signed a treaty, already adopted by the UN General Assembly, which prohibits governments from holding people in secret detention. We have condemned countries in the past for detaining people in secret and then covering up that detention, but we now choose not to join much of the rest of the world in condemning this outrageous tactic, which the President admitted last fall is a tactic our government has been using.

Even more inexplicably, our government also declined to join 58 other countries that signed a non-binding accord banning the use of child soldiers. That is an abhorrent practice, which has brought misery to so many children around the world, and I cannot imagine why our government would pass up this opportunity to condemn it in the strongest possible terms.

One of the reasons the image of this country has been so damaged during recent years is because the world believed that we stood for something better. They hold us to a higher standard, and they want us to live up to our own ideals, as do we all. When we fall short of that standard, it is not only our reputation that suffers—the cause of justice everywhere also suffers. And the hope of oppressed and suffering people everywhere dims whenever we dim our beacon of human rights leadership.

In Darfur we see the tragic replay of suffering and death. Hundreds of thousands of innocent people killed, or raped, tortured, and forced to flee the ashes of their homes. This was the topic of our new subcommittee's hearing last week.

What happened in Rwanda was, I believe, among the most egregious failures of the international community to protect human rights since the Cambodian genocide of the 1970s. We cannot allow that horror to be repeated.

We will do what we can to seek—at every opportunity— additional humanitarian aid and funding for international peacekeeping troops in Darfur. We need to ask what more can be done to convince the Sudanese Government to disarm the militias that are responsible for the genocide and to allow the United Nations to deploy additional troops to buttress the African Union force.

We also need to determine whether our own laws provide adequate authority to prosecute in the United States acts of genocide by non-U.S. nationals that occur outside this country, whether in Darfur or anywhere else.

Life-Saving Medicines

I am also redoubling my efforts to reexamine our patent laws in the hope that by making thoughtful and practical changes, we can greatly increase access to essential medicines throughout the world. We can help struggling families in developing nations while improving U.S. relations with large segments of the world's population. The current global health crisis is one of the great callings of our time. Whether it is the

avian flu, AIDS, SARS, West Nile virus, or the approaching menace of multidrug-resistant bacteria, we need to recognize that the health of those halfway around the world now influences our security and affects our lives here in the United States. I want the work of the Judiciary Committee to be a catalyst to help make life-saving medicines more readily available around the world.

Iraq

The issue that continues to dominate the national discussion is the failed policy in the aftermath of the invasion of Iraq. I imagine that you, like I, know Guardsmen and Reservists who have been sent to Iraq—sometimes several times—along with tens of thousands of other brave young women and men.

As part of the Judiciary Committee's efforts, we held a hearing with Congressman Hamilton and former Attorney General Meese on the Iraq Study Group recommendations—bipartisan

This administration has over the last several years brazenly refused to answer the legitimate oversight questions of the public's duly elected representatives. The administration has acted outside lawful authority to wiretap Americans without warrants, and to create databanks and dossiers on law-abiding Americans without following the law and without first seeking legal authorization.

Our constitutional balance must be restored. Congress has a solemn duty to protect the rights of the American people and to perform meaningful oversight to make sure the laws are faithfully followed. Real oversight makes government more accountable, more effective in keeping us safe, and more responsive to human rights.

I am immensely proud to be one of the two senators given the opportunity to represent a state that boasts such a rich tradition of defending those rights. Vermont was the first colony to abolish slavery, in 1777. Vermont did not and would not become a state until 1791, the year the Bill of Rights was

We can greatly increase access to essential medicines throughout the world. We can help struggling families in developing nations while improving U.S. relations with large segments of the world's population. The current global health crisis is one of the great callings of our time.

recommendations. Our focus was on the Iraqi police forces, which have been infiltrated and corrupted by partisan militias and death squads. The police forces have proven to be among the worst failures of the occupation. The human rights violations ongoing in Iraq today rival if they do not surpass those of the oppressive regime of Saddam Hussein. These abuses persist, and the violence grows.

We may not be able to control what others do, but we can control our own actions. Accordingly, I strongly believe that any American aid must be conditioned on adherence to the Leahy Law. That law prohibits American aid to military units that engage in human rights violations. That law needs to be honored and enforced, not ignored.

Oversight and Restoring Checks and Balances

We have begun seeking to restore constitutional values and the rights of ordinary Americans here at home and to repair a broken oversight process, in order to return a measure of accountability to our government.

ratified. Vermonters have traditionally risen up against abuses and against infringements of the people's rights, even when doing what was right was not necessarily popular at the time.

…We all support monitoring the communications of suspected terrorists. It is essential, and it is permitted under existing law. It is also essential that when that monitoring impinges upon the rights of Americans, it needs to be done lawfully and with adequate checks and balances to prevent abuses. Initially the administration stonewalled our inquiries and claimed unilateral power and a monopoly on deciding what needs to be done and how to do it.

Restoring Basic American Values and Human Rights

Another core concern that strikes close to home are the excesses of the Military Commissions Act, passed in the run-up to the last election. It was wrong to suspend the great writ of Habeas Corpus—a keystone of American liberty—in order to avoid judicial review that prevents government abuse. That law needlessly undercut our freedoms and values…. It allowed

the terrorists to achieve something they could never win on the battlefield: an action from fear rather than strength that undercut the Constitution. It was a squandered opportunity to write a good law to set enforceable guidelines for fighting and winning the war on terror without sacrificing American values and American leadership on human rights.

Justice Scalia wrote in the Hamdi case: "The very core of liberty secured by our Anglo-Saxon system of separated powers has been freedom from indefinite imprisonment at the will of the Executive." I am committed to restoring basic American values to the way we combat terrorism and to developing a more effective strategy.

As a result of that sweeping, ill-conceived law, we have now eliminated basic legal and human rights for 12 million lawful permanent residents who live and work among us, to say nothing of the millions of other legal immigrants and visitors whom we welcome to our shores each year. This decimation of basic rights for legal immigrants and visitors follows on our government's continuing mistreatment and deportation of too many of the people who come to this country seeking asylum from persecution abroad, as the bipartisan United States Commission on International Religious Freedom recently found.

If you saw the movie *Babel* and were moved by the toll taken in individual lives by the callous ways that government can treat people, think about the possible sequel, with story lines of unlimited detention of innocent people, and our own government sending people to Syria and to secret prisons to be tortured. That is not the America we have known or what we want America to be.

Sam Dash is known for his role in helping to rescue our own government from abuses of power. But he also devoted much time and effort to defending human rights in far-off places like Chile, South Africa, the former Soviet Union, and Northern Ireland. Someone aptly called Sam Dash a "force for good." His patriotism drove him to demand the highest standards from our legal system, and from those who benefit from it, and it also drove him to empathize with those far away from our shores who yearn for their own human rights. Many who benefited from his labors will never know his name or what he did to help protect their rights and to defend their humanity.

...Even though we have the blessings of a remarkable Constitution, it falls to each generation of Americans to keep its promise alive. Our generation now faces its own tests.

The matters I have raised will not be resolved in an hour or a day. They will be resisted by powerful forces. They will take sustained effort over weeks and months and maybe years. I hope that you will think about ways in which you can help in this struggle.... Shouldn't each of us, in our own way, strive... to be a force for good?

Senator Barbara A. Mikulski
Taken from Two Senate Floor Speeches
February and March of 2007

President Bush says he doesn't need congressional consent, but he is going to get some congressional advice. This military escalation is reckless—it won't produce the political reconciliation Iraq needs to stop the violence and it won't bring stability to the region, but it will put more of our troops in harm's way.

A great American military cannot be a substitute for a weak Iraqi Government. Neither Congress nor the American people will ever abandon our troops. They have a tough job and we are proud of them.... Let's send in the diplomats and bring our troops home safely and soon.

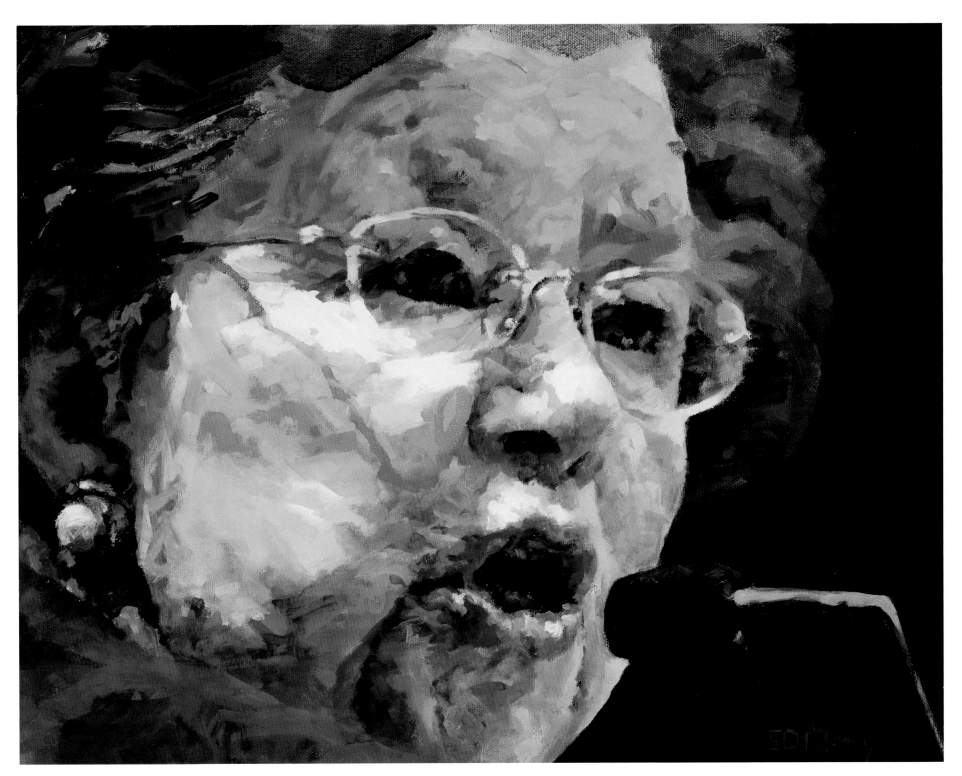

Senator Barbara Mikulski, 2007, oil on canvas, 14" x 18"
Democratic Principles Series, No. 13

It is time for our troops to come home. And it is time for us to bring them home swiftly. But we have a moral obligation and a constitutional obligation to bring our troops home safely. This is why I support the Reid resolution.

This resolution states clearly that the Congress and the American people support our troops. Yet, at the same time, we're saying "bring the troops home by March 31, 2008." We are following the guidelines of the Iraq Study Group—wise heads who pondered what were some of the best new ways to go forward. So the Reid resolution sets a framework and a timeline about what needs to be done, yet it assures our troops that we honor their service and we're going to protect them on the battlefield. We are going to make sure they have the resources to do the job, and when they come back home we want to be sure that they have health care, and that they have jobs, and that they have job training.

Now, I'm not new to this position on the war. I never wanted to go to war in the first place—not because I'm a pacifist,

Naval Bethesda, you talk to the troops coming home from Iraq. We know what we got. When we got there, there were no weapons of mass destruction, but destruction sure happened.

No one could ask more of our troops—they are brave and courageous and they have fought valiantly. After four years of fighting, where are we in Iraq? Well, the United States went to war with Iraq and today, we are at war within Iraq. Saddam is gone, but we're still there, mired in a civil war between different ethnic and sectarian groups.

Now you know what I am against, but let me tell you what I am for…. It's time for us to come home. And it's time for us to come home following the Iraq Study Group. We need a new way forward in Iraq. The Iraq Study Group gave us 79 recommendations, surely we could agree on 50…. It is time to engage the international community…. It is always better to send in the diplomats before you send in the troops. Let's send in the diplomats so that we can bring our troops back home. The Iraq Study Group calls for enhanced diplomatic and

To all who are listening, you can sit-in every single day; you can follow me throughout my Senate career; you can tail me to my grave. I will not vote to in any way harm the men and women in the U.S. military, nor will I cut off the support to their families.

though I respect those that are. But I read that national intelligence report. I'm on the Intelligence Committee. I was one of the 23 who voted against this war four years ago, on October 11, 2002. I will never forget it. I did not believe the administration's arguments then, and I do not believe them now.

I really had very grave suspicions about the level of weapons of mass destruction Saddam had. But I also believed it was the U.N.'s job to go there and to do the work that the U.N. was supposed to do. I opposed giving the President unilateral authority to engage in a preemptive attack. I said the U.S. had to exhaust our diplomatic options and I encouraged the administration at that time to "please, stick with the U.N.," so that the U.N. could meet its responsibility to deal with the Saddam threat. I said we shouldn't go on our own and we should work with the U.N. and the international community.

The day of the vote in 2002, I was so filled with apprehension about the course we were embarking on. When I spoke, I said, "We don't know if our troops will be greeted with flowers or with land mines." Well, now you go to Walter Reed, you go to

political efforts in Iraq and outside of Iraq. It provides a direction for the U.S. and Iraqi Governments to follow that would bring our forces home by the first quarter of 2008. That's what the Reid resolution calls for.

The Reid resolution sets a goal of bringing all U.S. combat forces home by March 31, 2008, except for limited numbers of troops for force protection, training of Iraqi troops and targeted counterterrorism operations. It would begin a phased redeployment within four months after the passage of this legislation. But it also develops a comprehensive diplomatic, political and economic strategy. And finally, this resolution requires the President to report to Congress within 60 days.

I support the Reid resolution because I believe what the Iraq Study Group said—that the Iraq problems cannot now be solved with a military solution, no matter how brave, no matter how smart. It requires a political solution by the Iraqis and a diplomatic solution with Iraq's neighbors. It says that the Congress and the American people will also support the troops.

The Warner-Biden resolution…makes clear to our men and women in uniform that Congress will not abandon them. It says Congress should not take any action that will endanger U.S. military forces in the field, whether on the battlefield or on the home front. Our troops deserve to know that Congress supports them, not just with words, but with deeds.

I support the Warner-Biden Resolution, because it reflects what the intelligence community tells us—NIE [National Intelligence Estimate] says any solution in Iraq requires political solution from Iraqis. It is up to Iraqi leadership to make difficult changes. They must go beyond their sectarian interests to take on extremists, establish effective national institutions, and stop corruption. The solution in Iraq requires a political solution from Iraqis, not military muscle from Americans.

There are parts of the Warner-Biden resolution I don't agree with. It calls the President's plan an "augmentation." This isn't an augmentation; it's an escalation. I'm opposed to any escalation of this war. This isn't about the number of troops the President wants to send. It is about ending the war and getting our troops out of this sorry situation.

We need a way forward in Iraq. The Iraq Study Group gives us 79 recommendations as a way to go forward. The Iraq Study Group report calls for new and enhanced diplomatic and political efforts in Iraq, and a change in the primary mission of U.S. forces in Iraq to enable the U.S. to begin to move our forces out of Iraq responsibly. It provides a direction for the U.S. and Iraqi Governments to follow that could lead to the withdrawal of U.S. forces by the first quarter of 2008.

In short, where do we go from here?

Number one—send in the diplomats before we send in the troops. We need a robust diplomatic strategy to match our robust military strategy.

Number two—make it clear that Congress will not abandon our troops in the field. The best way to support our troops is to surge U.S. diplomacy and Iraqi political progress, because without cooperation of regional powers and backbone of the Iraqi Government, U.S. military strategy alone can't stabilize Iraq.

Number three—make it clear that if Iraqi Prime Minister Maliki can't act, the U.S. won't support him. Prime Minister Maliki and his government must meet the benchmarks we've set: political compromise and national reconciliation, a

government that will function on behalf of its people, a strong Iraqi Army and an effective Iraqi police force, an end to corruption in government ministries, and an agreement on sharing oil revenues.

President Bush says he doesn't need congressional consent, but he is going to get some congressional advice. This military escalation is reckless—it won't produce the political reconciliation Iraq needs to stop the violence and it won't bring stability to the region, but it will put more of our troops in harm's way.

A great American military cannot be a substitute for a weak Iraqi Government. Neither Congress nor the American people will ever abandon our troops. They have a tough job and we are proud of them…. Let's send in the diplomats and bring our troops home safely and soon.

I want this war to end…. Yet, in ending the war, it's my responsibility to ensure that our troops are brought home not only swiftly, but safely. I've had people sit in my office four times during the last few weeks. Four times, people have come to sit in in my office. Some come to protest. Some come to get arrested. All have a right to speak out.

They want me to vote against the spending bill for the war. Yet, there is no way that a responsible Senator can vote against spending. There is no one line item that says "war, yes or no." That's not the way the supplemental works. That's not the way the Defense budget works. That's not the way our entire budget works. There is no line item vote that says "war, yes or no."

So, I say to the protesters, I say to those well-intentioned activists, know we are on your side, but what are you asking us to vote against? Do you want us to vote against the pay for the soldiers and for their spouses and for their children? I won't vote "no" against their benefits. What do you want us to vote against? The bullets and what they need to fight? I won't vote against that. Do you want us to vote against the body armor and the armored Humvees they need for survival? I won't vote against that. What about if they are injured? One of the things that saves lives are the tourniquets on the battlefield. When they are injured, jet fuel gets the helicopters and the planes from Baghdad to Germany to Walter Reed and Bethesda.

We will clean up Walter Reed. We will fix Bethesda. But they have to get here. When they get here, they need medical care —hats off to acute care. Now we need outpatient care. Now we need the long-term care for the 50 years that these men and women will have left. Twenty-two thousand people have

Purple Hearts in Iraq. More have been injured than we will ever know, or we will know only years from now.

I can't vote against funding. To all who are listening, you can sit-in every single day; you can follow me throughout my Senate career; you can tail me to my grave. I will not vote to in any way harm the men and women in the U.S. military, nor will I cut off the support to their families. And if you want to picket, you want to protest, you want to disrupt my life—better my life is disrupted than the lives of these men and women in uniform. I'm going to support this Reid resolution because I think it helps bring the war to an honorable end. But, at the same time, we are going to support our troops. It is time to stop the finger-pointing and it's time to point a new way forward.

Speaker of the House Nancy Pelosi
A Call for a New America
Opening Remarks, the 110th Congress
January 4, 2007

Now it is our responsibility to carry forth that vision of a new America into the 21st century. A new America that seizes the future and forges 21st-century solutions through discovery, creativity, and innovation, sustaining our economic leadership and ensuring our national security. A new America with a vibrant and strengthened middle class for whom college is affordable, health care is accessible, and retirement reliable. A new America that declares our energy independence, promotes domestic sources of renewable energy, and combats climate change. A new America that is strong, secure, and a respected leader among the community of nations.

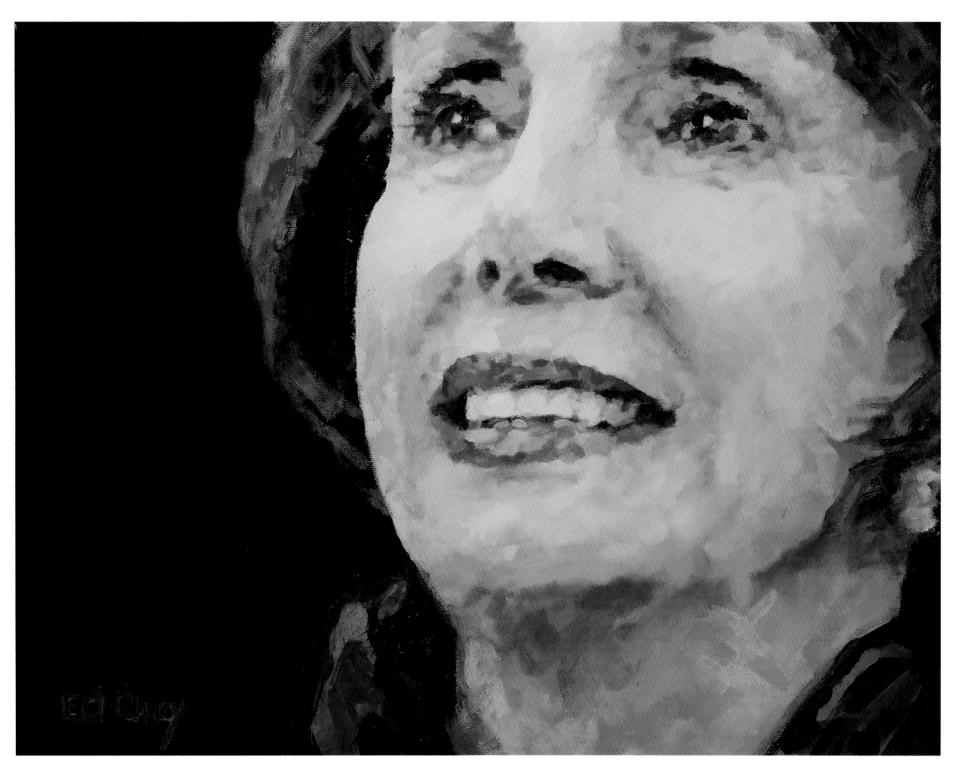

Speaker of the House Nancy Pelosi, 2007, oil on canvas, 14" x 18"
Democratic Principles Series, No. 19

I accept this gavel in the spirit of partnership, not partisanship, and I look forward to working with you, Mr. Boehner, and the Republicans in the Congress for the good of the American people.

After giving this gavel away in the last two Congresses, I am glad someone else has the honor today.

In this House, we may be different parties, but we serve one country, and our pride and our prayers are united behind our men and women in uniform. They are working together to protect the American people; and in this Congress, we must work together to build a future worthy of their sacrifice.

In this hour, we need and pray for the character, courage, and civility of a former Member of this House, President Ford. He healed the country when it needed healing. This is another time, another war, and another trial of American will, imagination, and spirit. Let us honor his memory not just in eulogy, but in dialogue and trust across the aisle.

I want to join Leader Boehner in expressing our condolences and our appreciation to Mrs. Ford and to the entire Ford family for their decades of leadership and service to our country.

With today's convening of the 110th Congress, we begin anew. I congratulate all Members of Congress on your election. I especially want to congratulate our new Members of Congress. Let's hear it for our new Members.

The genius of our Founders was that every two years, new Members would bring to this House their spirit of renewal and hope for the American people. This Congress is reinvigorated, new Members, by your optimism and your idealism and your commitment to our country. Let us acknowledge your families whose support has made your leadership possible today.

Each of us brings to this Congress our shared values, our commitment to the Constitution, and our personal experience. My path to Congress and to the speakership began in Baltimore where my father was the mayor. I was raised in a large family that was devoutly Catholic, deeply patriotic, very proud of our Italian-American heritage, and staunchly Democratic. My parents taught us that public service was a noble calling, and that we had a responsibility to help those in need.

It is a moment for which we have waited for over 200 years. Never losing faith, we waited through the many years of struggle to achieve our rights. But women were not just waiting; women were working. Never losing faith, we worked to redeem the promise of America that all men and women are created equal. For our daughters and our granddaughters, today we have broken the marble ceiling. For our daughters and our granddaughters, the sky is the limit. Anything is possible for them.

The election of 2006 was a call to change, not merely to change the control of Congress, but for a new direction for our country. Nowhere were the American people more clear about the need for a new direction than in the war in Iraq.

The American people rejected an open-ended obligation to a war without end. Shortly, President Bush will address the Nation on the subject of Iraq. It is the responsibility of the President to articulate a new plan for Iraq that makes it clear to the Iraqis that they must defend their own streets and their own security, a plan that promotes stability in the region and a plan that allows us to responsibly redeploy our troops.

Let us work together to be the Congress that rebuilds our military to meet the national security challenges of the 21st century.

Let us be the Congress that strongly honors our responsibility to protect the American people from terrorism.

Let us be the Congress that never forgets our commitment to our veterans and our first responders, always honoring them as the heroes that they are.

The American people also spoke clearly for a new direction here at home. They desire a new vision, a new America built on the values that have made our country great.

Our Founders envisioned a new America driven by optimism, opportunity, and courage. So confident were they in the America that they were advancing that they put on the seal, the Great Seal of the United States: "Novus ordo seclorum," a new order for the centuries. "Centuries"; they spoke of the centuries. They envisioned America as a just and good place, as a fair and efficient society, as a source of hope and opportunity for all.

This vision has sustained us for over 200 years, and it accounts for what is best in our great Nation: liberty, opportunity, and justice.

Now it is our responsibility to carry forth that vision of a new America into the 21st century. A new America that seizes the future and forges 21st-century solutions through discovery, creativity, and innovation, sustaining our economic leadership and ensuring our national security. A new America with a vibrant and strengthened middle class for whom college is affordable, health care is accessible, and retirement reliable. A new America that declares our energy independence, promotes domestic sources of renewable energy, and combats climate change. A new America that is strong, secure, and a respected leader among the community of nations.

And the American people told us they expected us to work together for fiscal responsibility, with the highest ethical standards and with civility and bipartisanship.

After years of historic deficits, this 110th Congress will commit itself to a higher standard: pay-as-you-go, no new deficit spending. Our new America will provide unlimited opportunity for future generations, not burden them with mountains of debt.

In order to achieve our new America for the 21st century, we must return this House to the American people. So our first order of business is passing the toughest congressional ethics reform in history. This new Congress doesn't have two years or two hundred days. Let us join together in the first one hundred hours to make this Congress the most honest and open Congress in history. One hundred hours.

This openness requires respect for every voice in the Congress. As Thomas Jefferson said, "Every difference of opinion is not a difference of principle." My colleagues elected me to be Speaker of the House, the entire House. Respectful of the vision of our Founders, the expectation of our people, and the great challenges that we face, we have an obligation to reach beyond partisanship to work for all Americans.

Let us stand together to move our country forward, seeking common ground for the common good. We have made history; now let us make progress for the American people.

May God bless our work, and may God bless America.

Biographies

Secretary of State Madeleine K. Albright

Madeleine Korbel Albright served as U.S. Secretary of State from 1997 to 2001—the first female Secretary of State and, at that time, the highest-ranking woman in the history of the U.S. Government. Dr. Albright served as the United States' Permanent Representative to the United Nations as a member of President Clinton's Cabinet and the National Security Council, and was formerly President of the Center for National Policy. Dr. Albright is the founder of the Albright Group, a global strategy firm. She is a Research Professor of International Affairs and Director of Women in Foreign Service Program at Georgetown University's School of Foreign Service. She also served as a Senior Fellow in Soviet and Eastern European Affairs at the Center for Strategic and International Studies.

http://www.state.gov/secretary/former/40381.htm

Senator Joseph R. Biden, Jr.

Joseph R. Biden, Jr., was first elected to the United States Senate in 1972 at the age of 29 and is recognized as one of the Nation's most powerful and influential voices on foreign relations, terrorism, drug policy, and crime prevention.

Senator Biden is known for his strong commitment to bipartisan foreign policy and is acknowledged by his Congressional peers for his uniquely well-informed and common-sense approach to the complexities of American foreign policy issues. Senator Biden has been instrumental in crafting almost every major piece of crime legislation over the past several decades. He is the author of the landmark Violence Against Women Act of 2000, which contains a broad array of ground-breaking measures to combat domestic violence and provides billions of dollars in federal funds to address gender-based crime. He is also very active in environmental protection, especially along the Delaware coastline. He has taken a strong stand on the rising cost of college education in America by providing legislation to allow tax deductions to families with college attendees.

http://biden.senate.gov/biography/

Senator Barbara Boxer

A forceful advocate for families, children, consumers, the environment, and her State of California, Barbara Boxer became a United States Senator in January 1993, after 10 years of service in the House of Representatives. Elected to a third term in 2004, she received more than 6.9 million votes, the highest total for any Senate candidate in American history. She is a national leader on environmental protection and the first woman to chair the U.S. Senate's Committee on Environment and Public Works (EPW). She has won numerous awards for her efforts to create a cleaner, healthier environment. Boxer has written landmark legislation establishing the first-ever after-school programs. She is also a strong advocate of medical research and authored a Patients' Bill of Rights in 1997. She is known as the Senate's leading defender of a woman's right to choose.

In addition to her chairmanship of the Committee on Environment and Public Works, Senator Boxer also serves on the Senate Foreign Relations Committee and Commerce Committee, is the Democratic Chief Deputy Whip, and serves on the Democratic Policy Committee's Committee on Oversight and Investigations.

http://boxer.senate.gov/about/bio/index.cfm

Senator Robert C. Byrd

Robert C. Byrd has served longer than all but one member of Congress. In June 2006, Byrd became the longest-serving Senator in the history of the Republic and, in November 2006, he was elected to an unprecedented ninth consecutive term in the Senate. During his tenure, his colleagues have elected him to more leadership positions than any other Senator in history. Throughout his career, Byrd has cast nearly 17,800 roll call votes—an amazing 98.7 percent attendance record in his nearly five decades of service in the Senate.

In the halls of Congress, Robert C. Byrd is best known for his fierce defense of the Constitution and the institution of the Senate. The Almanac of American Politics says that Byrd "may come closer to the kind of senator the Founding Fathers had in mind than any other."

http://byrd.senate.gov/biography/story/story.html

President Jimmy Carter

Jimmy Carter (James Earl Carter, Jr.), 39th President of the United States, was born in 1924 in rural Georgia. He was the Democratic National Committee campaign chairman for the 1974 congressional and gubernatorial elections and was elected President of the United States in 1976.

Significant foreign policy accomplishments of his administration include the Panama Canal treaties, the treaty of peace between Egypt and Israel, the SALT II treaty with the Soviet Union, and the establishment of U.S. diplomatic relations with the People's Republic of China. He championed human rights throughout the world. On the domestic side, the administration's achievements included a comprehensive energy program conducted by a new Department of Energy, major educational programs under a new Department of Education, and major environmental protection legislation.

In 2002, he was awarded the Nobel Peace Prize "for his decades of untiring effort to find peaceful solutions to international conflicts, to advance democracy and

human rights, and to promote economic and social development." Mr. Carter is the author of 22 books. He and his wife continue to volunteer one week every year to Habitat for Humanity.

http://nobelprize.org/nobel_prizes/peace/laureates/2002/carterbio.html

President Bill Clinton

William Jefferson Clinton was born in 1946, in Hope, Arkansas. Elected President of the United States in 1992 and 1996, President Clinton was the first Democratic president to be awarded a second term in six decades. Under his leadership, the United States enjoyed the strongest economy in a generation and the longest economic expansion in U.S. history.

Clinton graduated from Georgetown University and in 1968, won a Rhodes Scholarship to Oxford University. He received a law degree from Yale University in 1973, and shortly thereafter entered politics in Arkansas. In 1976, Clinton was elected Attorney General of Arkansas and in 1978 he was elected Governor of Arkansas. After losing a bid for a second term, he regained the office four years later, and served until his 1992 bid for the presidency of the United States.

After leaving the White House, President Clinton established the William J. Clinton Foundation with the mission to strengthen the capacity of people in the United States and throughout the world to meet the challenges of global interdependence.

http://www.whitehouse.gov/history/presidents/bc42.html
http://www.clintonfoundation.org/wjc-bio.htm

Senator Hillary Clinton

Senator Hillary Rodham Clinton was born in Chicago, Illinois, in 1947. She is a graduate of Wellesley College and Yale Law School and is married to former President William Jefferson Clinton.

Hillary Rodham Clinton was elected to the United States Senate in 2000, after years of public service on behalf of children and families. She is the first First Lady of the United States elected to public office and the first woman elected independently statewide in New York State. The Senator supports a return to fiscal responsibility because she knows that wise national economic policies are essential to protect America's future.

Senator Clinton is a candidate for the United States presidency in 2008.

http://www.hillaryclinton.com/about/

Governor Howard Dean

Dr. Howard Dean became the State of Vermont's governor in 1991 and was re-elected four more times. He has also served as chairman of the National Governors' Association, the Democratic Governors' Association, and the New England Governors' Conference. Before entering politics, Dean received a medical degree from the Albert Einstein College of Medicine in New York City in 1978. Upon completing his residency at the Medical Center Hospital of Vermont, he went on to practice internal medicine in Shelburne, Vermont. His political career began in the early 1980s when he was elected to the Vermont House of Representatives.

After achieving national prominence in his bid for the Democratic nomination for President, Governor Dean founded Democracy for America in 2004 in order to elect fiscally responsible and socially progressive candidates to all levels of government while working with the grassroots constituency.

Dr. Dean is currently the Chairman of the Democratic National Committee.

http://www.democrats.org/a/party/chairman/aboutthechairman.html

Senator John Edwards

In 1998 John Edwards became a U.S. Senator. As a member of Congress he was known to champion issues that make a difference to American families: quality health care, better schools, protecting civil liberties, preserving the environment, saving Social Security and Medicare, and reforming the ways campaigns are financed.

As a member of the Select Committee on Intelligence, Edwards worked to strengthen national defense and Homeland Security.

http://www.johnedwards.com/about/john/

Senator Dianne Feinstein

As California's senior Senator, Dianne Feinstein has built a reputation as an independent voice, working with both Democrats and Republicans to find common-sense solutions to the problems facing California and the Nation.

Since her election to the Senate in 1992, Senator Feinstein has worked in a bipartisan way toward a significant record of legislative accomplishments helping to strengthen the nation's security both here and abroad, combat crime and violence, battle cancer, and protect natural resources in California and across the country.

http://feinstein.senate.gov/public/index.cfm?FuseAction
=AboutDianne.Biography

Vice President Al Gore

Albert Gore, Jr., was inaugurated as the 45th Vice President of the United States in 1993 alongside President Clinton. He was the Democratic Party presidential nominee in the 2000 election. In one of the closest and most disputed elections in United States history, Gore and his running mate, Senator Joseph Lieberman, were defeated. In 1969, he volunteered for enlistment in the U.S. Army and served in the Vietnam War.

Since his earliest days in the U.S. Congress thirty years ago, Al Gore has been the leading advocate for confronting the threat of global warming. Al Gore was instrumental in leading the Clinton-Gore Administration's efforts to protect the environment in a way that would also strengthen the economy.

Mr. Gore is the author of *An Inconvenient Truth*, and the movie of the same title, which has already become one of the top documentary films in history. Vice President Al Gore was awarded the Nobel Peace Prize on October 12, 2007—an honor he shares with the Intergovernmental Panel on Climate Change.

http://www.algore.com/
http://www.climatecrisis.net/
http://bioguide.congress.gov/scripts/biodisplay.pl?index=G000321
http://www.algore2004.org/gorebiography/albio.htm

Senator Edward M. Kennedy

Senator Ted Kennedy has represented Massachusetts in the United States Senate for forty-three years. Kennedy has been re-elected to seven full terms, and is now the second most senior member of the Senate and is currently the senior Democrat on the Health, Education, Labor and Pensions Committee in the Senate. He also serves on the Judiciary Committee, where he is the senior Democrat on the Immigration Subcommittee, and on the Armed Services Committee, where he is the senior Democrat on the Seapower Subcommittee. He is also a member of the Congressional Joint Economic Committee and the Congressional Friends of Ireland. He is also a trustee of the John F. Kennedy Center for the Performing Arts in Washington, D.C.

His effort to make quality health care accessible and affordable to every American is a battle that Kennedy has been waging ever since he arrived in the Senate. In addition, Kennedy is active on a wide range of other issues, including education reform and immigration reform, raising the minimum wage, defending the rights of workers and their families, strengthening civil rights, assisting individuals with disabilities, fighting for cleaner water and cleaner air, and protecting and strengthening Social Security and Medicare.

http://kennedy.senate.gov/senator/index.cfm

Senator John Kerry

John F. Kerry was born in December 1943 and raised in Massachusetts. Upon graduating from Yale, John Kerry volunteered to serve in Vietnam, because, as he later said, "it was the right thing to do." He believed that "to whom much is given, much is required." John Kerry served two tours of duty and was awarded a Silver Star, a Bronze Star with Combat V, and three Purple Hearts.

Kerry graduated from Boston College Law School in 1976. He was then elected Lieutenant Governor of Massachusetts in 1982. Two years later, he was elected to the United States Senate and he has won re-election three times since. He is now serving his fourth term, after winning again in 2002.

In 2003, John Kerry mounted a come-from-behind campaign to win the Democratic nomination for the presidency. Kerry came close to the presidency in 2004—and dusted himself off, thought about what mattered to him most, and continues to keep up the fight for the people whose concerns have been his cause these last thirty-five years.

http://www.johnkerry.com/about

Senator Patrick Joseph Leahy

Patrick Leahy was elected to the United States Senate in 1974 and remains the only Democrat elected to this office from Vermont. At 34, he was the youngest U.S. Senator ever to be elected from the Green Mountain State. Leahy was born in Montpelier and grew up across from the Statehouse. A graduate of Saint Michael's College in Colchester (1961), he received his Juris Doctor from Georgetown University Law Center (1964). He served for eight years as State's Attorney in Chittenden County. He gained a national reputation for his law enforcement activities and was selected (1974) as one of three outstanding prosecutors in the United States. Leahy is the Chairman of the Judiciary Committee and is a senior member of the Agriculture and Appropriations Committees. He ranks seventh in seniority in the Senate.

http://leahy.senate.gov/biography/index.html

Senator Barbara A. Mikulski

Growing up in the Highlandtown neighborhood of East Baltimore, Senator Barbara A. Mikulski learned the values of hard work, community, and heartfelt patriotism. She often saw her father open the family grocery store early so local steelworkers could buy lunch before the morning shift.

Determined to make a difference in her community, Mikulski became a social worker in Baltimore, which soon evolved into community activism and an attraction to politics. Her first election was a successful run for Baltimore City Council in 1971, where she served for five years. In 1976, she ran for Congress and won, representing Maryland's 3rd district for ten years. In 1986, she ran for Senate and won, becoming the first Democratic woman Senator elected in her own right. She was re-elected with large majorities in 1992, 1998, and 2004.

A leader in the Senate, Mikulski is the Dean of the Women—serving as a mentor to other women Senators when they first take office.

http://mikulski.senate.gov/SenatorMikulski/biography.html

Senator Barack Obama

Barack Obama has dedicated his life to public service as a community organizer, civil rights attorney, and leader in the Illinois state Senate. Obama now continues his fight for working families in the United States Senate. He graduated from Harvard Law School where he was the first African American president of the Harvard Law Review.

Senator Obama serves on the Health, Education, Labor and Pensions Committee, which oversees our nation's health care, schools, employment, and retirement programs. He is a member of the Foreign Relations Committee, which plays a vital role in shaping American policy around the world, including our policy in Iraq. And Senator Obama serves on the Veterans' Affairs Committee, which is focused on providing our brave veterans with the care and services they deserve. In 2005 and 2006, he served on the Environment and Public Works Committee, which safeguards our environment and provides funding for our highways.

Obama has worked to create programs like the state Earned Income Tax Credit, which in three years provided over $100 million in tax cuts to families across the state. He also pushed through an expansion of early childhood education, and after a number of inmates on death row were found innocent, Senator Obama enlisted the support of law enforcement officials to draft legislation requiring the videotaping of interrogations and confessions in all capital cases.

Senator Obama is a candidate for the United States presidency in 2008.

http://obama.senate.gov/about/
http://www.barackobama.com/about/

Speaker of the House Nancy Pelosi

Since 1987, Nancy Pelosi has represented California's Eighth District in the House of Representatives. The Eighth District includes most of the City of San Francisco including Golden Gate Park, Fisherman's Wharf, Chinatown, and many of the diverse neighborhoods that make San Francisco a vibrant and prosperous community. Overwhelmingly elected by her colleagues in the fall of 2002 as Democratic Leader of the House of Representatives, Nancy Pelosi is the first woman in American history to lead the majority party in the U.S. Congress. Before being elected Leader, she served as House Democratic Whip for one year and was responsible for the party's legislative strategy in the House. On January 4, 2007, Nancy Pelosi was elected Speaker of the United States House of Representatives.

http://www.house.gov/pelosi/biography/bio.html

Senator Charles E. Schumer

In 2004, New Yorkers re-elected U.S. Senator Charles E. "Chuck" Schumer to represent the State of New York in the U.S. Senate for a second six-year term. He started off his second term by being appointed to the Democratic Leadership team by Senate Democratic Leader Harry Reid (D-NV). He also earned a seat on the Senate Finance Committee, which oversees the nation's tax, trade, social security and health care legislation. Chuck Schumer also sits on the Committee on Banking, Housing, and Urban Affairs, the Judiciary Committee, and the Rules Committee. He is the ranking member of the Administrative Oversight and the Courts Subcommittee and the Economic Policy Subcommittee. Prior to his election to the Senate, he represented the Ninth Congressional District in Brooklyn and Queens for eighteen years. Before that, he represented the Forty-Fifth Assembly District in Brooklyn for six years.

http://www.senate.gov/~schumer/SchumerWebsite/about_chuck/
ac-bio_chuck.html

Senator Paul Wellstone

The son of Jewish immigrants from Russia, Paul David Wellstone was born in 1944 and raised in Arlington, Virginia. He attended the University of North Carolina and went on to complete his Ph.D. in political science at the University of North Carolina. At the age of 24, he became a professor at Carleton College in Minnesota.

In 1989, Wellstone announced his candidacy for the U.S. Senate and won. Virtually unknown to Minnesota voters, but with a loyal following built up during his years as an organizer, he captured the Democratic Party nomination. He was elected to a second term in 1996. In 2002, Wellstone sought a third term to the Senate, and was targeted by the White House's political operation as a top target for defeat. Despite taking a politically unpopular vote against the impending war in Iraq, polls showed him with a solid lead going into the final two weeks of the campaign.

On October 25, 2002, Paul, his wife, and one of their children were tragically killed when their plane crashed in northern Minnesota while traveling to campaign events.

http://www.wellstone.org/archive

The artist would like to express her sincere gratitude to the following people:

Jean Trout, Richard Solomon and Richard Davison, who were extremely important in the beginning stages.

Raphael Rubenstein, Killian Jordan and Susan Burke, who guided critical publisher and content choices.

Bart Fisher and Jim and Jack Albertine, for their enthusiasm which led to early paintings hanging, on loan, in Senate and leadership offices.

Zel Lipsen and Joan Firestone for guiding us to prospective participants.

The Associated Press, Reuters and Getty news services for permitting the use of archived photos as references for the paintings.

Brandon Webster, Washington D.C. fine arts photographer for remarkable photographs of the paintings, and the people at Nancy Scans, Chatham, New York, for imaging expertise.

The press offices who responded to questions about the public domain speeches; President Carter and his press secretary, Deanna Congileo, for allowing us to use segments of the President's Nobel Laureate Address and his Eulogy for Coretta Scott King.

Jon Gams, Anne Bei and the team at Hard Press Editions for their immediate grasp of the power and potential of this concept, for nurturing its graphic power and protecting its editorial integrity.

Peter Frank, Senior Curator of the Riverside Art Museum and nationally recognized art critic and Eleanor Heartney, distinguished art historian and critic—their highly informed commentaries contributed immensely to the power and scope of this book.

Senator John F. Kerry, who has honored this project from its inception with his enthusiasm and respect, and whose personally written Foreword eloquently speaks to the centrality of democratic principles in this great democracy.

Ann and Tim Felker, whose unflagging generosity of intellect, heart and home literally sustained the art and the vision.

And George McClancy, whose informed, hands-off encouragement liberated this shocking gift to find its full expression, whose discernment and devotion to the truth informed every aspect of this project. Our divine synergy has made possible the substance of *Democratic Priciples*, its mission and scope.

—Elizabeth C. McClancy
January 2008

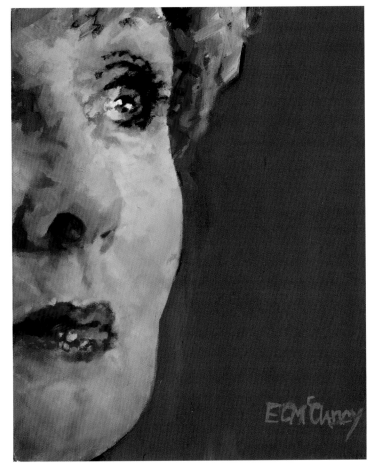

Self Portrait, Elizabeth McClancy, 2007
oil on canvas, 8" x 6"